Japanese Prints
and Western Painters

Japanese Prints and Western Painters
Frank Whitford

Studio Vista
London

A Studio Vista book published by
Cassell & Collier Macmillan Publishers Ltd,
35 Red Lion Square, London WC1R 4SG
and at Sydney, Auckland, Toronto, Johannesburg,
an affiliate of
Macmillan Publishing Co., Inc.,
New York.

ISBN 0 289 70752 8

Designed by Anthony Cohen.
Filmset and printed in 10/12 pt Apollo
by BAS Printers Limited, Wallop, Hampshire.
Bound by Webb & Sons Ltd.

A drop of their blood has mixed with our blood and no power on earth can eliminate it.

Louis Gonse in *Le Japon artistique,* 1888

Contents

Preface

In his influential book *Pioneers of the Modern Movement*, published in 1936, Nikolaus Pevsner has this to say:

> The history of the part played by China and Japan in European art since 1860 has not yet been written. It would be interesting to show the influence of the East making here for a loose technique in painting, there for a playful weightlessness of construction, and again in other works for flat-pattern effects.[1]

Since that was written, several studies have appeared either wholly or partly devoted to the role played by Japanese art in the development of modern painting. I am thinking particularly of Hugh Honour's *Chinoiserie* (1961), Mark Roskill's *Van Gogh, Gauguin and the Impressionist Circle* (1970) and Michael Sullivan's *The Meeting of Eastern and Western Art* (1973). I am also thinking of four important exhibitions which, together with their catalogues, have made valuable contributions to this important field: 'Der Japonismus in der Malerei und Grafik des 19. Jahrhunderts', organized by Leopold Reidemeister in 1965 in the Haus am Waldsee, West Berlin; the unnervingly comprehensive 'Weltkulturen und Moderne Kunst', staged by the City of Munich and largely organized by Professor Siegfried Wichmann in conjunction with the 1972 Olympics; 'The Great Wave', staged in 1974 at the Metropolitan Museum, New York; and 'Japonisme', initiated in Cleveland and shown at galleries in two other American cities during 1975–6.

Why, therefore, a book on the subject, especially since I have drawn heavily on the studies already mentioned and on other books and articles recorded in the bibliography? My answer is that although the chapters on European art contain little that is original, they do bring together for the first time most of the available published information, and some of the unpublished information, about the strong links between Western painters (and print makers) and Japanese art. This material appears for the first time within the same covers as a detailed description, history and discussion of

the Japanese art which the European painters and print makers found so seductive. Because of this I hope that the connections between Japanese and Western art during the nineteenth century will emerge with new clarity, and that previously unperceived affinities will be seen.

What follows is anything but comprehensive. I have concentrated on the major figures. I have dealt chiefly with the painters, though with some reference to graphic art, touching on the applied arts only where these seem to be of relevance to painting. Moreover, I have confined myself almost entirely to France, and the inevitable imbalance may make the treatment of England and, more especially, of the German-speaking countries, seem unsatisfactory or frustratingly skimpy.

The most obvious danger of a book of this kind, with its relatively narrow focus, is that it will encourage a distorted outlook. To concentrate so exclusively on the influence of Japan is to run a risk of overemphasizing its importance. Japanese art was crucial to the development of modern painting, but of course it was by no means the only factor in the emergence and refinement of the various styles which dominated the avant-garde from the 1860s onwards. If I have neglected the other factors, it has been in the desire to avoid too complicated a line of argument.

Friends and colleagues have suggested improvements to the manuscript and have helped in other ways, although any mistakes or ambiguities which remain are entirely mine. I am indebted to Dr John McMaster and his specialist knowledge of Japanese history; to Dr Paul Joannides, who corrected facts and ironed out some of the infelicities of style; to Mary Anne Stevens, Toshio Watanabe and Helen Weston, who read the manuscript and suggested numerous improvements; and to Ashley St James for useful comments. Dr W. van Gulik of the Rijksmuseum voor Volkenkunde at Leyden was kind enough to answer queries, and Kaneko Sensei, the Tōkyō scholar and collector who remembers working for

an *ukiyo-e* publisher in his youth, provided much in the
way of information and inspiration. I am also grateful to
students at Homerton College and at the University of
Cambridge for their stimulating discussions and for their
patience in the face of so much talk about Japan.

Had it not been for the singular assistance given me by
Peter Townsend, formerly editor of *Studio International,*
and William C. Bendig and Alan Laming, publisher and
editor respectively of the *Art Gallery Magazine,* I should
not have been able to visit Japan in 1972 and 1974, nor
would it have been so easy to lay my hands on vital
catalogues from the United States. The Japanese depart-
ment at Sotheby's in London generously provided many
photographs, and Erika Fabarius of Fischer Fine Art also
provided illustrations. Colin Marr developed and printed
pictures at short notice. Jörn Merkert of the Neue
Nationalgalerie, Berlin, acquired for me a rare and
enlightening catalogue. Tristram Holland helped to
assemble the illustrations, and Robert Saxton, my editor
at Studio Vista, has done much to improve the original
manuscript. I am also grateful to the staff of the library
and print room of the Victoria and Albert Museum, to the
Oriental Department of the British Museum, and to the
staff of the University Library at Cambridge.

If I mention my wife it is not because it is one of the
time-honoured conventions of acknowledgement-writing
to do so, but because this book would have been neither
begun nor finished without her. A descendant of
Christopher Dresser, one of the pioneers of Anglo-
Japanese design, she introduced me to Japan and
educated me in the history and ways of that singularly
beautiful country. She prepared bibliographies and
summaries of books in Japanese, compiled the glossary
of Japanese words and wrote almost the whole of the
chapter on the history of the *ukiyo-e*. It is to her parents
in Japan and to mine in England that I should like to
dedicate what follows.

Great Wilbraham, Cambridge, March 1976

Part One: Japan

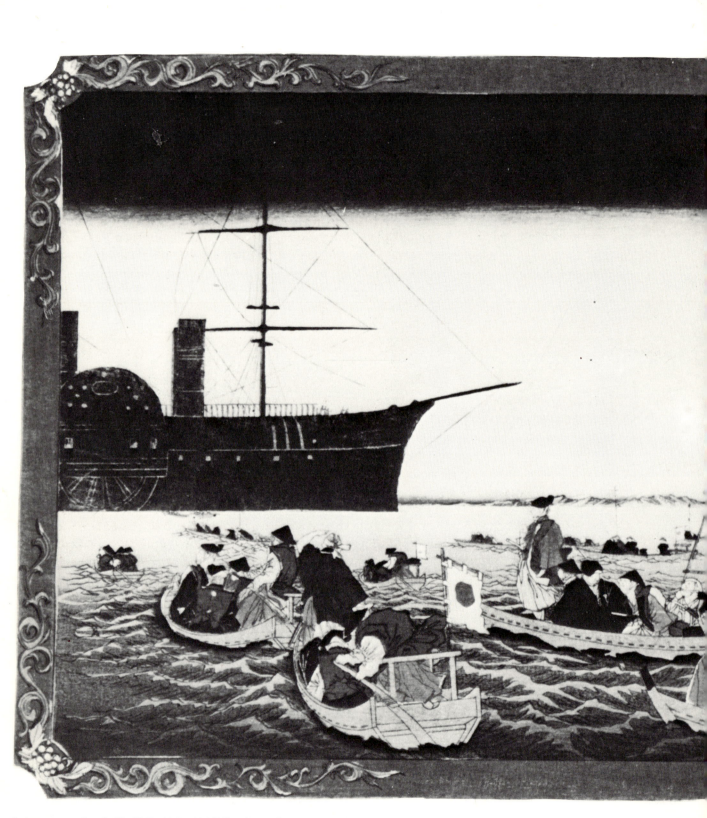

1 **Anonymous** *Perry's ship*, 1860s. 34·4 × 22·8 (13½ × 9), British Museum, London

The Coming of the Black Ships

In July 1853 Commodore Matthew C. Perry steamed into Kurihama Bay with a squadron of ships of the United States Navy and dropped anchor off Uraga, a seaside village not far from Edo. Perry's arrival ended Japan's isolation from the rest of the world. For 215 years this had been almost total. Now a chain of events was initiated which would eventually result in major changes in every aspect of Japanese life.

After 1639, when the Shōgun (the head of the military government), fearful of Western domination, had issued the last of a series of orders to close Japan against foreign, and especially Catholic, influence, the country had turned in upon itself. Although the Calvinist Dutch were permitted to maintain a trading station on Dejima (an artificial, fan-shaped island in the harbour of Nagasaki), and although the Chinese were also allowed occasional contact, the Japanese attempted to insulate themselves against all knowledge of events abroad. It was forbidden for any Japanese to travel. The dramatic developments in science, technology, economics and philosophy which, in Europe, had resulted in new social structures during the eighteenth and early nineteenth centuries, could have almost no effect on Japan. As though locked in a time capsule, it remained bound by old ways and old habits of thought.

The landing of Perry's black ships must therefore have seemed to many Japanese as incredible as the arrival of creatures from another planet. Propelled by steam as well as sail, the ships were unlike anything the Japanese had ever seen, and so were the curious costumes the pink-skinned foreigners wore. The Japanese watched in amazement as the great vessels moved up the bay against the wind. The more adventurous among them took to small boats and went out to inspect the aliens more closely. Some of them were artists, anxious to do sketches of the scene to be made into coloured woodblock prints, which were later to be sold in great numbers.

Eventually the governor of the province arrived.

According to Francis Hawks, chronicler of Perry's expedition, the governor, in his sumptuous robes, looked like 'an unusually brilliant knave of trumps'.[2] He attempted to persuade Perry to leave, but with no success, for the American had been given instructions by his government in Washington to deal only with the supreme ruler, and to persuade him to allow American ships to use certain Japanese ports. All conversations were conducted through interpreters in Dutch. Because of the trading rights enjoyed exclusively by the Netherlands since 1640, Dutch remained the *lingua franca* until the 1860s, when those Japanese who had learned it with much effort discovered that English was by now the most useful foreign language. (When foreign settlers first went to Yokohama in July 1859, Japanese students of Dutch, such as Fukuzawa Yukichi, were disappointed to find most of the population were British shopkeepers.)

Commodore Perry had brought to Japan as a gift a miniature steam-train, and the Japanese queued for hours for a chance to ride on this magic vehicle after a track had been laid down on the shore. To the more simple among them it proved that the foreigners were impressive magicians; to the more intelligent it showed how far the outside world had advanced during the centuries of Japanese isolation and how the Japanese would be powerless should any foreigners come, not as friends, but as enemies wishing to invade.

It was probably such a fear that ensured Perry was eventually brought before the Shōgun and allowed to communicate the wishes of the American government, which wanted access to certain ports for merchant and fishing ships, so that they could take on supplies and seek refuge from storms. In 1854 Perry signed an agreement with the Shōgunal government to open the port of Shimoda to American shipping. The Shōgun also agreed to permanent diplomatic representation, and in 1856 the first American consul arrived at Shimoda: the celebrated Townsend Harris, whose activities in Japan probably provided the outline of the character Pinkerton, made famous by Puccini's *Madame Butterfly*.* Perry and, later, Harris erroneously believed that they were negotiating with the Emperor himself, but they could not have been expected to grasp the complexity of Japan's political situation. For centuries the country had been ruled by the military generalissimos, the Shōguns, who operated from Edo. The Emperor remained in Kyōto, reduced to the symbolic but still influential role of spiritual leader.

Although the Shōgunal government continued to resist foreign ideas, the inevitable march of history could no longer be postponed. This was still the age of colonial expansion. The European powers were still competing for land, trade and influence in all parts of the world. Determined not to be outdone by the United States, Britain and Russia sent fleets to Japan as soon as the end of the Crimean War made it possible. Big naval guns again hovered ominously on the horizon while a new body of negotiators presented themselves to the Shōgun. In 1858 Japan signed treaties with Russia, Britain, France and the United States and, eventually, with fourteen other nations. More ports were opened to foreigners: Kanagawa, Nagasaki and Hakodate in 1859, and Yokohama in 1860.

The first British envoy, Rutherford Alcock, arrived in 1859 and set up his embassy in a Buddhist temple in Edo. In 1860 the first Japanese delegation to visit a foreign country landed in San Francisco after a nine-month voyage in a small warship bought from the Dutch. Two years later the first delegation to Europe disembarked after a long voyage in a vessel acquired from the British. By 1866 Japanese diplomats were the object of much curiosity in London, Paris and Berlin. Information about the West was now flooding into Japan and was voraciously consumed. Fukuzawa Yukichi, who accompanied the first delegation to Europe as interpreter, wrote a book about his experiences, *Seiyō Jijō* (Conditions of Western Lands), which was an immediate best-seller.[3] How could it have been otherwise? It was not simply that the Japanese had been starved of information about the West, but that the information, when it came, proved so amazing.

However, in spite of this thirst for knowledge, the early stages of the forced marriage between the Japanese and the Western sailors and traders were no honeymoon. The treaties had humiliated Japan, which found itself the reluctant host not only to foreign diplomats and navies, but also to foreign soldiers now stationed at

* This honour is also claimed for a British merchant at Nagasaki, named Glover. Puccini's immediate source was probably Pierre Loti's *Madame Chrysanthème* (1887).

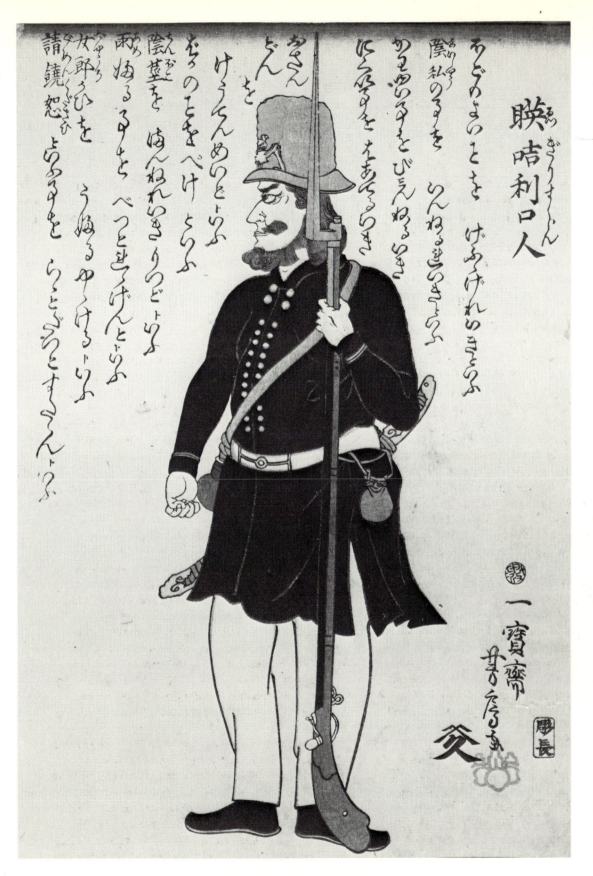

2 **Yoshifusa** *English soldier, c.*1870. 35·4 × 23·7 (14⅜ × 9⅜), British Museum, London

Yokohama. For about five years there was an upsurge of violent anti-Western feeling among the rank and file samurai, who felt that the Shōgunate was selling out to the Westerners. Assassinations and attacks on foreign embassies were common. Rutherford Alcock quickly discovered that the temple in which the British legation was located was especially difficult to defend because some of the monks had remained in residence. The most influential among the Japanese, on whom the Shōgunal government relied, deprecated these attacks, realizing with remarkable pragmatism that the best long-term defence against the foreigners would be not to resist their ways but to adopt them. They therefore persuaded the Shōgunate to adopt a Western-style navy as early as 1858, and they were so impressed by the Royal Navy that after 1868 British instructors were taken on.

Ironically, the Shōgunal government, which had signed the first treaties with the Western powers, was overthrown as an indirect result of Western influence. The Shōgunate, in spite of its acceptance of the need to Westernize Japan, soon began to be seen as an impediment to the fast assimilation of new ideas. It was adopting Western ways, but not with sufficient speed or conviction, and dissatisfaction with its sluggishness eventually resulted in open rebellion. After the rebel victory, which was achieved with British backing, a return to Imperial rule was proclaimed. In 1868 the young crown prince Mutsuhito succeeded to the Imperial throne. The name for his reign, as well as the title conferred upon the prince himself, was Meiji, or 'enlightened government'. Almost the first decision taken by his ministers, and certainly one of the most dramatic, was to transfer the Imperial capital from Kyōto (where it had been since the eighth century) to Edo, where the Shōguns had exercised their military might. Thus the impression was given that the Emperor, the spiritual leader of Japan, had triumphed over the Shōgun. Edo was renamed Tōkyō, or 'eastern capital'. Contemporary reports describe Mutsuhito's progress as newly proclaimed Emperor along the Tōkaidō road from Kyōto to Edo. It was a grand affair, with the Emperor riding in a magnificent palanquin. During a stop near Yokohama the train was entertained by a British infantry band stationed there, which played

'The British Grenadiers'.[4] History is full of such bizarre cultural confrontations.

Under the Emperor Meiji the country was propelled precipitately into the nineteenth century. The rigid and complex social barriers, which had been so necessary to the feudal system operating in Japan till now, were demolished. A Western form of government was introduced, and a curiosity about all things foreign was encouraged. It was thought desirable that Japan should absorb Western ideas and come abreast of advanced Western technology. The motive for this was not so much a fear of European domination (this fear had loosened its hold after about 1860) as an ambition among many members of the government to turn Japan itself into a colonial power. It is sometimes assumed that the Emperor was personally responsible for this revolution in attitudes that was taking place. In 1868, however, he was an ill-educated sixteen-year-old, merely the symbol of Westernizing tendencies which had been gathering force for years, and had swept the Shōgun from power and created the Meiji Restoration.

The Industrial Revolution had been an experience traumatic enough even for Britain, the country which had initiated it. Even more problems were caused in Japan, which now not only began a full-scale Industrial Revolution of its own, but simultaneously began to learn about all those scientific and cultural developments which had occurred during the two centuries of isolation. Popular writers and artists became obsessed with Western inventions and life in Western cities (see Colour Plate 1). Able young Japanese were sent to England, Germany, France and the United States to learn from each country the skills in which it particularly excelled. They also saw, *en route,* conditions in some of those countries colonized by the great powers, and they perceived the dangers for Japan if it were to play too subordinate a role in relation to the West. At the same time more than three thousand Westerners, the *Oyatoi Gaikokujin* as they were called at the time, were instructing the Japanese at home – American postal, agricultural and education advisers, German doctors and soldiers, French lawyers and marine engineers. Britain helped create the new Imperial navy, the merchant fleet, the banking

system and the railway network.

The Japanese language immediately registered these radical social changes. Words drawn from German, French, but above all from English, entered the vocabulary in modified form to describe concepts and objects which had previously been completely unknown. The most striking example is provided by the words for all dairy products, which before the Meiji Restoration had not been a part of the Japanese diet. When butter and cheese were introduced into Japan, the words for them were borrowed from English and are still on permanent loan; the same applies to all the words for Western eating utensils.

During the early years of the Meiji government the appetite for things Western was voracious. The building of factories, railway stations and steamships was accompanied by the wearing, in cities at least, of Western-style clothes and the adoption of Western-style manners. Western music and Western dances were the rage; Japanese writers modelled their work after Dickens, Dostoyevsky and Tolstoy; and Japanese painters began to imitate French and English styles. Parts of Tōkyō assumed a Western appearance with banks, department stores and public buildings designed in European styles, with street lamps and street cars, and with some fashion-conscious ladies and gentlemen parading in dresses and frock coats instead of the traditional kimono and *geta* (see Colour Plate 2 and Plate 4).

The effects of this unslakeable thirst for European fashions and customs could be seen more quickly in the cultural than in the economic sphere. Before 1868 Japan's economy had been almost completely agrarian, so that the industrial programme, although rapidly introduced, took some time to make itself felt. Even in the late 1870s the vast majority of the population lived directly from the land, and the move to the towns, necessary for industrial expansion, had only just begun. Progress was nevertheless impressively rapid during the next few decades. In 1905 the rest of the world was suddenly confronted with astonishing evidence of Japan's success in transforming itself into a modern industrial nation. In that year the Japanese defeated Russia in a naval battle of impressive tactical skill and fearsome determination, whereas fifty

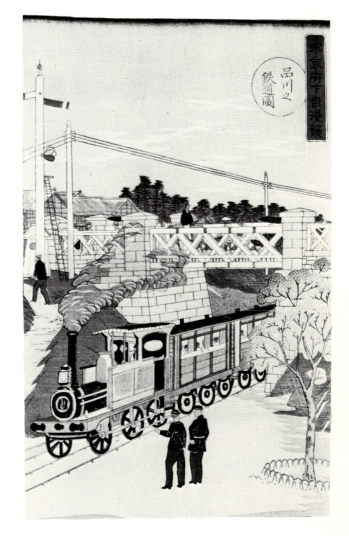

3 **Hiroshige III** *Railway train*, 1872. 34·6 × 24·6 (13⅝ × 9⅝), British Museum, London

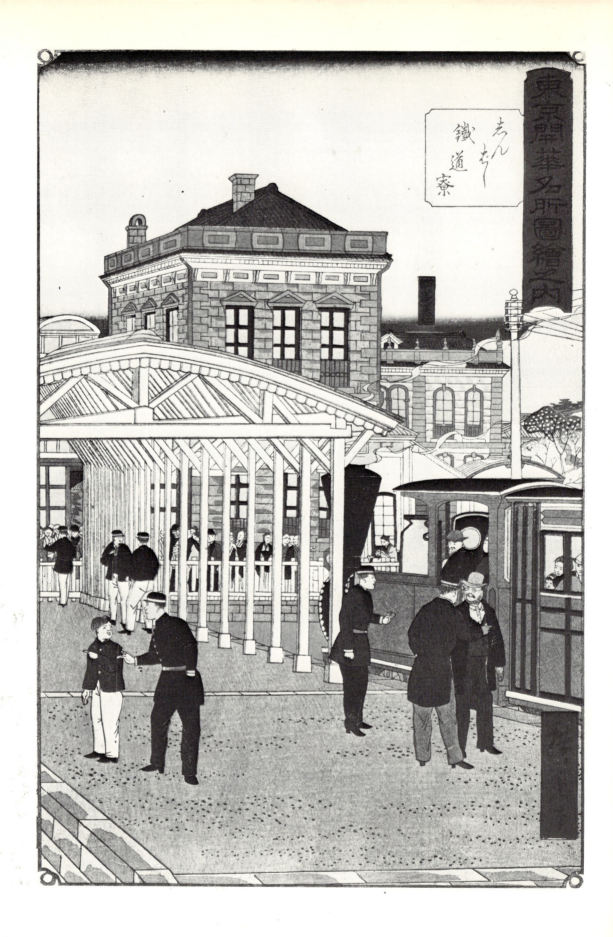

18

years earlier they had known no weapons more advanced than the sword, bow and arrow and muzzle-loaded musket. Japan had been an admirable pupil of the West, and it could now compete with the West on equal terms. It was a nation to be reckoned with, the possessor of a navy that Commodore Perry would have been proud to command.

Opposite
4 **Hiroshige III** *Opening of first railway station in Tōkyō*, 1872. 37·2 × 25·0 (14⅝ × 9⅞), British Museum, London

Below
5 **Toshihide** *Naval battle during the Russo-Japanese War*, 1906. Triptych, 38·6 × 72·5 (15¼ × 28½), British Museum, London

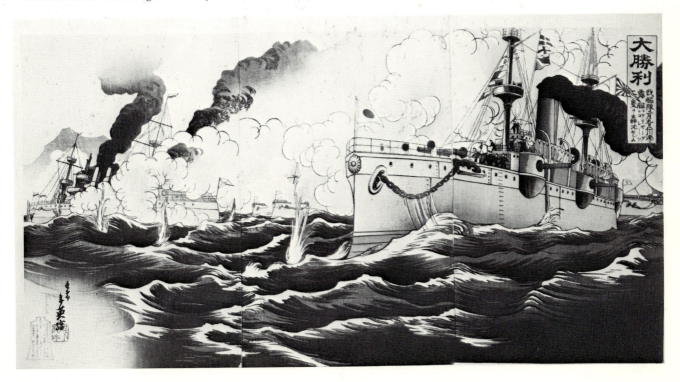

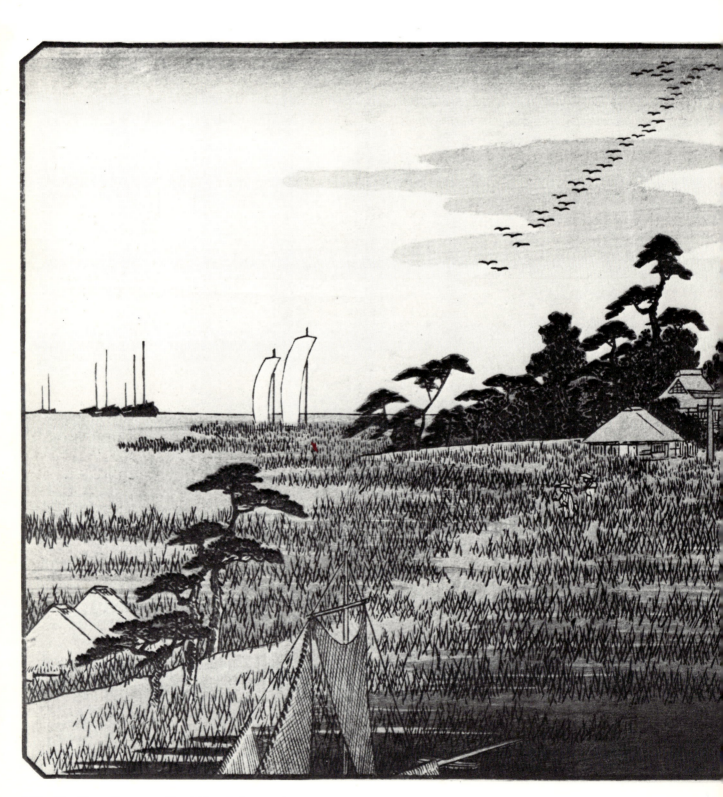

6 **Hiroshige** 'Descending geese at Haneda' from *Eight Views of the Environs of Edo, c.*1860. 23·0 × 35·2 (9 × 13), ex. Vever Collection, Sotheby's

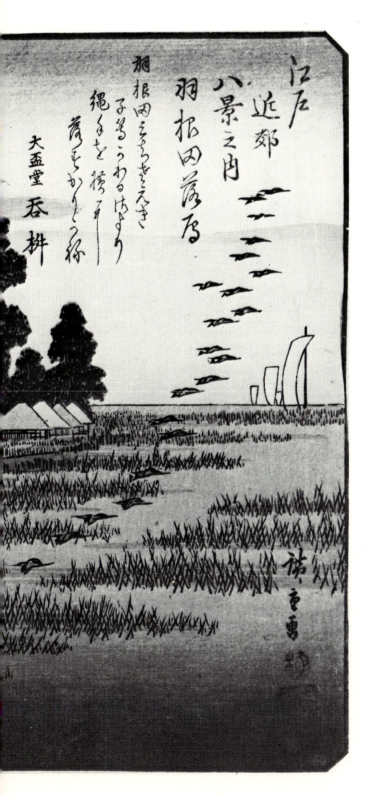

The Mysteries of the East

P.C

Japan's love-hate feelings towards the outside world were met by a passion born of intense curiosity. While the Japanese were admiring and emulating Western culture and technology, Europe and America experienced first a fashion and then a craze for Japan. This was inevitable. For two centuries Japan had been cloaked almost completely in mystery, the object of wild speculation and the subject of exaggerated reports from sailors shipwrecked there, a fabulous land inhabited by strange creatures and mythological beasts. Now the mystery was evaporating, yet the evidence that was penetrating Europe from this ancient and distant civilization seemed almost as strange as the mythical Japan. Moreover, at a time when strangeness and beauty were thought by many to be synonymous, Japanese goods and works of art provided those who saw them with a rare aesthetic thrill. Here were the products of what had previously been the least accessible culture in the world. Had they been unimaginative and shoddy they would have been fascinating enough; but these works of art, the woodcarving, porcelain and lacquerwork, were often remarkably fine creations.

The passion for Japan was fuelled by a mass of information about the country, its history and the lives of its inhabitants. In 1859 the official report of the Perry expedition, *Narrative of an American Squadron's Expedition to the China Seas and Japan,* edited by the Reverend Francis Hawks, appeared in three volumes, and if sales are anything to judge by, it was a great success. During the 1860s and 1870s there was a flood of books about Japan written in every major European language by Europeans who had actually been there. The popularity of such books in Victorian England was no doubt partly due to the accounts of Geisha houses and illustrations of mixed bathing some of them contained. The information provided was by no means limited to these areas however. In 1861 the merchant marine captain Sherard Osborn published his *Japanese Frag-*

ments, first in magazine instalments and then in a book with eighteen hand-coloured facsimiles of Japanese woodcuts illustrating aspects of the landscape and everyday life. One of the most interesting of these early accounts is Rutherford Alcock's *The Capital of the Tycoon,* published in 1863. Although the book, relating Alcock's experiences as British ambassador, is mostly about murder, mayhem and threats of violence to Westerners living in Tōkyō, there are passages which vividly describe life in the capital and comment on the state of the country at the time. The Japanese, we learn,

> have no architecture. . . . [Their houses] are all constructed of solid wooden frames strongly knit together, the walls being merely a thin layer of mud and laths to keep out the cold and heat; the whole surmounted in the better class by rather ponderous and overhanging roofs.[5]

Following a writer in the *Edinburgh Review,* Alcock compares Japan to Andorra:

> Andorre [sic] is the Japan of Europe, and Japan is another example of the power of isolation to produce stationary types of civilization and forms of govern-ment. Here, as in the valleys of Andorre, isolated by the ocean, as Andorre is by its mountains, from all other nations except China, until discovered in the sixteenth century, and then only in momentary communication with the rest of the world, is a petty nationality whose annals go far beyond Charlemagne – with a proud and feudal aristocracy and an absolute government, but a torpid administration and a laborious people.[6]

Information gleaned from such books was supported by what Japan chose to show of herself at the great international exhibitions which were staged with such regularity in the capitals of Europe during the second half of the nineteenth century. In Paris and London crowds clustered around the Japanese exhibits, curious about the houses, impressed by the craftsmanship, mystified by the script and enchanted by the clothes and the fabrics, which seemed both more luxurious and more colourful than contemporary European fashions. Ladies now wore imported kimonos or European dresses inspired by their lines. Collectors avidly sought lacquerware,

porcelain, paintings, prints, fans, ivories and embroideries, and writers and composers introduced Japanese themes and, supposedly, rhythms into their work. The traveller and popular author Pierre Loti wrote *Madame Chrysanthème* (1887), a romantic fantasy which provided many people in France (among them Vincent van Gogh) with all their attractive but entirely false ideas about Japan. Puccini composed *Madame Butterfly,* and in 1885 Gilbert and Sullivan staged the *Mikado,* the comic opera which, although set in an imaginary Japan, nevertheless employed costumes and sets produced only after the most careful research in the real Japan. Its creators' attitude to the Japanese craze is made clear in the lines about 'The idiot who praises with enthusiastic tone, All centuries but this and every country but his own'.

In Paris, as early as 1826, La Porte Chinoise, which began as a *salon de thé* but later started to sell Oriental objects, opened in the rue de Vivienne. During the 1860s and 1870s, several shops of a similar kind were established, among them A L'Empire Chinois, owned by a M. Decelle, and later, in 1862, the more famous shop opened by Mme Desoye beneath the aristocratic arcades of the rue de Rivoli, which quickly became a centre for artists and writers fascinated by things Oriental and especially Japanese. During the monthly dinner-parties at Sèvres of the Société Japon du Jinglar, founded in 1867 and consisting of writers, artists and intellectuals, chopsticks had to be used and the only available drink was *sake.*

In 1878 a Japanese fantasy by Ernest d'Hervelly opened to packed houses in Paris while, at the Opéra during the same year, a 'Japanese ballet' proved equally successful. Tiffany went so far as to import Japanese craftsmen into America to produce metalware in the authentically Japanese way, and English and Scottish aristocrats fetched over Japanese gardeners to transform the views from their stately homes. One result of this activity is Kyoto Court, Bognor Regis, Sussex, where evidence of the enthusiasm for even the horticulture of Japan can still be seen.

In 1875 Arthur Lasenby Liberty began to sell Oriental and Oriental-style fabrics and works of art from his new

shop in London's Regent Street. His success exceeded even his own expectations and led, in England, to a bonanza in Japanese manufactures and to the extension of the Japan craze to the ranks of the middle classes.

During the 1880s one of the most popular cabarets among artists and writers in Paris was the Divan Japonais on the rue des Martyrs, advertised so impressively by Toulouse-Lautrec. Its walls were hung with Japanese silks and fans and the waitresses were dressed in kimonos. All this provided cartoonists and satirists with material which seemed heaven-sent. The Japan vogue was sent up, travestied and ridiculed (and at the same time, in its more extreme forms, accurately described). 'May I have the recipe for the salad we have eaten here tonight?' asks one of the characters in Dumas' novel *Le Francillon* (1887):

'The Japanese Salad?'
'It's Japanese?'
'That's what I call it.'
'Why?'
'Because that's its name. Everything's Japanese nowadays.'[7]

The passion which provoked such taunts began during the late 1850s, spread like a brush-fire through Europe and America and smouldered on for something like half a century. There had been vogues for exotic cultures before, of course. During the eighteenth century, *chinoiserie* had left its mark on almost every art and craft; during the Napoleonic period, French involvement in Egypt had led to a brief interest in Egyptian designs and motifs; and Delacroix's painting is only the most sublime expression of the fascination for North Africa felt by many artists of the Romantic period, even academicians like Gleyre. The Japan craze in England was accompanied at the beginning by a similar fascination for India; while in Romantic Germany, philologists and philosophers such as Schelling, Schlegel, Hegel and Schopenhauer seriously addressed themselves to the problems of Indian art, language and religious thought.

The obsession with Japan, however, was something new in both extent and kind. Fed by accurate reports of life in Japan itself and by what became a flood of Japanese art and manufactures, it was both better-

informed and more influential than earlier fashions for the exotic. European art was only superficially affected by *chinoiserie,* which remained a kind of Oriental Arcadia of the aristocratic mind, and the interest in India proved fleeting. But European art was changed radically by the influence of Japan. Egypt and Africa found their way into European art in the form of decorative motifs, topographical subject matter and bright colour schemes, whereas Japan altered the very outlook of European artists and transformed their styles.

Clearly Japan was not the only source of influence on the European art of the second half of the nineteenth century. But on painting at least it was a particularly important and profound one, perhaps more important than any other. From Manet to Art Nouveau, advanced painting in France and elsewhere developed in a way which can largely be explained in terms of the growing understanding of the Japanese aesthetic. Manet himself, Whistler, Degas, van Gogh, Gauguin, Toulouse-Lautrec and the Nabis all incorporated into their styles qualities which eventually provided Post-Impressionism with its most characteristic features. Indeed, it is impossible to understand the basic characteristics of modern art in general without recognizing the extent of its debt to Japan.

Although artists were attracted by all aspects of Japanese art – by brush-drawing, screen and scroll painting and calligraphy – it was the woodblock prints which exerted the most powerful fascination. Not only artists were interested. Rutherford Alcock, who amassed a huge collection of prints and illustrated *The Capital of the Tycoon* with some of them, thought them worthy of mention in his book. The Japanese, he wrote,

have been familiar with the art of printing in various colours by blocks of wood – a process similar to our lately discovered art of lithochrome printing – from an unknown date, – similar at least, so far as the employment of several blocks in the same design for different colours. They do not seem, however, to print one colour over another to produce depth or richness, as we do.[8]

One of the reasons for this specific and widespread interest in woodblock prints was, quite simply, their

availability. They came into Europe in very large numbers and cost next to nothing to buy. European artists were also fascinated by the techniques used in their production. The art of wood engraving had, to all intents and purposes, died out in Europe during the early Renaissance. The technique was considered by the majority of artists to be too restrictive and crude. Print makers turned first to etching and then, much later, to lithography. The Japanese prints, however, were quite unlike anything Western and demonstrated a range of effects most European artists would have believed impossible. For one thing, they employed a large number of bright, powerful colours, and the quality of their lines, moreover, ranged from the strong and ample to the light and delicate. No European techniques were capable of such chromatic richness and graphic subtlety.

Japanese woodblock prints also appealed to European painters because of the unusual subjects they represented and the strange but effective compositional devices they employed. Many of the subjects were so foreign as to be incomprehensible. Some of them, however, were landscapes of great purity and simplicity; while others showed everyday life in Japan in all its aspects, with a directness and intimacy that appealed to those European artists who, fed on a rich but monotonous diet of academic Salon painting, were starved of depictions of human figures on a human scale.

The composition of woodblock prints is essentially decorative, organized in one plane from top to bottom, and although they represent depth in a number of ways, none of them approaches the traditional fixed-viewpoint perspective which most European artists had faithfully followed since the early Renaissance. Japanese prints employ large areas of solid colour bounded by a hard, usually black contour line, and they adopt formats highly unusual in the West, especially the extreme narrow vertical.

All these qualities attracted European painters at a time when they were searching for alternatives to the Renaissance tradition, and when their own styles seemed independently to be moving towards a more decorative, colourful approach. Knowledge of Japanese art exploded in the European artistic consciousness at a moment when

cracks were beginning to appear in the aesthetic structure erected by the Renaissance: realism, the essentially mimetic approach to painting, was no longer adopted without question. Significantly, many of the early apologists of Japanese art compared it favourably with Greek art. Thus the Goncourts, in a journal entry of 25 February, 1867: 'the architectural lines of Greece [are tedious] . . . while a Japanese gateway charms and pleases the eye.' On the other hand, Whistler, in his famous *Ten o'Clock Lecture,* is anxious to raise the one to the elevated status of the other. Were no other artistic genius ever to appear, Whistler said, 'the story of the beautiful is already complete – hewn in the marbles of the Parthenon – and embroidered, with birds, upon the fan of Hokusai at the foot of Fusiyama.'

Japanese art presented itself to Western painters as but one of several non-European alternatives to the Classical inheritance. This context is what made North Africa, with its brilliant light and exotic atmosphere, seem so seductive to Delacroix. The same sceptical attitude towards Classical canons was shared by the Impressionists and provoked Pissarro in particular to the extreme view that all museums should be razed to the ground. In Gauguin scepticism turned to scorn, and he began to experiment with a style derived from a mish-mash of exotic sources in a way as eclectic as that of any convinced historicist. The Nazarenes, the Pre-Raphaelites and even the Barbizon School also questioned traditional and conventional standards of beauty and looked back to the art of the medieval and early Renaissance periods, which they felt had not been compromised by excessive sophistication.

Delacroix recognized that this major break from tradition had already occurred when he wrote in a letter: 'Rome is no longer in Rome.'[9] Before long a number of artists discovered that many roads led not to Rome but to Tōkyō. Such developments were part of the evolution of a new, more abstract sort of art. In his important book *Abstraktion und Einfühlung* (Abstraction and Empathy, 1907) Wilhelm Worringer looked forward to a non-figurative art, an art which made no attempt to reproduce the appearance of the natural world, and he looked back at those historical developments which had made

abstraction not merely possible, but essential. '*Japonisme* in Europe,' he wrote,

> constitutes one of the most important steps in the history of the gradual rehabilitation of art as pure forms . . . and on the other hand it has saved us from the immediate danger of seeing the possibilities of pure form only within the Classical canon.[10]

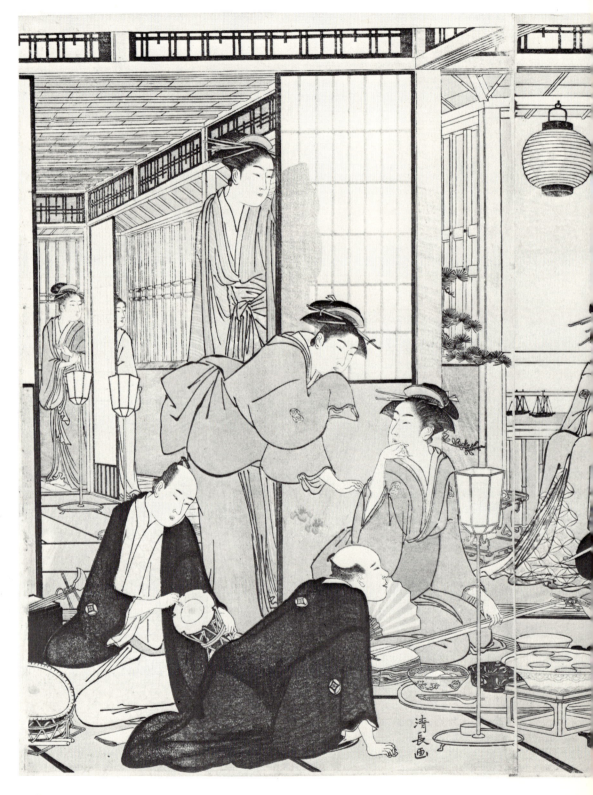

7 **Kiyonaga** *A party in the upper storey of one of the Shinagawa brothels*. Diptych, each panel approx. 35·8 × 26·0 (14⅛ × 10¼), Sotheby's

The Floating World

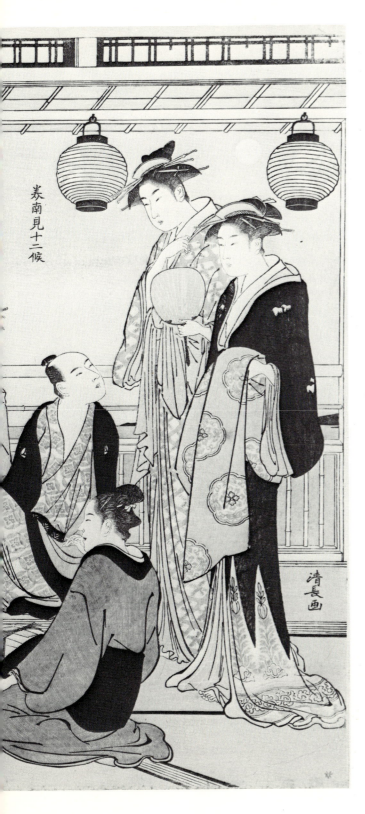

Japanese culture clearly reflected the feudal structure of its society. The strict hierarchy of warriors, scholars and religious orders, farmers, artisans and tradesmen was formulated by the Tokugawa Shōgunate who positioned it beneath the Kyōto *kuge,* or members of the Imperial household, and above the *hinin,* or 'non-people', who officially did not exist at all. *Hinin* were either born, or made by their choice of profession. Actors and courtesans were 'non-people' according to the second criterion. This rigid social system brought with it a hierarchy not only of language and manners, but also of art. All considerable art was the exclusive preserve of the aristocrats at the Imperial court at Kyōto, who developed distinct kinds of writing, painting and drama, and of the Buddhist monks and the samurai.

This feudal society, which theoretically prevented any kind of social mobility, was peppered with anomalies, the most extreme of which was the position of the successful tradesmen in the big cities. By 1550 a cash economy, at least in the towns, had superseded the universal barter system of exchange. Inflation and clever speculation resulted in enormous wealth for the merchants, debt for the samurai warriors, who had to trade with them, and poverty for the peasants, who were at the mercy of both. Yet the merchants could do little with their money. Sumptuary laws were introduced, designed to limit their influence and prevent their masquerading as aristocrats. The merchants were among the most wealthy members of society and yet almost the least privileged.

Unable to use their money to buy power, influence or social advancement, they spent it on self-indulgence and ostentation: on clothes and on entertainment of all kinds. Occasional government edicts designed to curb ostentation and keep the merchants in their place did not succeed. A tradesman forbidden to wear garments of silk would simply dress himself in cotton robes, dull on the outside, but with wondrously extravagant silken linings. Naturally enough, the wealthy merchants were anxious to

display their financial status, and to satisfy this demand art forms were evolved which paralleled those developed by the aristocracy and were equally esoteric.

Thus there developed in Japan a tremendously vital sub-culture which, although subject to frequent government restriction and censure, flourished for 250 years and occasionally reached sublime heights of artistic expression. The increase in literacy among the members of the merchant class led to the publication of books intended exclusively for them. These were mostly popular novels, guides to the brothels, books of poetry and sex manuals.

The kind of woodblock print admired by Western artists during the nineteenth century was an essential element in this sub-culture, created by and for the urban merchant class, and therefore it served the same function as the Kabuki theatre and the Yoshiwara (the pleasure quarter of Edo), both of which played an enormous role in the leisure of the merchants. All three were aspects of what the Japanese call *ukiyo,* or the 'floating world'. Originally a Buddhist word describing transient earthly pleasures, as opposed to the more permanent joys of the spirit and of the mind, *ukiyo* eventually came exclusively to mean the entertainment and culture of the urban merchant class, of the seething masses of the big cities.

The Kabuki theatre was entirely popular in conception and presented in dramatized form traditional legends, historical events, ghost stories and, at times, even plays with a satirical or socially critical message. Because of the importance of the Kabuki in the lives of all members of the merchant class, and because it provided so many print makers with their most important subjects, it is necessary to say more about it here.

The Kabuki has no counterpart in Western theatre. It combines dramatic and often stylized acting with song and dance. Its main repertoire consists of either historical pieces (*jidaimono*) or plays of ordinary life (*sewamono*), interspersed with musical performances, dancing and tricks of various sorts. The word is thought to have come from a sixteenth-century slang word, *kabuku,* which meant 'to lean in the direction of fashion', but which was later also written with the Chinese characters for 'song-dance-artistic skill'. The earliest form of the Kabuki was a kind of popular and vulgarly choreographed panto-

mime performed by travelling troupes of women who divided their time between the stage and brothel. This form of theatre was banned as immoral in 1629, but Kabuki continued to be acted, at first by boys and then by men, who also played the female roles.

In its mature form the Kabuki, which remains very popular in Japan, is largely concerned with presenting traditional or historical subjects in a lengthy, flamboyant style and providing its audiences with an exciting spectacle and the pleasures of hearing the language spoken in a poetic way. Kabuki delights in striking, formalized make-up, in ostentatiously rich costumes and in magnificent sets which provide impressive backgrounds for the tableaux which are formed by the actors at regular intervals.

Not only the stories are traditional: so too are the make-up and even the poses and gestures used by the leading actors. The audience knows each play backwards and so takes pleasure in the way in which each role is carried out and in the presentation of certain crucially dramatic scenes. At critical moments pleasure is often expressed by calling aloud, and at such times there is often more noise in the auditorium than on the stage. True afficionados leave after the last of these predictable climaxes has taken place.

The audience's enjoyment comes not only from the play itself. Its members want to see and be seen, to dress in their best clothes and to enjoy a social event. Indeed, few of them remain seated for an entire performance, which can last all day. The Kabuki-za, or theatre, is traditionally built on several levels, each of which has a corridor in which to promenade, and shops and restaurants in which food and drink can be bought and consumed, or souvenirs purchased. The Kabuki is therefore a social as well as cultural experience, and is enormously popular. Its actors were – and are – as lionized and adored as any film star during the golden age of Hollywood.

The three major cities of Japan – Edo, Osaka and Kyōto – were major Kabuki centres with several large theatres and important companies. Kabuki actors usually belonged to families traditionally linked with the theatre and often exclusively played roles associated with their families. This is especially true of female parts, to which male

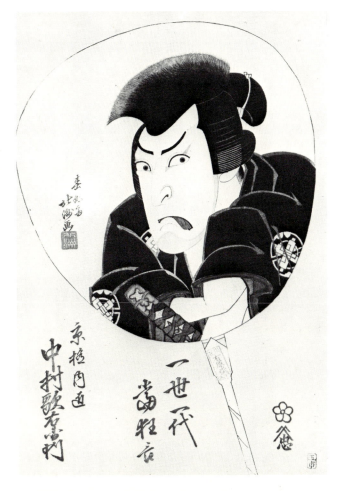

8 **Hokushū** *Portrait of Nakamura Utaemon* III, 1825. 36·8 × 25·4 (14½ × 10), Victoria & Albert Museum, London

actors were trained from an early age. It was inevitable that some of the male actors who regularly acted women's roles should have become catamites, and the Kabuki itself a brothel for male prostitutes.

In general, however, the Kabuki actors were more often sought by the idle, rich wives of merchants, or even by the ladies of the Shōgunate court, who were officially allowed out in public only twice a year. In 1714 there was a spectacular scandal involving an actor called Ikushima and the head lady-in-waiting, which ended in the execution of two courtiers, the exile of the lovers and the closure of the Yamamura-za theatre troupe to which Ikushima belonged.

In spite of the air of licentiousness which hung about the Kabuki theatre and in spite of their status as 'non-persons', the actors themselves were prominent members of urban society, arbiters of fashion and taste in artistic matters generally. Their importance was frequently acknowledged by the authorities, who took action against them for major or minor 'crimes'. In the 1840s the greatest actor of the time, Ichikawa Danjūrō VII, was expelled from Edo for almost ten years because of the extravagance of his productions and of his private life, and because he infringed samurai privilege by wearing real armour on stage.

Like all Japanese artists and craftsmen, Kabuki actors adopted sobriquets, which were passed from master to pupil. Thus, the great Osaka actor Nakamura Utaemon III was the son of Utaemon I, and names like Danjūrō, Kōshirō and Hanshirō are still in use today. Utaemon III (Plate 8), also an accomplished painter, playwright and poet, inspired such fierce loyalty among his fans that fighting often broke out between them and the followers of rival actors.

One of the earliest records of a Kabuki performance written by a European is an entry of 1826 in the diary of P. F. von Siebold, a German doctor employed by the Dutch trading mission on Dejima. Returning home from a visit to pay homage to the Shōgun at Edo with the Dutch consul, von Siebold stopped at Osaka and saw a play:

A dark passageway led toward the stage, which was fairly large, and more or less similar to those in Europe, but bare, without much care or decoration. . . .

The gallery, which in Europe opens on a corridor, is left open to let in light, since plays are performed during the day in Japan, not at night, with artificial lighting. Two high, bridge-like passages leading from the back of the theatre to the stage allow actors to enter, exit, and act in the midst of the audience. . . . Many first-class artists performed, who would have been acclaimed even in Europe. Their gestures and style of delivery deserve the highest praise, and the impression they created, heightened by their luxurious costumes, was enough to make us forget the poor appearance of the theatre itself.

Although the structure of the stage is quite similar to those in Europe, the curtain is drawn to the centre from both sides instead of falling from above. . . . Instead of having moveable flats, they change scenery very quickly with a revolving stage. There is a stand covered with bamboo mats on either side of the stage. A narrator sits on one and describes the details of the plot which are left out in the performance, in the manner of a Greek chorus, and *samisen* players sit on the other.[11]

In view of the passionate enthusiasm which the Kabuki inspired in its audiences it is not surprising that the prints, which catered for a large public, should have used the theatre as a major source of subject matter. Throughout the seventeenth, eighteenth and nineteenth centuries, artists portrayed scenes from current plays, or well-known actors, either in facial portraits or striking a characteristic pose. Indeed, it was common for publishers of prints to book seats for their artists at the first performance of a new production so that depictions of scenes from it, and portraits of actors in the new costumes, could be sold to audiences during most of the play's run.

The relationship between the theatre and the world of print making was incestuously close. The theatre management realized that prints of its actors and plays were good for business and sold them in the Kabuki-za. It also commissioned print firms to design posters, programmes and handbills. Print publishers for their part did their best to keep their products up-to-date with new portraits of actors and prints of the most recent productions. In some cases, as in the print by Kunisada

illustrated here (Plate 10), the text of a scene accompanies an illustration of it. If a famous actor went on tour, as was often the case, artists produced prints of some of the roles he was playing in order to keep his fans at home informed. Thus, a portrait of the actor Ichikawa Danjūrō VII by Toyokuni (Plate 9) commemorates the debut of this famous actor, and in another print Toyokuni shows together the recently deceased actor Matsumoto Kōshirō IV and his successor, Kōshirō V (Colour Plate 3). Hokuei, in a series called *Mist on the Mirror of Fashion,* depicts a number of actors in current plays (Plate 11).

9 **Toyokuni** *Portrait of the actor Ichikawa Danjūrō* VII, 1807. 38·7 × 27·3 (15¼ × 10¾), Victoria & Albert Museum, London

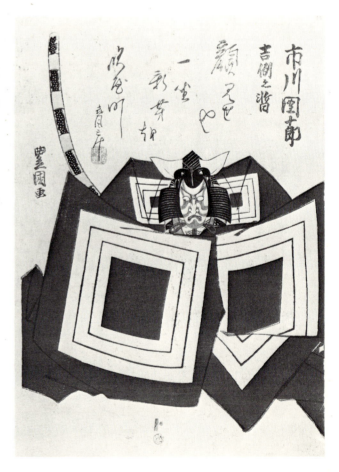

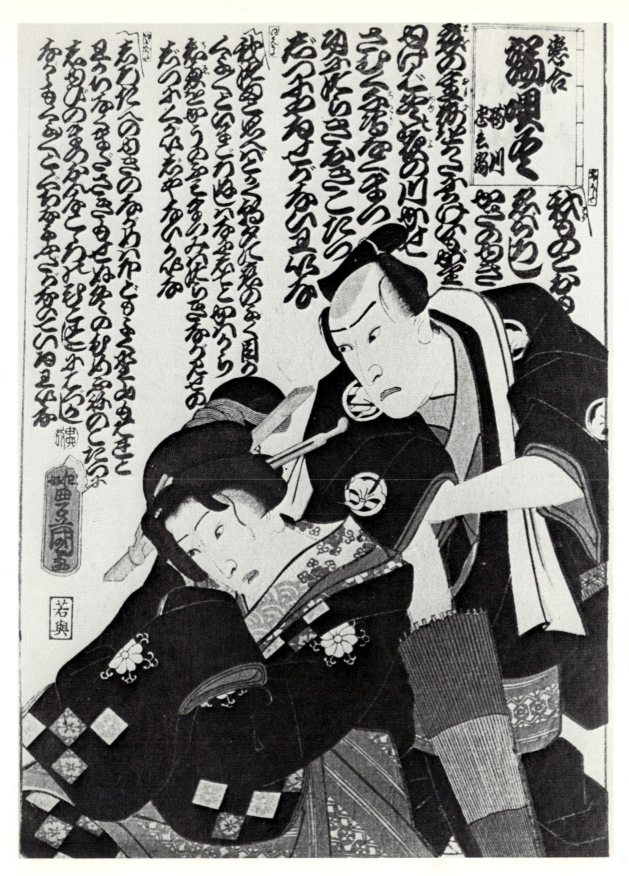

10 **Kunisada** *Text of a Kabuki play with two of its characters*, c. 1855. 35·5 × 24·5 (14 × 9½), Author's collection

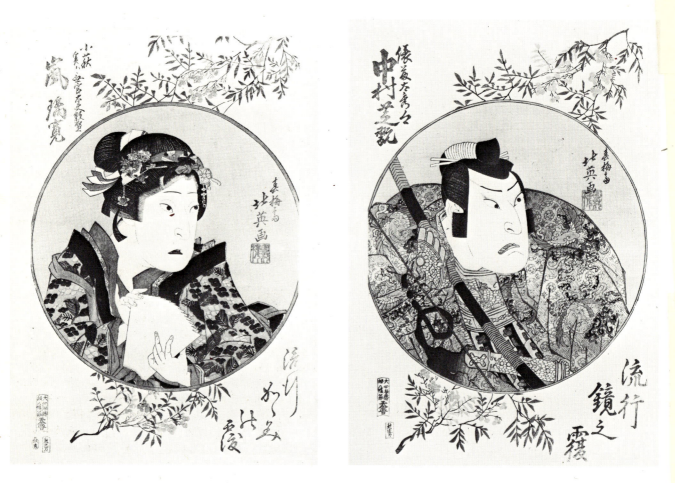

11 **Hokuei** *Mist on the Mirror of Fashion: portraits of actors, c.*1834–5. Three panels from a pentaptych, each sheet 37·6 × 25·2 (14$\frac{7}{8}$ × 9$\frac{7}{8}$), Victoria & Albert Museum, London

The highly stylized prints, moreover, shared important qualities with the markedly gestural and formalized kind of acting promoted by the Kabuki. The prints even influenced the designers of sets, who often created their flats and backdrops with the styles of certain print makers in mind. And some of the actors developed certain poses, knowing that they would appeal to the print artists; thus they hoped to achieve immortality in print form.

The life of the Yoshiwara also provided the print artists with an inexhaustible supply of motifs. The Yoshiwara was the brothel quarter of Edo where, behind the green shutters of the houses, courtesans of varying accomplishment, reputation and physical attributes would entertain their clients, not only by allowing themselves to be made love to, but also by singing, telling stories, playing musical instruments, dancing and elaborately preparing tea. The *oiran*, or courtesans, of the Yoshiwara rivalled as a recognized social institution the *hetairae* of ancient Athens. Government censors permitting, the print artists described, chronicled and dramatized the activities of the 'green houses', as the brothels were called. They made stylized portraits of the courtesans, often with their names and addresses, showing them standing on balconies, out walking at various times of the year, at their toilet, and, with a frankness that can still shock, pleasuring their clients. Tourists could buy a print of a Yoshiwara subject rather as they might a depiction of a Kabuki scene: as a reminder of a memorable performance.

The pleasure quarters of Edo, one of the most bawdy cities the world has ever known, were a major industry. Almost every merchant (whose marriage had been arranged for economic reasons and the purpose of raising children) went to a brothel as often as he could afford. The Yoshiwara was the only area of its kind licensed by the government and was therefore the largest and most famous of the Edo pleasure quarters. But there were also many *okabasho*, or unlicensed brothel areas, such as those at Shinagawa (see Plate 7) and Fukagawa. Fukagawa was very famous and lay on the undeveloped left bank of the Sumida river. It was said by connoisseurs to be more simple, and therefore more enjoyable, than the Yoshiwara, which was elaborately ostentatious.

Colour 1 **Yoshifusa** 'The Port of London' from *Views of Savage Countries, c.*1870. Tripych, 35·6 × 72·4 (14 × 28½), Victoria & Albert Museum, London

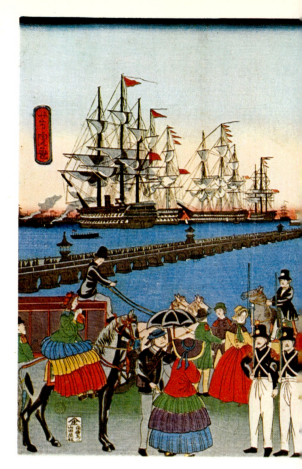

Colour 2 **Kunitora** *Tōkyō, Nihonbashi,* 1870. Triptych, 35·6 × 72·4 (14 × 28½), Victoria & Albert Museum, London

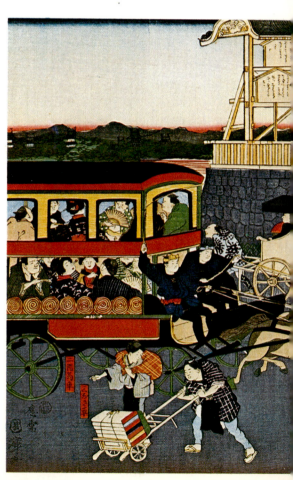

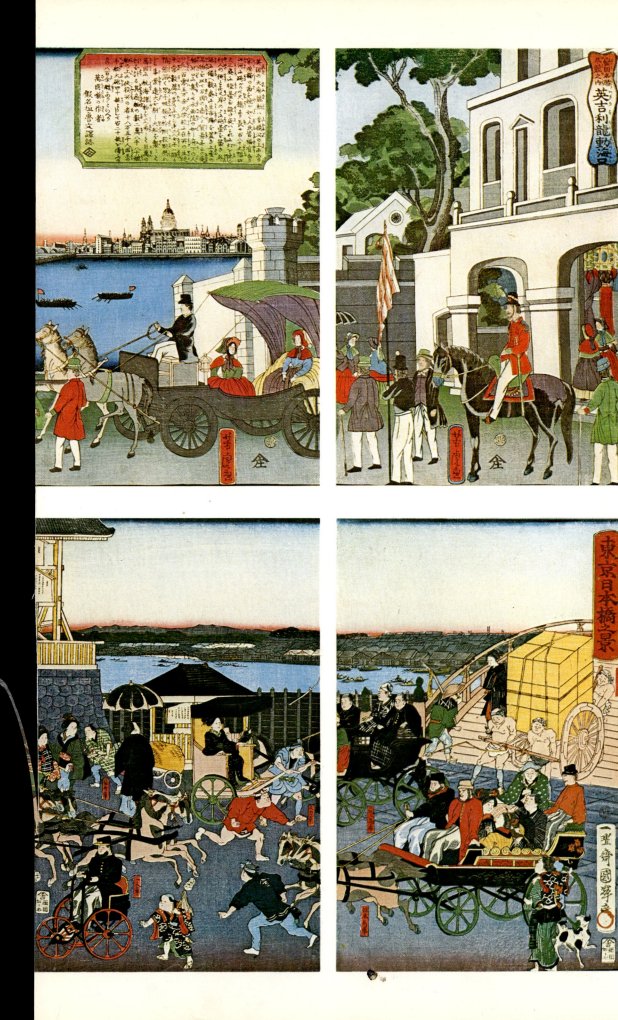

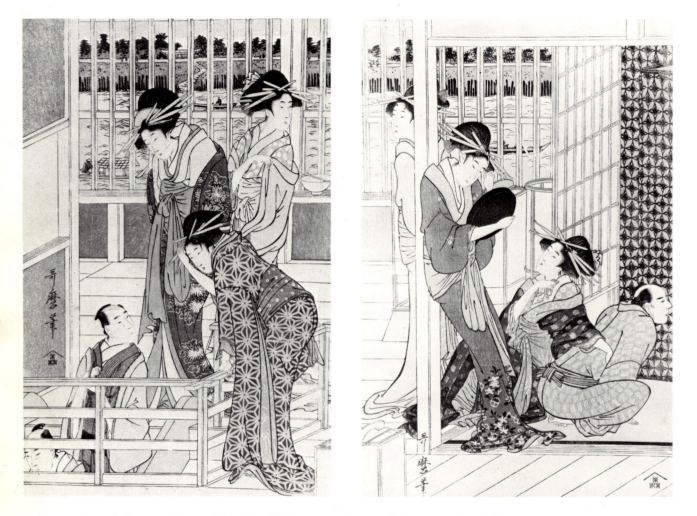

12 **Utamaro** *A scene in the rooms of the second floor of one of the Green Houses*. Two panels from a triptych, each sheet 37·2 × 24·5 (14⅝ × 9⅝), ex. Vever Collection, Sotheby's

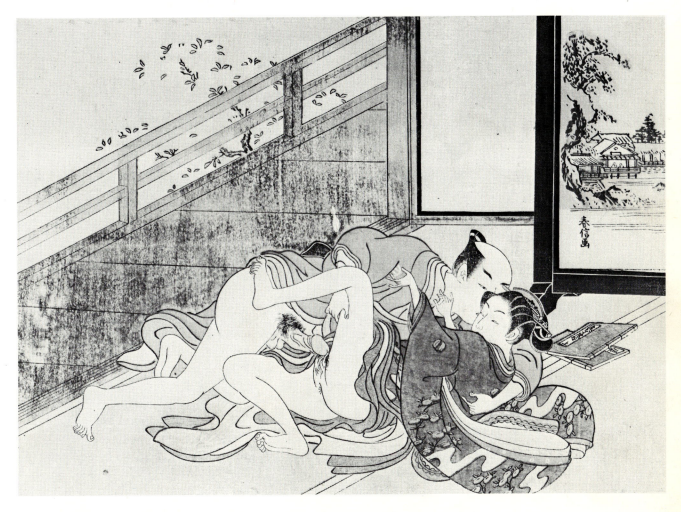

13 **Harunobu** *Lovers by a landscape screen, c.* 1768. 19·5 × 27·0 (7$\frac{7}{8}$ × 10$\frac{1}{8}$), Victoria & Albert Museum, London

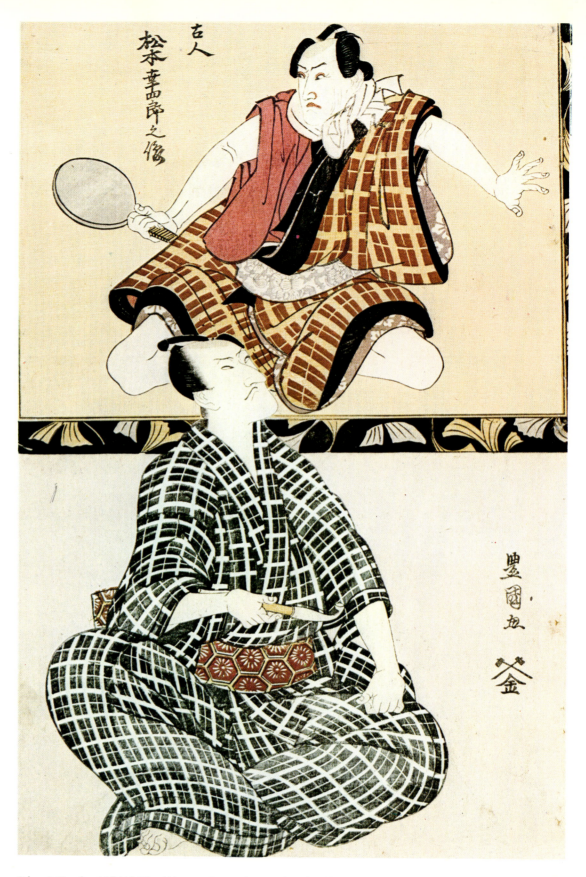

Colour 3 **Toyokuni** *Kōshirō IV and his successor*, seen in two roles. The older actor is seen as though on a hanging wall-painting. Diptych, 35·9 × 49·5 (14⅛ × 19½), Victoria & Albert Museum, London

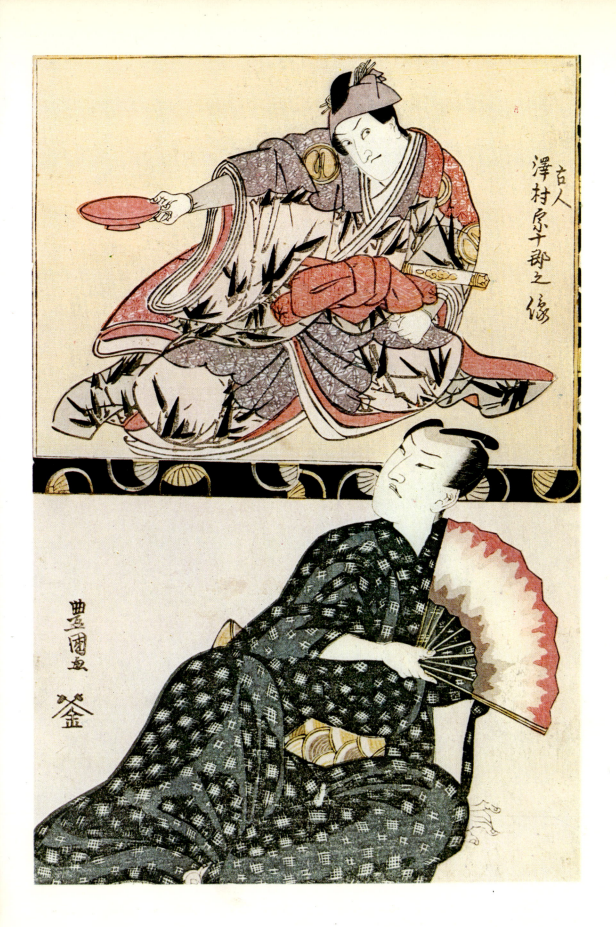

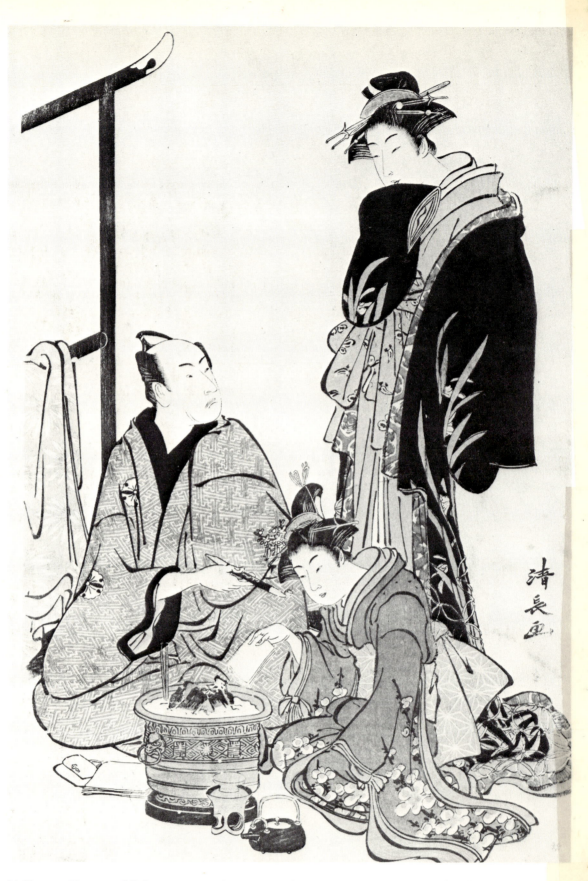

14 **Kiyonaga** *Matsumoto Kōshirō* IV·*in company with a courtesan and her kamuro, c.* 1787. 32·0 × 22·2 (12⅝ × 8¾), ex. Vever Collection, Sotheby's

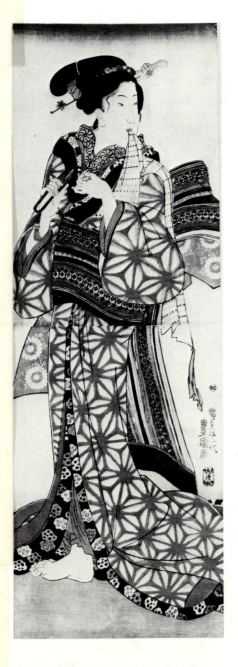

15 **Kunisada** *Girl trimming her nails*, 1844–5. 70·5 × 24·8 (27¾ × 9¾), Victoria & Albert Museum, London

The career of the *oiran* resembled in many ways that of the actor or craftsman. To begin with, a long apprenticeship was required. Girls were usually recruited to the trade by agents who toured rural areas and bought them as children from parents who needed money. From the age of about eight the girl had to be trained as a *kamuro*. After a spell of general help in the brothel, she would become a servant to a particular courtesan. At the age of thirteen or fourteen she was said to 'enter the kitchen': she left the *oiran* and began to receive instruction from the brothel madam in the elementary mysteries of her craft. This part of her training would last until she was about fifteen. After that she worked as a *shinzō*, or understudy to another courtesan. During this period she was not supposed to have contact with clients. When she graduated at the age of eighteen, she was said to be 'taking an apartment'.

The apprentice prostitute was not only required to master the most elaborate techniques of sexual intercourse. Her future clients would employ her for her abilities as all-round entertainer and practitioner of the tea-ceremony, as well as for the physical relief she offered. If, moreover, she wished to be elevated to the highest rank of *oiran*, she would need to hold herself and walk with extreme grace, to tie and wear her kimono superlatively well, and to white her face, black her teeth and shave the nape of her neck to perfection. There was little joy in this life of unremitting toil. The young courtesan was exploited by the house and its clients alike, and only a very few girls reached the top and were able to buy themselves out of bondage.

Many masters of the woodblock print specialized in portraits of prostitutes, which were frequently sold in series of *bijin-e*, or 'pictures of beautiful women'. They also often showed them in mundane situations, intending, no doubt, to enhance the atmosphere of intimacy (see Plates 15 and 16). They almost never attempted to capture a likeness of any of their subjects, preferring to treat them as stereotypes. Often, the real purpose of such prints is not so much to depict an *oiran* as to display an especially beautiful kimono, and consequently prints often make courtesans look like tailor's dummies, clad in sumptuous, intricately brocaded silks, with their *obi* tied at the front

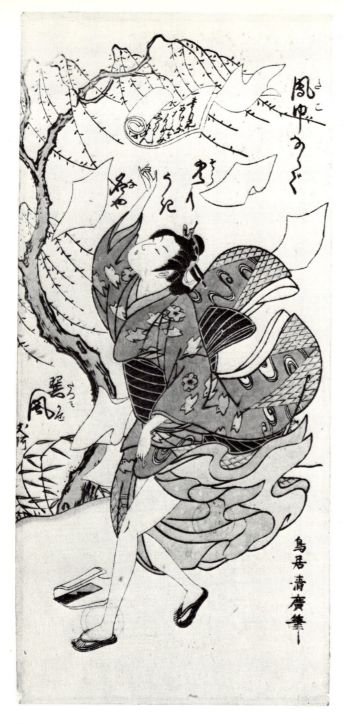

Above
16 **Kiyohiro** *Courtesan's love letters caught by a gust of wind*, c. 1758–9.
29·5 × 13·4 (11⅝ × 5¼), British Museum, London

Opposite
17 **Hiroshige** 'Eagle over Fukagawa' from *One Hundred Views of Edo*.
34·4 × 22·9 (13½ × 9), Fitzwilliam Museum, Cambridge

and revealing a little of their scarlet underwear (Colour Plates 4 and 5).

The Yoshiwara and the Kabuki, major elements in the *ukiyo*, the floating world, were the main subjects of the woodblock prints, which were therefore known from the first as *ukiyo-e*, or 'pictures of the floating world'. But the print makers did not concern themselves exclusively with such subjects. They also chronicled the careers of *sumō* wrestlers and illustrated highlights in Japanese history. Landscapes were also very popular, especially during the first half of the nineteenth century when they ceased to be used merely as backgrounds for human figures. Studies of flora and fauna were popular too, and this was one of the few areas where the *ukiyo-e* tradition departed early on from its basic preoccupation with Kabuki and the Yoshiwara. After the Meiji Restoration, portrayals of important contemporary events were also common, and some of the most charming documents of that period are provided by prints which show Tokyo growing into an industrial city. (Plates 3 and 4 and Colour Plate 2).

The landscape was, of course, right from the beginning, one of the major traditional subjects of both Chinese and Japanese painting. Like the European Classical landscape painting of the seventeenth and eighteenth centuries, it sought to portray ideal aspects of nature which exemplified canons of beauty that were universally held. It preferred certain kinds of view and specific kinds of picturesque detail, such as mountains, trees, rivers, bridges and so on. Even the emotional connotations of each kind of landscape were clearly prescribed.

During the nineteenth century, when woodblock artists, and especially Hiroshige and Hokusai, seriously turned their attention to the landscape, it was with an eye for realism and a refusal to accept the prescriptions of the picturesque tradition that had been followed in painting. They portrayed the road from Kyōto to Edo, the sights of Edo itself, and interesting views from all over Japan, with a precision which made the results attractive to tourists who wanted a record of their journeys.

Other favourite subjects for prints were provided by traditional myths and legends, and there was a preference for the dramatic, the bloodthirsty and the ghostly (Plate 20). Such subjects allowed artists to let their imaginations

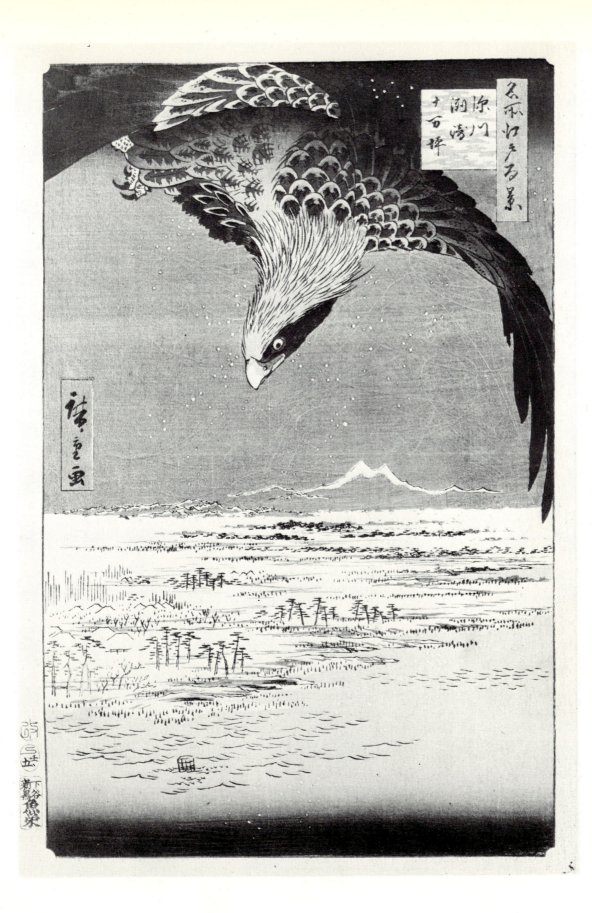

43

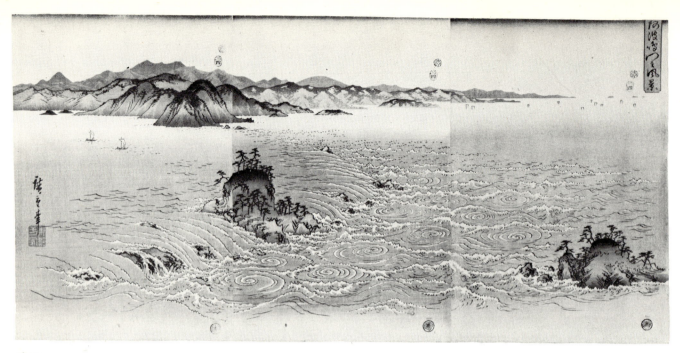

Above
18 **Hiroshige** *A view of the whirlpool in Awa*, 1857. Triptych, each sheet approx. 36·0 × 24·8 (14¼ × 9¾), Sotheby's

Below
19 **Hokusai** 'Fuji with lightning' from *Thirty-six Views of Mount Fuji*, 1823–9. 24·1 × 35·7 (9½ × 14), ex. Vever Collection, Sotheby's

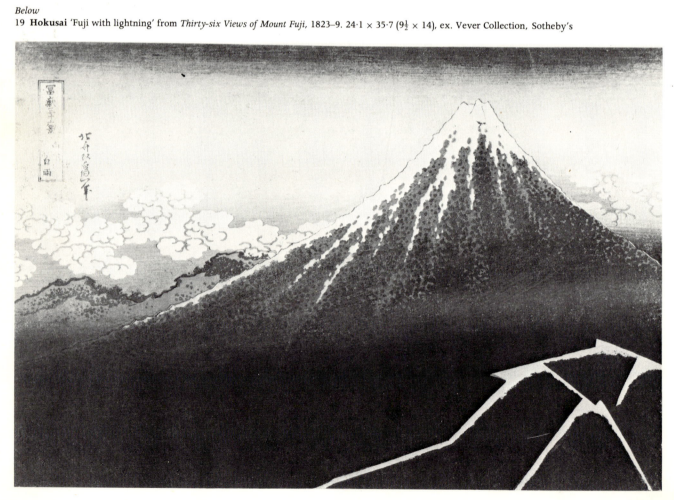

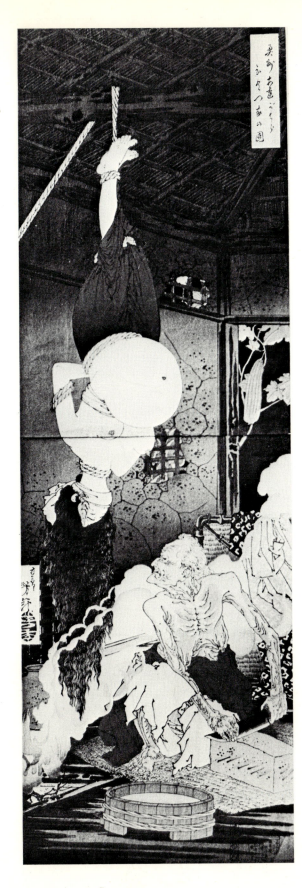

20 Yoshitoshi *An episode from the story of Hitotsu-ya, the Solitary House*, 1890. 80·0 × 25·4 (31½ × 10), Blackburn Museum & Art Gallery

Below
21 Hokusai 'The lantern offered to the spirit of Oiwa by her husband, by whom she had been murdered' from *The Ghosts, c.*1830. 25·3 × 18·2 (10 × 7½), ex. Vever Collection, Sotheby's

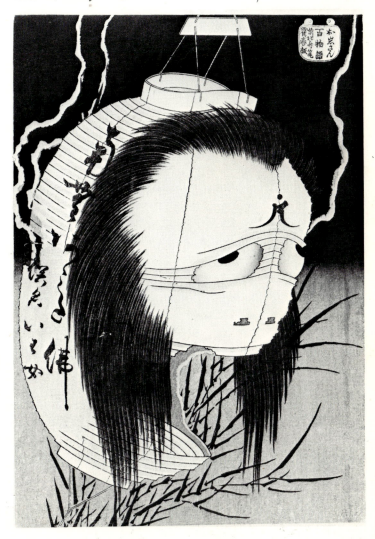

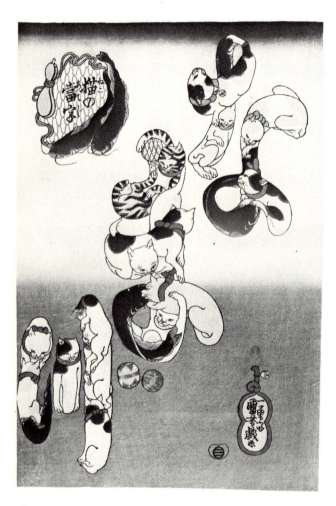

Above
22 **Kuniyoshi** *Cats forming the word 'namazu' ('cat-fish')*, c.1842.
36·4 × 25·0 (14¼ × 9⅞), Private collection

Right
23 **Kiyomitsu** *Nakamura Tomijūrō as a young girl*, c.1760–3. 39·3 × 17·7
(15½ × 7), British Museum, London

Above
24 **Utamaro** *The singer Tomimoto Itsutomi, c.* 1790. 37·4 × 25·1 (14¾ × 9⅞), ex. Vever Collection, Sotheby's

run wild, and many of their sea-monsters and super-natural beings are models of invention and ingenuity (Plate 21). The artists not only wanted to shock and scare, they also wanted to amuse, and many of their prints show people humorously deformed, or strange beasts with bizarre proportions acting like humans.

Embedded in many of the prints there is a multiplicity of meaning which, although obvious to contemporaries, can now only be teased out by scholars. Many prints incorporate texts which may refer only obliquely to the subject depicted. Some prints include a scene or object framed separately and kept apart from the main subject, commenting upon it indirectly and providing a clue to its deeper significance. Kuniyoshi's *Cats,* later used as a source by Gauguin, are shown forming the characters for *namazu,* meaning catfish (Plate 22). Puns like this, both visual and verbal, are common in *ukiyo-e.* A print by Kiyomitsu showing a young girl includes a poem containing the line *kite wa hore,* punning on the word for black peony, which also means the female genitals (Plate 23). In a composition on the theme of spring, Koryūsai shows two girls feeding carp and puns on the word *koi,* which means both carp and love (Colour Plate 6). Sometimes these vignettes spell out the subject's name in the form of a rebus, as in the Utamaro portrait of a singer (Plate 24). One of the most frequent motives for double-meaning was political. In the repressive society of the Shōgunate, the reporting of political scandals was not allowed. The print artists would therefore show familiar historical characters in similar situations. Sometimes the censors passed such prints, although aware of their true significance; sometimes the hidden meaning would be too deep; more often, the censor's seal would be withheld, preventing publication. Occasionally an embarrassed censor would realize that something had slipped through and would suppress the second edition of a print.

This, then, is something of the background of those woodblock prints which fascinated artists in the West during the second half of the nineteenth century. It was a background which only gradually became clear to them, as detailed knowledge about Japan slowly became available.

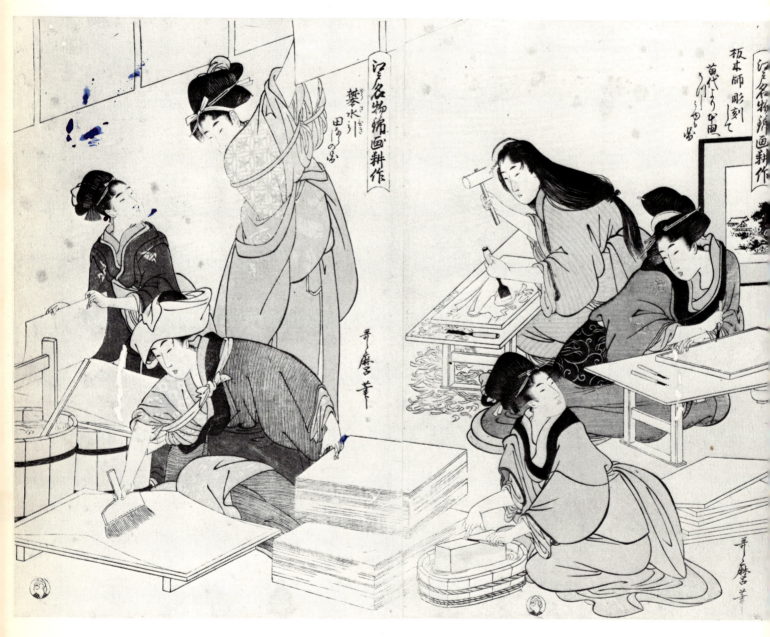

25 **Utamaro** *A fanciful picture of Utamaro's studio, with all the artisans represented as women,* c. 1790. Triptych, each sheet approx.
37·5 × 24·5 (14¾ × 9⅝), ex. Vever Collection, Sotheby's

The Technique of Woodblock Printing

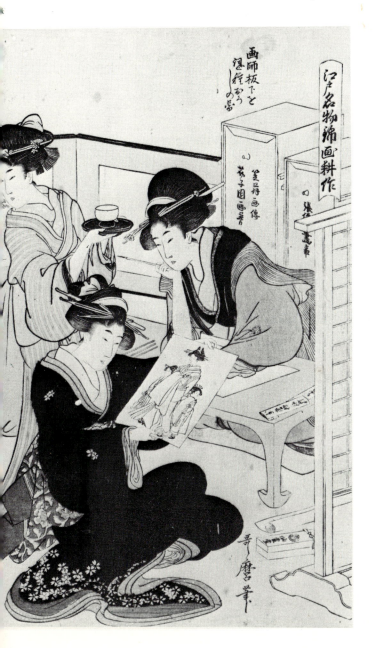

Like so much else, the technique of printing from woodblocks came to Japan from China and Korea. It was brought by Buddhist missionaries primarily as a means of printing books. These books were often illustrated, and the much later practice of printing autonomous images on single sheets developed from book illustration. Colour was at first restricted to black alone, or black with one other hue, usually pink or green, which was painted on by hand. Not until just after the mid-eighteenth century were print makers technically advanced enough to employ several colours successfully. At that time the number of printed colours that could be achieved increased from two to three: the first three-colour print was achieved by Harunobu in 1765. After 1786, prints could be produced in five or more colours. Thus was born the polychrome print, for which the proper Japanese name is *nishiki-e* (because *ukiyo-e,* which refers to subject, not technique, can mean hand-painted pictures as well as prints).

In their conception, creation and distribution, Japanese woodblock prints differed from European graphics in every way. They were the responsibility not of one man but of a team, at the head of which was the publisher who put up the money and often conceived the initial idea, either for a print or for a series of prints. He was, above all, a businessman interested in profits. If he was successful, he knew which subjects the public would buy in large editions, and he recognized that novelty, whether of subject or technique, was a strong selling-point. Some publishers became so powerful that they organized themselves into trade corporations, and companies with shareholders.

Something of the sort of studio in which the ideas for prints were executed is shown in Utamaro's *mitate* – or fanciful, humorous picture – of his own studio in a publisher's establishment, where the craftsmen are shown as pretty girls 'making the famous Edo colour-prints', as the text on the print explains (Plate 25). In spite of the

humour (Utamaro even shows himself as a girl to the right of the picture, holding a completed print), most of the various techniques involved are accurately shown.

Often it was a question of designing not just one image, but several related ones, for a subject was frequently conceived in terms of a long series of single sheets, or as a diptych, triptych or polyptych. The designer could also choose from a number of standard formats: for instance, *ōban* (39 × 26cm. $15\frac{1}{4} \times 10\frac{1}{4}$in.), *aiban* (33 × 23cm. 13 × 9in.), *chūban* (between 28 × 21cm. $11 \times 8\frac{1}{4}$in. and 22 × 16cm. $8\frac{5}{8} \times 6\frac{1}{4}$in.) and *koban,* which is smaller still. There were also the 'narrow pictures': *hoso-e* (32 × 15cm. $12\frac{5}{8} \times 5\frac{7}{8}$in.) and *tanzaku* (44 × 7·6cm. $17\frac{1}{4}$ × 3in. or smaller); the 'tall' or 'pillar' pictures, known as *naga-e* or *hashira-e* (61 × 11cm. $24 \times 4\frac{3}{8}$in.); and the *kakemono-e* (76 × 26cm. $30 \times 10\frac{1}{4}$in.).

Having chosen his format, the artist would make a brush drawing in black ink on very thin, *minō* paper. The drawing would then be stuck face-down on to a block of wood with weak rice-starch dissolved in water. The wood was usually wild cherry and the drawing was placed not across the grain but parallel to it, in the manner of Dürer and his contemporaries. The craftsman responsible for cutting would rub the back of the *minō* paper to remove several layers and then apply oil to make the rest transparent. The resulting effect was as if the original design had been reversed and drawn directly on to the block. The final drawing, the *shita-e,* was usually achieved only after many initial attempts. Illustrated here is one of the preparatory drawings (Plate 26), together with the finished print (Plate 27), for an illustration by Hokusai for one of his books, the *One Hundred Views of Mount Fuji.*

The next stage was for the carvers to excise parts of the block, leaving raised those areas which would carry the ink. Carvers served a ten-year apprenticeship and had a variety of cutting tools (all very like their European equivalents), which had to be kept extremely sharp in order to give the carving the vitality and other characteristics of the original brush drawing. Utamaro's *mitate* shows one of the girls sharpening her chisel on a stone. After carving, two marks were incised into the block as a

26 **Hokusai** Sketch for 'The Storm Dragon below Fuji' from *One Hundred Views of Mount Fuji.* ex. Vever Collection, Sotheby's

27 **Hokusai** 'The Storm Dragon below Fuji' from *One Hundred Views of Mount Fuji.* 18·1 × 24·9 ($7\frac{1}{8} \times 9\frac{3}{4}$), ex. Vever Collection, Sotheby's

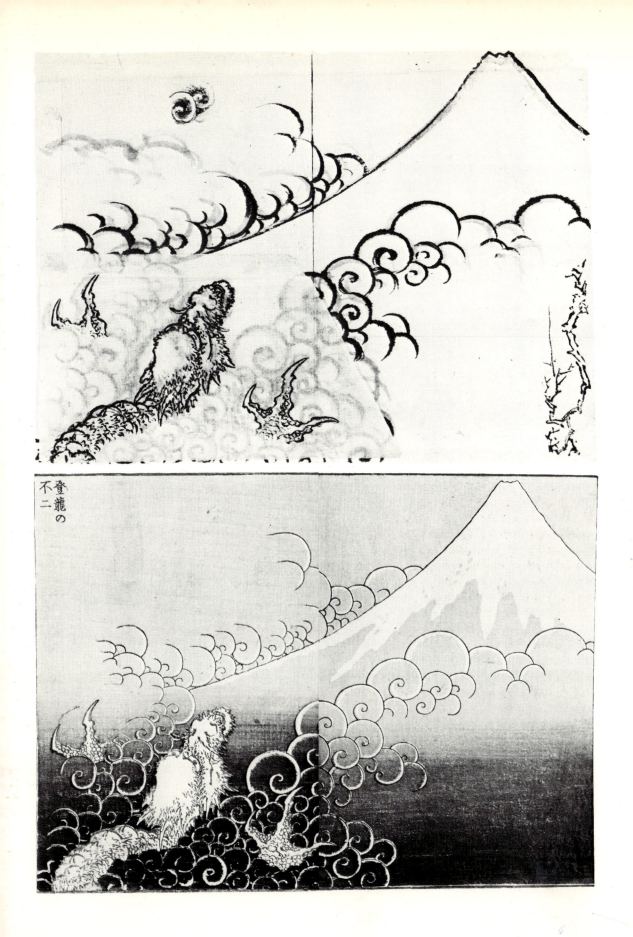

登龍の不二

51

register. The first key block, usually for black, was cut from the hardest part of the cherry wood, while the softer parts were used for the colour blocks. In consequence, large colour areas in many prints bear a pattern from the grain of the wood. It is not clear whether this graining was always intentional. There was a hierarchy of carvers. The face would always be cut by the workshop master, while less important areas were cut by subordinates who were not so experienced. Once the first key block had been made, the wood shavings could be brushed from the incisions and proof prints could be pulled on further sheets of *minō* paper, one for each colour required. The artist, now using red, added instructions on to each of the proofs and indicated each area of colour. The proofs were then applied to the other blocks and cut in the way already described. For reasons of economy, the blocks were usually cut on both sides. The master printer then pulled a few trial proofs under the supervision of the designer, who chose the best. This served as the model for the rest of the edition.

The most important difference between Japanese and European woodblock technique lay in the method of printing. In Japan no press was involved, and the method developed there permitted a much greater subtlety of tone and colour than its Western counterpart. The block to be printed was covered with ink (originally a vegetable dye, later an aniline pigment) with a variety of brushes. The paper, traditionally made from the inside of the bark of the mulberry tree mixed with bamboo fibre, was kept damp for about six hours and then placed on the block. The printer rubbed over the paper very firmly, applying pressure with the aid of a smooth tool called a *baren*. Tonal gradations in a sky (changing from dark to light blue, for example) and even two quite different colours, could be printed from one block by wiping parts of the ink with a cotton cloth. Additional subtleties could also be achieved by varying the pressure of the *baren*.

As techniques improved and publishers grew eager for novelties, various tricks were developed to make prints look spectacular. Glue and alum were sometimes mixed with dye to add a glaze to some areas of the print. Embossing, especially of parts of costumes, was intro-

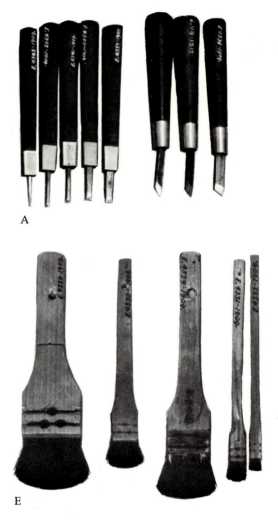

A

E

28 Tools used in the making of a woodblock print. A: knives for cutting outlines B: gouges for removing larger areas of superfluous wood C: chisels D: brushes for calligraphy E: brushes for applying colour to the blocks F: a *baren*, without its bamboo sheath G: a *baren* inside its sheath, underside and topside. Victoria & Albert Museum, London

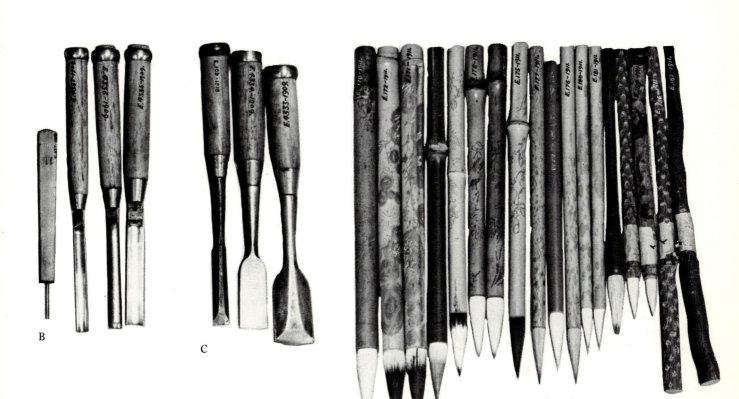

duced. And a small number of printers mastered the use of mica powder to make backgrounds shine like burnished gold or silver.

Finally, the signature seals of the publisher and, during times of official censorship, the seals of government office, would be applied. These were important to the artist, who took them into consideration when planning the composition, using them to provide the last weight to give a delicate balance to the whole picture.

These prints were collective creations in a very real sense. Although the designer was responsible for the original conception, a sharp, expressive line could only be achieved by an expert cutter, and subtle colours, mixed well, were the contribution of the printer. Even the publisher could rightly take some of the credit for a good print, for the subject may have been suggested by him and the quality of each sheet—which depended, for instance, on the grade of paper and ink—reflected the amount of money he was prepared to invest in the project.

Prints would often be published in a large series, and if a subject proved popular, prints would continue to be made until the blocks wore out or new blocks had been cut. The most primitive colour prints were printed at the astonishing rate of 200 a day. Indeed, the expression *ippai tori* (literally, 'full production') which is now used by Japanese printers to denote a batch of 200 sheets of paper, dates back to the time when 200 prints was the daily output of *ukiyo-e* artisans. The prints were sold by hawkers on the street (usually boys) or from specialist shops that could be found by the dozen in the centre of all the major cities. They would be sold to all members of the merchant class, but especially to tourists and Kabuki enthusiasts. They were frequently used to decorate *byōbu*, or moveable screens, and were also often stuck together to form a thick book, which opened out like a concertina. None of the purchasers of the *nishiki-e* would have dreamed of considering the prints as art. They were functional objects of decoration, as transitory as the things they depicted. They evoked pleasant associations, and were the equivalents of our pin-ups of pop-stars, soccer players and glamour girls.

In Japan there was no belief in the supreme importance of the individual creative imagination, as there had come to be in Europe. Consequently, the designers of prints were often thought to be no more or less important than the other members of the team. Indeed, designers only began to sign their prints towards the end of the seventeenth century, although it must be admitted that many of them worked hard to acquire a professional reputation for themselves, which, once achieved, they guarded jealously. Inevitably, in Japan as well as Europe, it is the designers rather than the publishers, carvers or printers who have come to be regarded as the true creators of the prints, and it is their names we now remember.

The career of the *nishiki-e* artist was similar in many ways to that of the Kabuki actor. He began his training young, and most often belonged to a family associated with the business, although some artists came from an agricultural or trade background or were even, in some cases, members of the samurai class with a passion for popular culture. A master artist, who would often adopt a number of different artistic titles and signatures, would have anything up to thirty pupils. The best pupil would normally, on reaching maturity, be permitted to use the artistic name of his teacher as a sign that he was continuing the master's style. The others commonly took the last part of their master's name as the beginning of their own. Thus, the nineteenth-century artist Kuniyoshi was the pupil of Toyokuni, and Kuniyoshi had, in turn, a pupil who called himself Yoshikuni. It was usual for a pupil to remain faithful to his master's style after finishing his apprenticeship, although he would inevitably modify it in various ways. Thus, schools of print making grew up, one or more of which would dominate the field at any one time.

Although some artists were able to live well and were admired members of society, the majority, exploited by the publishers, were forced to live in poverty, or else do other things to survive. Hokusai, who with Hiroshige towers above the other *nishiki-e* artists of the nineteenth century, remained poor, even though he was faced with a flood of commissions that never abated. Kuniyoshi, although the prints he designed always sold well, experienced many lean years, during which he could afford to live only in a hovel and had to support himself

by repairing and selling *tatami,* or straw mats. If European painters such as van Gogh had realized that so many of the Japanese artists they admired had been faced by economic difficulties similar to their own, they would have been drawn to them even more strongly.

29 **Moronobu** *Travellers passing on the road, c.*1680. 27·0 × 41·0 (10⅝ × 16⅛), British Museum, London

A Short History of the Woodblock Prints

Ukiyo-e depicted subjects associated with the merchant class, which slowly began to increase in influence during the mid-sixteenth century. After the disastrous fire of 1657 which destroyed most of Edo, the city was reshaped with the Yoshiwara rebuilt on its north-eastern outskirts, not far from the Kannon temple at Asakusa. This reconstruction enriched the merchants and enhanced their influence even further. A book published in 1661, the *Ukiyo Monogatari* (Stories of the Floating World), provided the following definition of *ukiyo*:

> living only for the moment, turning our full attention to the pleasures of the moon, the snow, the cherry-blossoms and the maple-leaves, singing songs, drinking wine, and diverting ourselves just in floating, floating, caring not a whit for the pauperism staring us in the face, refusing to be disheartened, like a gourd floating along with the river current: this is what we call *ukiyo*.[12]

But the word was not new. The Buddhist-inclined mind of the tenth and eleventh centuries first wrote the word using the Chinese characters for 'sad world'. By the seventeenth century, however, when the terrible wars of unification had ceased and the merchant class was emerging, unencumbered by the ethics of the samurai and with money to spend on amusement, the word had come to mean, with different Chinese characters, 'floating' or 'carefree world'.

It was the new merchant class, at first in Kyōto and in the nearby port of Sakai, who were the first patrons of the *ukiyo-e*. No longer afraid of war, they built their houses with space for screens and sliding doors. They wanted to decorate these as the nobles and samurai did, but they did not want the same kind of aristocratic, esoteric art. Instead they wanted an art which reflected their lives and interests: pictures of pretty singers, prostitutes, bath-house waitresses. The merchants could afford to pay for what they wanted and to engage the most skilful artists available. This was the time when

57

many of the screen painters who had been engaged in decorating the new castles and mansions of the victorious *daimyō*, or feudal warlords, were gradually becoming redundant, so there was no shortage of talent for hire.

Most of the painters of screens and scrolls employed by the merchants did not sign their work, and only one of them is known to us now: Iwasa Matabei, who was a court painter to the Fukui clan and whose only involvement with the *ukiyo* was in a series of paintings about craftsmen.

The rich merchants wanted books as well, and they wanted them illustrated. There had long been a tradition of *Yamato-e,* or painted scrolls, which were used mainly for religious stories in the fifteenth and sixteenth centuries. Some of these were beautifully illustrated in many colours, including gold and silver. Later, bound books, known as *nara ehon,* were produced, illustrated in the same way. Screen and scroll painters were engaged in the mass production of these, but demand exceeded their ability to supply. The only answer to the problem was the technique of printing books with woodblocks.

The first book to be produced in this way was the classic *Ise Monogatari* (Tales of Ise) which had black and white illustrations. Other, equally popular story-books followed. The illustrations were very crude and naïve, but the ground had been prepared for the arrival of the first real illustrator who felt that his work should be signed, and who subsequently made the illustrations so popular in themselves that the pictures were regarded as more important than the text.

This illustrator was Hishikawa Moronobu (1618–94) who, as one of the horde of nameless designers employed by Edo publishers, brought out his first book between 1658 and 1660. Moronobu's first signed work dates from 1672, when he began to design autonomous prints, liberated from the books in which they had previously appeared as illustrations. Moronobu and his followers monopolized *ukiyo-e* prints until the end of the seventeenth century. Like most artists of the time, Moronobu designed hundreds of works describing life in the Yoshiwara. Significantly, however, about two-thirds of his work is concerned with travel, poetry and heroic stories. His reputation had become so secure that he

could try his hand at subjects which were less obviously saleable than hard or soft pornography (Plate 29).

Moronobu and his followers, usually referred to as the Hishikawa school, achieved an impressive degree of technical skill, which nevertheless looks naïve in comparison with that of the next generation of print artists, the Torii school, who succeeded in breaking the monopoly of the Hishikawas. The founder of the Torii school was Torii Kiyonobu (1664–1729), who followed his father as a painter of posters for the Kabuki. Indeed, the Torii family was responsible for almost all the theatre poster painting in Edo until the nineteenth century. They also dominated the making of theatrical prints in general, until the livelier, full-colour works of the artist Shunshō took over.

Torii Kiyonobu's prints, hand-coloured with a red-lead pigment, combine grace and boldness and confer a vitality on their subjects by a clever use of vigorous lines abruptly changing from thick to thin. This technique was called unflatteringly *hyōtan ashi, mimizugaki* – 'gourd-shaped legs, worm-like brush-strokes'. The method overemphasized the muscles and made the black and white contour lines seem to wriggle with life, and it had been used for a while by poster painters so that their work would be seen from a distance. The subjects' eyes bulged and stared, probably because the artists used *jōruri* puppets as models – the puppet theatre was still more popular than the new-fangled Kabuki.

Kiyonobu's son, Torii Kiyomasu I, softened the boldness of his father's lines, as did his brother, Kiyonobu II, who specialized in strongly-patterned costumes and delicate contours. The Torii school gradually turned its attention to subjects outside the Kabuki and began to include portraits of courtesans in its repertoire. This subject was mastered by Kiyonaga, a fourth-generation Torii, who came to prominence during the 1780s. His works possess all the hallmarks of the great *ukiyo-e* prints: complex, multi-figured compositions, the use of six or more colours, and a vital, articulated line.

But many developments had to take place before the chromatic richness of a Kiyonaga was possible. Soon after the death of Moronobu, a simple technique of hand-colouring finished prints with *tan,* or yellowish red,

30 **Kiyonobu** *Portrait of actors*, *c.* 1725. 31·8 × 15·2 (12½ × 6), Victoria & Albert Museum, London

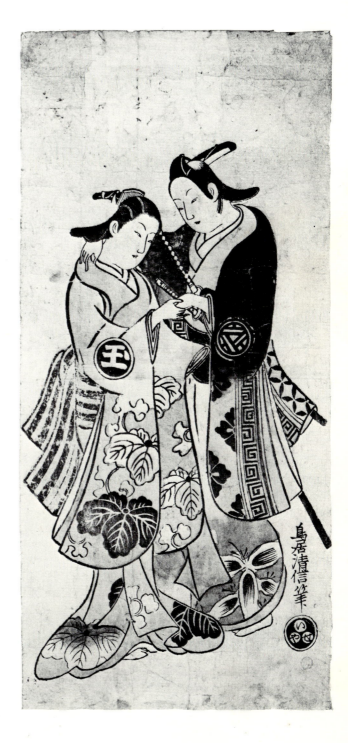

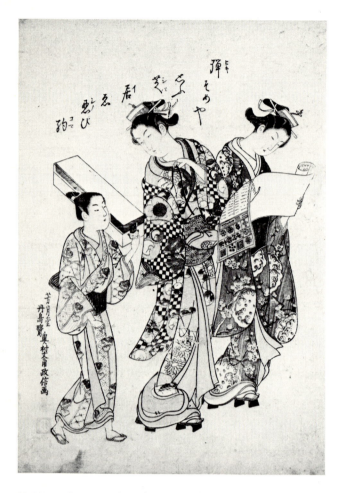

31 **Masanobu** *Two geisha and a kamuro going to a play,* 1750–60.
Benizuri-e. 42·3 × 30·2 (16¾ × 11⅞), British Museum, London

began to be used by Kiyonobu and the members of the
Kaigetsudō school. By the middle of the eighteenth
century, the second generation of craftsmen had
developed a multi-coloured print called the *beni-e,* soon
to be followed by the *urushi-e. Beni-e* (literally, 'red
pictures') used red, yellow, green and purple. At a later
date, to make the black of, say, the hair, look more shiny,
glue was mixed into the paint and this produced a
urushi, or lacquered effect. Soon lacquering was being
applied to any colour where it seemed suitable. Okumura
Shimmyō Masanobu (*c.* 1686–1764) was the outstanding
creator of the simpler, *beni-e* prints. He was the son of a
printer-publisher and kept up the business while work-
ing as a designer. Masanobu was the first to apply a
trademark to his work, in the form of a red gourd. He
also worked out effective standard sizes for individual
prints and is said to have been the inventor of the
hashira-e, the long, thin pictures designed to be hung on
pillars. There are conflicting opinions as to whether he
also devised the triptych, but this format certainly made
its appearance while he was active.

During Masanobu's lifetime, the technique of making
colour prints entirely from woodblocks, without hand-
painting, was introduced. As early as the mid-seventeenth
century the Chinese method of using several blocks for
colouring a print was known in Japan. Mass production
by this method did not occur until almost a century later
however, and the prints produced in this way – the
benizuri-e, or 'red printed-pictures' – represent the last
crucial step before the polychromatic *nishiki-e* (literally,
'brocade pictures') finally appeared. The artist who best
used the *benizuri-e* technique was Ishikawa Shūha
Toyonobu (1711–85). Toyonobu lived to see the *benizuri-e*
prints superseded by the multicoloured *nishiki-e,* which
first appeared around 1765 and then began to dominate
the *ukiyo-e* market. By 1770 trade in the new prints was
booming. Unlike most *benizuri-e,* which used cheap paper
and inks, the *nishiki-e* were expensive products which
ostentatiously flaunted the sophisticated techniques that
had gone into creating them, including embossing and the
use of mat and glazed pigments. The first *nishiki-e* were

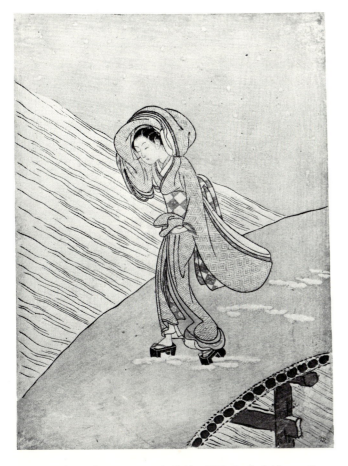

32 **Harunobu** *Girl crossing a wooden bridge,* 1765. On the bridge are the numerals of the 'long' and 'short' months of the year. 28·0 × 20·6 (11 × 7⅞), ex. Vever Collection, Sotheby's

private publications of 1765 and 1766. A number of Edo connoisseurs exchanged albums and New Year calendars specially printed in the advanced techniques. When such full-colour prints were first sold publicly in 1766, there began what can fairly be described as a minor renaissance in later Japanese art.

Suzuki Harunobu was one of the designers of the private albums and must be regarded as the first true master of the *nishiki-e,* even though he did not begin to use the new method until a mere five years before his death in 1770. During his last five years he designed some seven hundred single-sheet prints and also illustrated books (see Plates 13 and 32). Harunobu was able to take advantage of a booming economy and to benefit from certain improvements in technique: thicker paper could now be used, cherry wood had replaced the cheaper catalpa, improvements had been made in the manufacture of ink, and there were more skilled craftsmen available. But besides being the first major artist to exploit these new discoveries, Harunobu was also an innovator in subject matter. He would often use quotations from classical Japanese poetry to add a touch of class to an otherwise banal subject, and he was the first to place his subjects against a realistic background. His prints depicted not only the 'stars' of the Yoshiwara, but women closer to home, like O-Sen, the daughter of the owner of the tea-shop in the Inari shrine in Sasamori. Yet he was no portrait painter. He idealized his subjects, conferring on them delicate, detached and innocent expressions. Harunobu wanted his prints to have the chromatic richness of paintings and styled himself *Yamato eshi,* a title that had always been used by the ancient court painters. From 1765, Harunobu began to choose soft, flat tones of greys and olive-greens for his backgrounds, which had previously been left white by print makers. He now also used stronger tints for the figures. The style that emerged became known in the provinces as *Edo nishiki-e* – Edo brocade painting. Harunobu celebrated his technical achievements by subsequently including the date 1765 (Meiwa 2) in all his prints.[13]

With Harunobu's death, many of the other artists who had stood in his shadow now entered the limelight. Many of them found that they could not very quickly

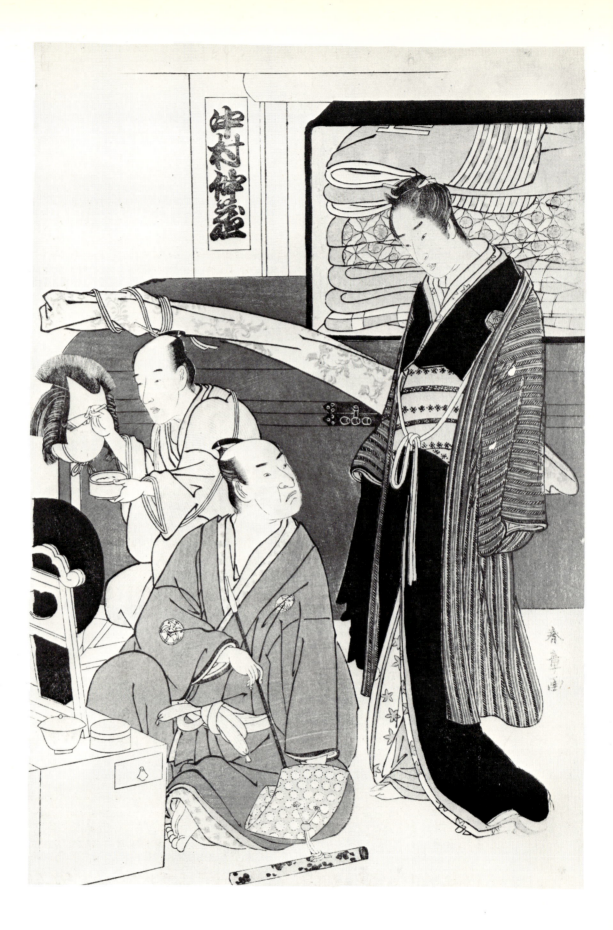

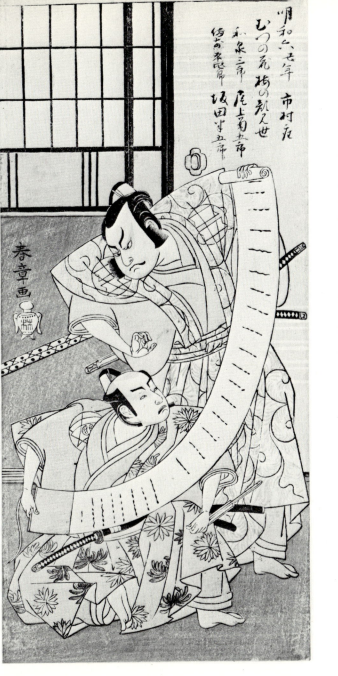

Above
34 **Shunshō** *Two actors*, 1769. 32·0 × 14·7 (12⅝ × 5⅞), British Museum, London

Opposite
33 **Shunshō** *Nakamura Nakazō backstage*. 37·8 × 26·0 (12⅝ × 10¼), Sotheby's

cast off his influence, but one man who managed, even during Harunobu's lifetime, to develop a popular style of his own, was Isoda Koryūsai, who was originally a dispossessed samurai. His women looked healthier and tougher than Harunobu's, and he even designed a few prints without backgrounds, in the old style, possibly as an attempt to be individual.

The Torii school, meanwhile, had now been concentrating on actor prints for two generations, and the gourd-shaped legs and worm-like contours were becoming old-fashioned. Some of the Torii artists, such as Katsukawa Shunshō and Ippitsusai Bunchō, felt frustrated and left the family, and managed to succeed on their own.

Shunshō, who later became the first known teacher of Hokusai, saw the potential of the *nishiki-e* techniques for bringing the popular actors closer to their fans. *Nakamura Nakazō backstage* (Plate 33), for example, shows the famous actor chatting to a colleague in the dressing rooms, while the hairdresser works on a wig. The wardrobe door is open, showing folded costumes. The colleague looks effeminately handsome, as befits a female impersonator. It is all very intimate, and beautifully executed. Shunshō's pupil Shunkō later produced close-up portraits of twelve actors, all in their most popular roles, in one spectacular *ōban* print. He used coloured contours, rather than black ones, so that the make-up stands out vividly.

Torii Kiyonaga, who (although not a blood-relative of the Torii) took over the school on the death of his master, was another artist of great skill. He concentrated on depicting women, producing work which was extremely popular. When he used actors as subjects, they were part of a larger, theatrical print, with as much emphasis given to the action of the play, or to the subordinate roles, as to the leading player.

Torii Kiyonaga's influence was far-reaching. His tall, slender women, clad in intricately designed kimonos, were said to make publishers weep because they could only be executed by the best and therefore the most expensive carvers. He was widely studied and copied by other artists, the most prominent of whom was the young Kitagawa Utamaro, who arrived in Edo, fresh from the country, at the age of about twelve.

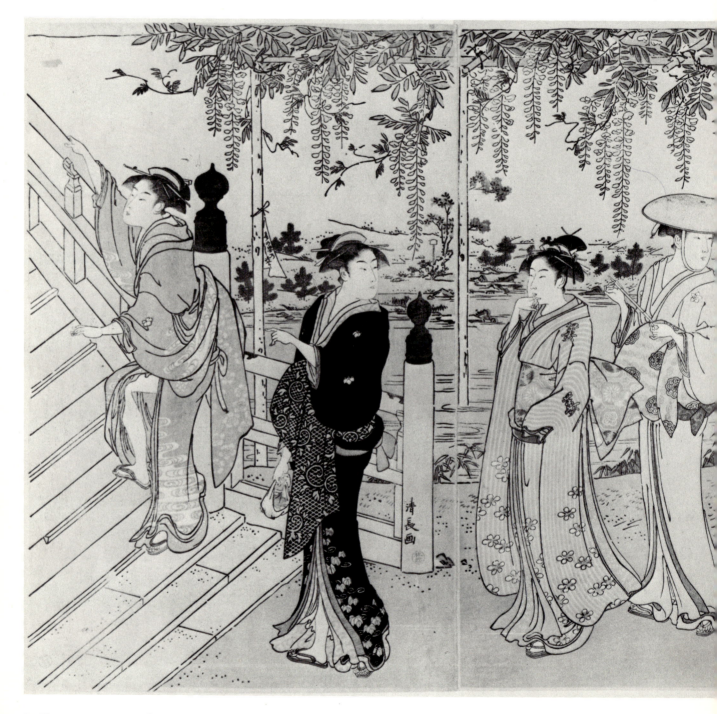

35 **Kiyonaga** *Five women and a kozō at the Kameido Shrine*. Diptych, each sheet 38·8 × 25·9 (15¼ × 10¼), Sotheby's

36 **Kiyonaga** A print from the series *A Collection of Humorous Poems*. The text reads: 'Even a kept mistress gives *koto* lessons to two or three pupils' – that is, to give the impression she is not a prostitute. 26·1 × 19·5 (10¼ × 7⅝), Sotheby's

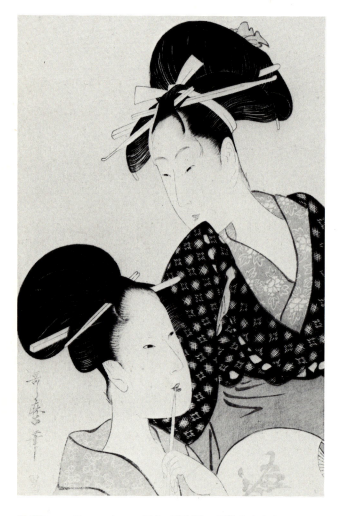

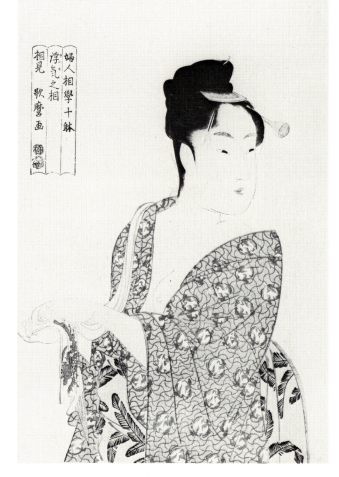

37 **Utamaro** *Two courtesans.* 37·8 × 29·2 (15 × 11½), Sotheby's

38 **Utamaro** 'The inconstant type' from *Ten Examples of the Physiognomies of Women.* 38·0 × 25·1 (15 × 9⅞), Sotheby's

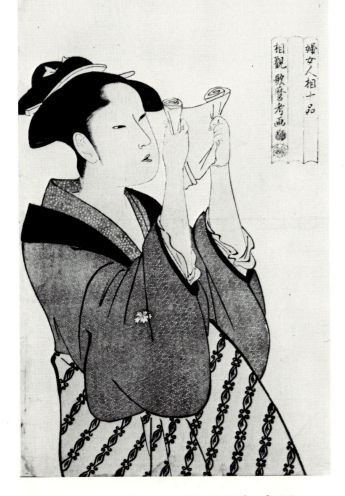

39 **Utamaro** *Woman reading a letter.* 37·5 × 25·0 (14¾ × 9¾), Rijksmuseum, Amsterdam

Utamaro (1754–1806) was the greatest print designer of the so-called Golden Age of *nishiki-e,* a period which, according to many authorities, lasted from 1789 to 1801 (a rather narrow span implying an underestimation of several nineteenth-century artists, such as Kuniyoshi, who were considerable talents by any standards). Utamaro specialized in Yoshiwara subjects and succeeded in conferring an elegance and grace upon his portraits of courtesans, who are long, slender and elegantly proportioned. He began his artistic career at about the age of twenty-three in the school of Toriyama Sekien. His apprenticeship was a wide-ranging one, and if he was later to become insufferably arrogant, he had good reason to be so. When his master Sekien died, Utamaro was ready to work on his own, having already established himself with the publication of a lavish work called *Ehon Mushi Erami.* This was an anthology of popular poetry on the subject of insects, fully illustrated with *nishiki-e.*

Utamaro was fortunate enough to have been discovered by Tsutaya Jūzaburō, an astute publisher who was also a writer and art connoisseur. He possessed a rare eye for new talent and Utamaro was his most famous protégé, fulfilling Jūzaburō's desire to have someone in his pay whose reputation could rival the popularity of Kiyonaga.

Utamaro's prints of life in the Yoshiwara were often extremely frank and he frequently had difficulties with the censors. Eventually he was imprisoned because of the political nature of some of his prints. The life of the *ukiyo-e* artist was fraught with such difficulties, and he was frequently badly paid into the bargain.

Evidence of the sheer extent of the *nishiki-e* industry at this time is provided by the fact that, although Utamaro was undoubtedly the leading light of the period between 1780 and 1800, he was by no means the only considerable figure. Artists like Kitao Shigemasa, the Toriis, or Chōbunsai Eishi (a samurai, trained in the classical style of painting) were all very popular. There were, moreover, enough publishers in business to employ all the craftsmen needed for the countless prints that artists at this time were designing. It is estimated that Utamaro alone had worked for fifty-two publishers by the time he died.

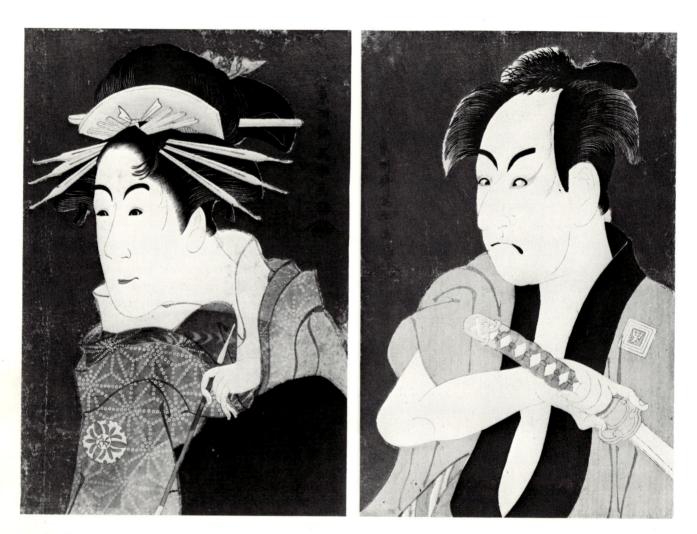

40 **Sharaku** *Portrait of Matsumoto Yonesaburō*, 1794. 36·2 × 24·4 (14¼ × 9⅞), British Museum, London

41 **Sharaku** *Actor, c.* 1794. 38·1 × 25·1 (15 × 9⅞), Sotheby's

This was the Golden Age not only of print making but also of the culture of the Tokugawa period (which stretched from 1603 to 1868) in general. In the late eighteenth century, the Kabuki achieved its modern perfection of technique with the invention of the revolving stage and the introduction of the *gidayū* (narrative chorus). And in the same period the Kabuki finally triumphed over the puppet theatre in the contest for popularity.

Many new plays were written, and here again the close contact between the world of prints and that of the theatre is clear. From the school of the print maker Shigemasa came one Masanobu, who later, under the pen-name of Santō Kyōden, became one of the most prolific of playwrights. He also wrote hundreds of anecdotal stories, many of which he illustrated. Kyōden was not unique in this.

Another of Utamaro's contemporaries was Tōshūsai Sharaku, whose artistic career spanned the amazingly brief period of ten months between 1794 and 1795. He concentrated on portraits of Kabuki actors, many of which he treated humorously, even grotesquely (Plates 40 and 41). Indeed, he is credited with having introduced realism into the *ukiyo-e* portrait, which previously had been content to work exclusively with idealized types and conventionalized gestures. Sharaku is the most famous and the most difficult of the *ukiyo-e* mysteries. In the ten months of his artistic career he produced no less than 140 prints, and these can be divided into four distinct periods. His earliest prints are mainly close-ups of actors and concentrate on their often unusual facial characteristics. The prints of the second period emphasize the movements of the actors, who are shown, usually in pairs, against a white or plain background. The third period is dominated by the *sumō-e,* or pictures of wrestlers, including some of the very popular, prodigiously huge infant, Daidōzan. Actor prints are also found at this time, but the movements of the subjects have become more and more restricted. The last period consists only of fourteen prints. In them Sharaku returns to actors and begins to depict historical subjects as well, but now the actors are shown in frozen poses and there is no longer any interest in their movements. It might be imagined that Sharaku, having encountered severe criticism and unpopularity because of the cruelty of his caricatures, became more and more subdued and finally abandoned his artistic career in despair. Or he might simply have died. The true reason remains a mystery: Sharaku appeared in the print world from nowhere, fully armed with a mature style which deteriorated rapidly, and then disappeared again as suddenly as he had come.

Many historians of prints call the period following the Golden Age the Age of Decadence, apparently on the grounds that there must always be a decline after perfection. It is true that the *ukiyo-e* experienced another change around 1800, but to see this development as a decline is to miss the quite extraordinary qualities of the work of the major artists at this time.

After the 1790s there were very frequent and arbitrary government measures which sought to bolster the declining feudal system and curb the increasing influence of the merchant class. Enforced cuts in Kabuki production were introduced; merchants were forbidden to wear silk; facilities in the Yoshiwara were reduced; and thriving businesses were made subject to swingeing taxation. The government also restricted the production of luxury prints and the use of materials such as mica (which Sharaku and Utamaro had exploited to great effect to create a shiny ground). In 1799, moreover, censorship was introduced: every completed print had to be passed and stamped by a government office, and a year later erotic prints, single-sheet luxury prints and calendars were banned completely. Of course, the *shumpon,* or books of erotic prints, continued to be published; they were simply distributed less openly. But the censorship did have an important effect on the subject matter of prints, especially later, when it became more wide-ranging. In 1842 all prints of actors, dancers and courtesans were banned, and triptychs and prints using more than seven colour-blocks were also forbidden. Every published print was required to display the censor's seal and every design had to be passed even before the cutting began. Print artists, deprived of Yoshiwara and Kabuki motifs, now turned to landscapes and studies of birds and animals, or else they continued to exert their customary magic in a disguised form. For

42 **Toyokuni** *The womenfolk of a rich merchant family in their apartments,* c. 1810. 36·2 × 71·8 (14¼ × 28¼), Victoria & Albert Museum, London

example, many battle scenes were published, in which the major protagonists were given the recognizable features of famous actors, or else well-known courtesans were shown as characters from legend or as famous historical personages. It was above all the landscape print, however, which triumphed at this time.

During the first half of the nineteenth century, the intelligentsia were becoming disillusioned with the

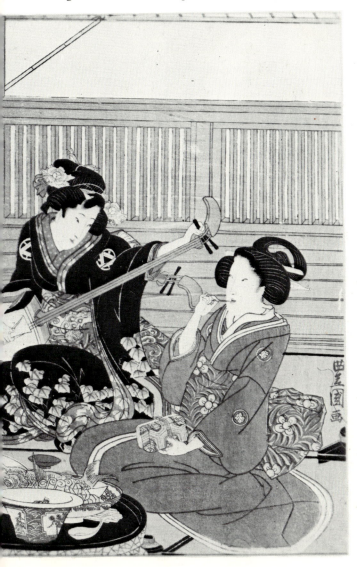

reactionary Tokugawa Shōgunate and increasingly interested in the Western learning now coming into Japan, brought by the Dutch on their yearly voyages to Dejima. The interest of those fortunate enough to lay their hands on the forbidden Western literature filtered down to the masses, especially in the towns, and *ukiyo-e* artists, always eager for new subjects and determined to satisfy every popular vogue, perfected their knowledge of the *uki-e,* or perspective drawing, in which they imitated the look of Western art with its fixed-viewpoint perspective and its interest in solid masses, volumes and space. There was nothing new in this. *Uki-e* had been occasionally produced since the eighteenth century, and Okumura Masanobu had made great discoveries of his own in this area. But now a more sophisticated and subtle variety of perspective print was being perfected. Renewed interest in the foreign barbarians and their culture, moreover, led to large numbers of prints being produced in Nagasaki, the city from which foreigners could most easily be observed on their island in the bay. The citizens of Osaka or Edo could now buy prints – the *Nagasaki-e* – depicting the strange people in their everyday surroundings, with special attention to their clothes, their food, their big ships and their peculiar customs.

If the people were curious about the forbidden world outside Japan, they were also interested in other areas of their own country. Merchants, pilgrims and the purely adventurous journeyed to and from the capital in spite of the many restrictions and dangers. Funny stories about two Edo men travelling to the Kamigata (the Kyōto and Osaka area of Japan), lavishly illustrated, sold well. People from the provinces came to Edo, saw the Kabuki, visited the Yoshiwara and bought the *nishiki-e*. The Edo people, who were forbidden to travel, read or heard the stories about other parts of Japan and bought travel prints showing the notable sights of the provinces, as well as *Nagasaki-e*.

At this time, *nishiki-e* print making was dominated by the Utagawa school, founded by Ichiryūsai Toyoharu, one of the artists who specialized in perspective prints, which he modelled on Dutch copperplate engravings. Toyoharu is not as well-known as his pupil Toyokuni I (1769–1825), who produced female portraits in the

manner of Utamaro before reaching artistic maturity.
Illustrated here (Plate 42) is an example of his mature,
more ornate style. Toyokuni had a large number of
pupils (some reports credit him with as many as twenty-
eight at one time), some of whom were wealthy aristo-
crats determined to acquire something of Toyokuni's
expertise.

Toyokuni was the most influential member of the
Utagawa school, but it was one of Toyokuni's pupils,
Gotōtei Kunisada (1786–1864), who was its most prolific
artist. Kunisada turned his hand to every possible
subject, including portraits of courtesans and ladies as
well as landscapes, but the subject of his best work was
the Kabuki. Perhaps because of his huge output, some of
which was inevitably of poor quality, Kunisada has not
been treated well by the historians of *ukiyo-e,* although
much of his work, especially of the early period,
reached the highest standards. Kunisada was a proud
man. Before he died, Toyokuni passed on his name to his
son, but Kunisada, considering himself to be the most
talented of all the pupils, assumed the title Toyokuni II
without permission, and used it for his signature until his
death, thus causing problems for succeeding generations
of collectors and historians.

Kunisada's great rival was a younger fellow pupil,
Ichiyūsai Kuniyoshi (1797–1861). Kuniyoshi brought to
ukiyo-e print making a sense of drama, a delight in the
grotesque, and a preference for complicated, busy
compositions which might be termed baroque. Some of
his prints of women are beautifully delicate (see Plate 45),
but he is best known for his gory battle-scenes and
fights with gigantic sea-monsters (Plate 46 and Colour
Plates 8 and 9), or fearfully magnified insects and
spectral beings (Plate 47). His range of subject matter was
wider than that of most of his fellow artists.

Kunisada's greatest contemporary – indeed, with
Hiroshige, the greatest Japanese artist of the nineteenth
century – was Katsushika Hokusai (1760–1849), a
painter, as well as print artist, of truly astonishing
gifts. Hokusai was probably the natural or adopted son of
a mirror maker. He first worked as a bookseller, and
then as a wood engraver until 1777, when he was
accepted as an apprentice of Katsukawa Shunshō.

43 **Kunisada** 'Lady' from *Six Poets, c.*1860. 35 × 24·75 (13¼ × 9¾),
Author's collection

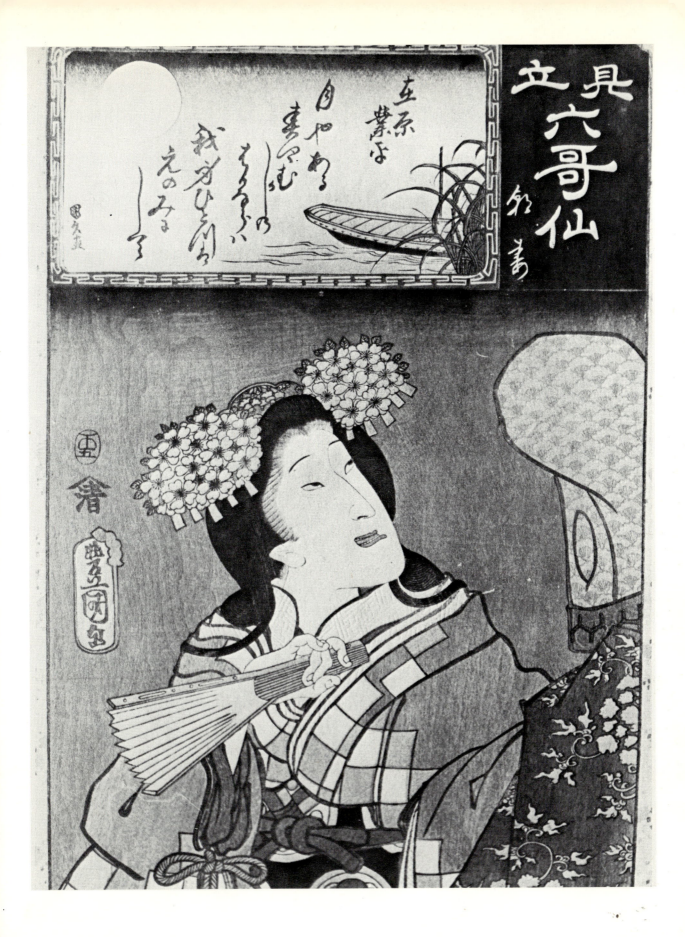

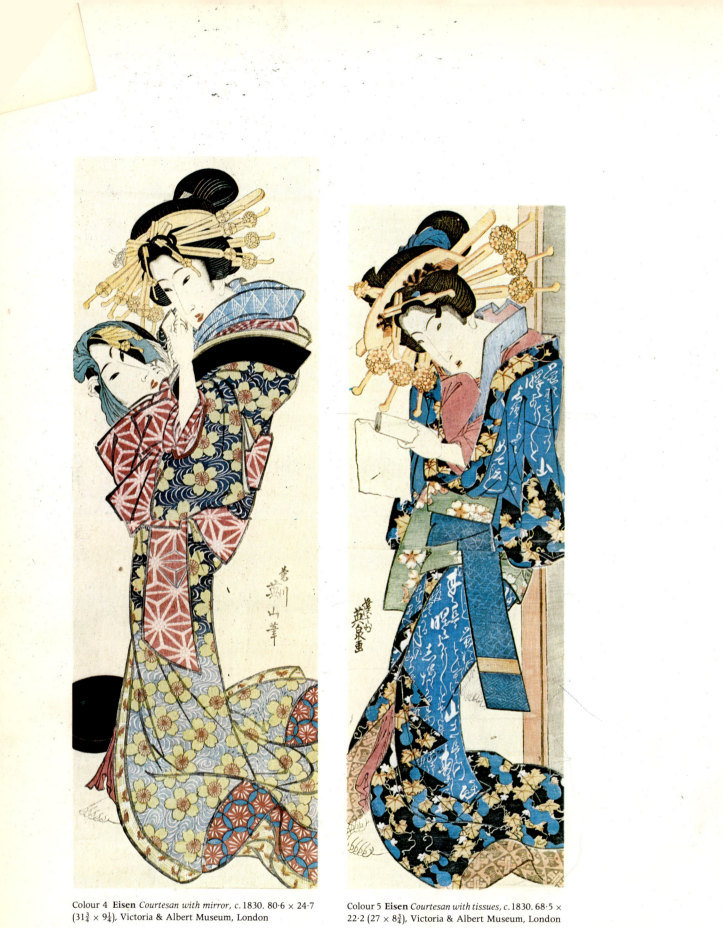

Colour 4 **Eisen** *Courtesan with mirror, c.* 1830. 80·6 × 24·7
(31¾ × 9½), Victoria & Albert Museum, London

Colour 5 **Eisen** *Courtesan with tissues, c.* 1830. 68·5 ×
22·2 (27 × 8¾), Victoria & Albert Museum, London

Colour 6 **Koryūsai** *Girls feeding carp, c.* 1770. 24·8 × 19·0 (9¾ × 7½), British Museum, London

44 Kunisada *Two friendly rivals from the play 'Nuregami Hanachigoma', c.*1860. 36·0 × 25·0 (14 × 9¾), Author's collection

45 **Kuniyoshi** *Girl with chrysanthemum
plant*, 1843–6. 36·8 × 25·4 (14½ × 10),
Victoria & Albert Museum, London

Above
Colour 7 **Hiroshige** 'Oi' from *The Sixty-nine Stations of the Kiso kaidō*, 1886. The Kiso kaidō was a highway which ran to the mountain shrine of Kiso Ontake in Central Japan. 26·0 × 36·8 (10¼ × 14½), Victoria & Albert Museum, London

Right
Colour 8 **Kuniyoshi** *Ushiwaka and Benkei on Gojō Bridge*, *c.* 1840. Triptych, 36·6 × 73·5 (14⅜ × 28⅞), British Museum, London

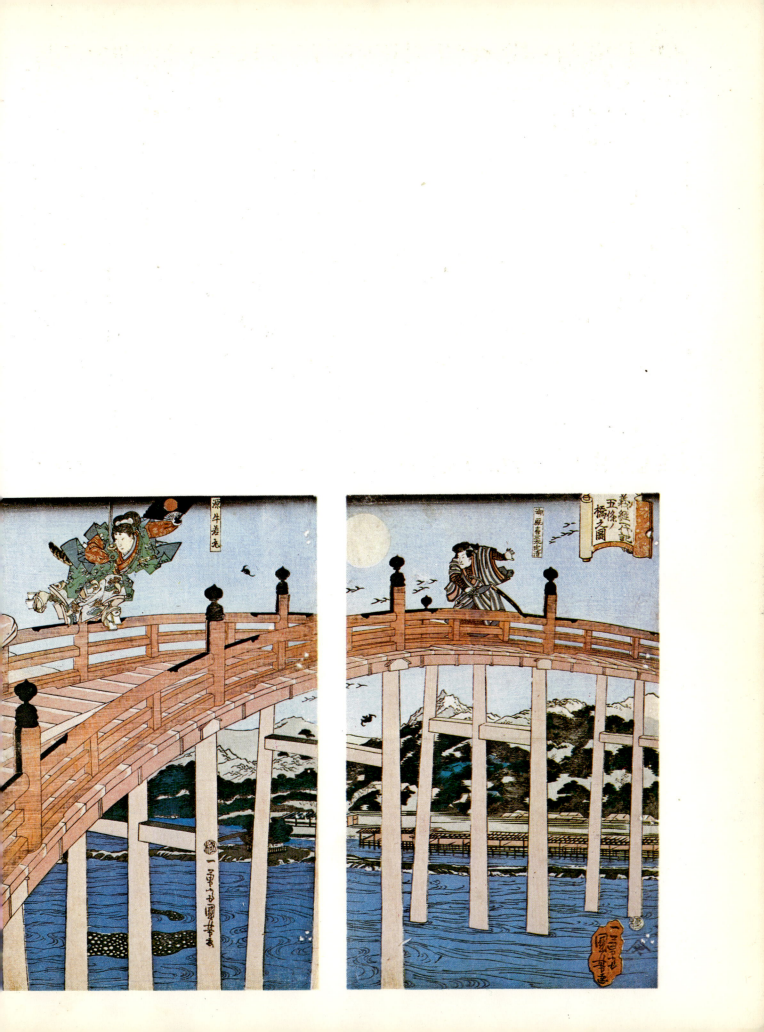

46 **Kuniyoshi** *The Taira ghosts attacking Yoshitsune's ship*, 1818. Triptych, each sheet approx. 36·0 × 25·0 (14¼ × 9⅞), Private collection

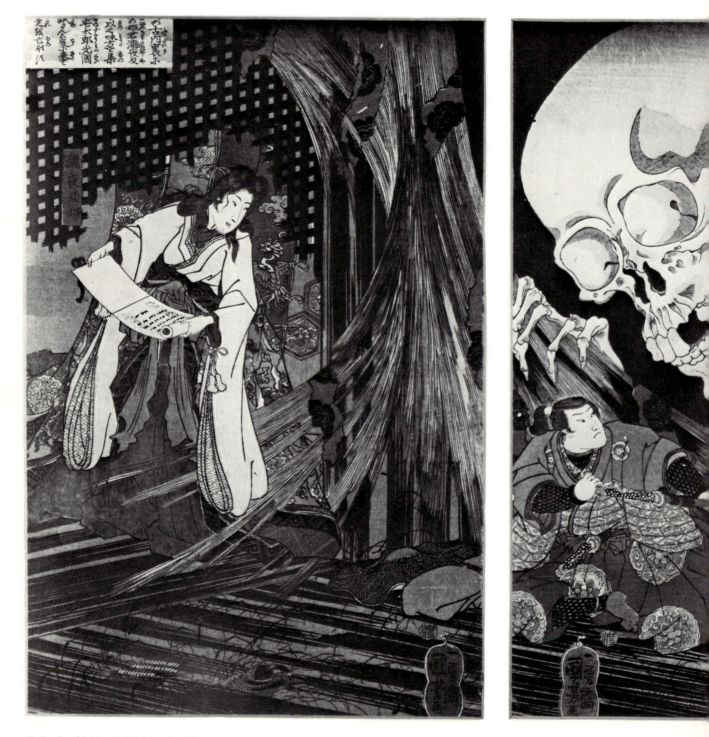

47 **Kuniyoshi** *Mitsukuni defying the skeleton-spectre, c.* 1845. Triptych, 34·9 × 70·5 (13¾ × 27¾), Victoria & Albert Museum, London

48 **Hokusai** Studies for Vol. XII of the *Manga*, *c*. 1831. 29·7 × 20·1 (11¾ × 7⅞), ex. Vever Collection, Sotheby's

After a rupture with Shunshō, Hokusai was forbidden to use the Katsukawa name. A difficult period followed when the artist was forced to change his name and address frequently. Some accounts of his life claim that he was so poor for a time that he was reduced to selling calendars and red peppers on the streets. What compromised Hokusai's reputation at the time is what makes his work so attractive to a European: the constant striving for novelty and originality; the variety of subjects; and the ease with which he was able to absorb a wide variety of influences, including European styles of representation (as in Plate 50).

Hokusai was widely admired in Europe during the later nineteenth century. It was one of Hokusai's illustrated books which introduced numerous French artists to Japanese art, and it can be argued that French painters drew more heavily on his work as a source than on that of any other print maker. The book by Hokusai which filled so many French painters with a healthy respect for Japanese art in general was one of the fifteen volumes of the *Manga* (a word which literally means 'sketches', 'cartoons' or 'studies'). The *Manga* is an astounding achievement, attempting to capture in black, white and pink the extent of Hokusai's world and to provide at the same time a source-book for other artists seeking to copy a certain object, implement or pose.

All human life seems to be in Hokusai's *Manga*: every conceivable type of landscape in miniature, animals, humans deformed in any number of ways, studies of water, fish, insects, monsters, ghosts, magicians performing tricks, people pulling grotesque faces. There are even diagrams explaining Western perspective, and page after page showing people performing everyday actions. The mind as well as the eye is impressed by the *Manga*, which is the work not only of a consummate technician, but also of a warm, inquisitive personality.

Ichiryūsai Hiroshige (1797–1858), almost forty years younger than Hokusai, was the last great *ukiyo-e* artist. He brought the landscape print to heights of description never reached before. Although in the finished prints he departed from his model in the interests of compositional coherence, nevertheless he did draw his inspiration directly from real landscapes.

Above
49 Hokusai *Irises and a grasshopper.*
24·5 × 36·7 (9⅝ × 14½), Fitzwilliam
Museum, Cambridge

50 Hokusai *A view of Hikata Noborito.*
Note the Western-style signature and
frame. 18·7 × 25·8 (7⅜ × 10¼), Sotheby's

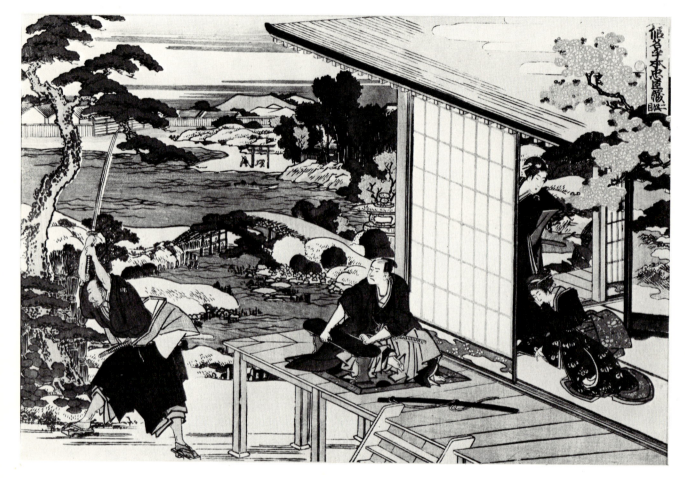

Above
51 **Hokusai** *Act* II *of the play 'Chūshingura'* (or 'The Forty-seven Rōnin'). 25·7 × 38·1 (10⅛ × 15), Victoria & Albert Museum, London

Opposite
52 **Hokusai** Page 10 from Vol. X of the *Manga*. 18·0 × 13·0 (7 × 5), Cambridge University Library

53 **Hokusai** Page 5 and 6 from Vol. XII of the *Manga*. Each 18·0 × 13·0 (7 × 5), Cambridge University Library

塩治
判官

天眼鏡

Left
54 Hokusai Page 12 from Vol. XII of
the *Manga*. 18·0 × 13·0 (7 × 5),
Cambridge University Library

Opposite
55 Kunisada *Memorial portrait of
Hiroshige*. Approx. 37·0 × 25·0 (14⅝ ×
9⅞), Fitzwilliam Museum, Cambridge

Hiroshige made a considerable number of journeys through Japan and filled countless sketchbooks with his impressions. His views of famous places, such as the *Fifty-three Stations of the Tōkaidō* and *One Hundred Views of Edo,* were extremely popular during his lifetime, so popular indeed that his prints have suffered from the worn blocks, careless printing and poor-quality pigments that are symptomatic of overproduction.

Hiroshige's landscapes continually astonish. He enlarged the possibilities of the woodcut, surely the most difficult and unyielding of all the graphic media, to encompass effects of great atmospheric subtlety and variety. A snow scene, in which icy winds seem to blow, has been achieved with only four colours, three of which are used on three small figures, with the fourth, a wash from black to grey, describing the whole of the background (Colour Plate 7). Hiroshige manages with such limited means to create perfect evocations of warm summer rain (Colour Plate 11), autumnal mists, and spring evenings with a touch of frost in the air.

Hiroshige lived to learn of the arrival of Commodore Perry's black ships, which signalled not only the end of the Shōgunal government, but also of the *nishiki-e* as a major popular art form. After the Meiji Restoration, prints of actors, beautiful women and other conventional *ukiyo-e* subjects failed to compete with photography and lithography; and the attempt to boost sales, as Yoshitoshi did, by concentrating on bloodthirsty, gruesome subjects or on contemporary events, came to nothing.

Yoshitoshi was a pupil of Kuniyoshi. He lived in his master's house and had access to his enormous store of Western pictures. While his early work was in the manner of the Utagawa school, his style changed during the 1860s as his subject matter became morbid, violent and frightful (see Colour Plate 12). He died in a mental asylum in 1892.

Descriptions of contemporary events, or *jikyokuga,* came into their own during the Sino-Japanese war of 1894–5, when battle-scenes were produced in large editions. They provided large numbers of artists and craftsmen with employment after years of poverty enforced by a falling off in their trade, but decline set in again immediately after the end of the war, although prints continued to be published. Even the Russo-Japanese war of 1904–5 failed to revive the dwindling fortunes of the *nishiki-e.*

More recent attempts to breathe new life into traditional print making also seem to have floundered, perhaps largely because what was once a frankly popular, unselfconscious, little-regarded form has since been recognized as an art of rare quality and distinction, and this recognition has hampered artists who have attempted to work in the *ukiyo-e* tradition.

As far as the influence on Europe was concerned, however, the *ukiyo-e* had long since done its work.

Opposite
56 **Hiroshige** 'Saruwaka-chō', from *One Hundred Views of Edo.* 35·9 × 24·8 (14⅛ × 9¾), Fitzwilliam Museum, Cambridge

Part Two : Europe

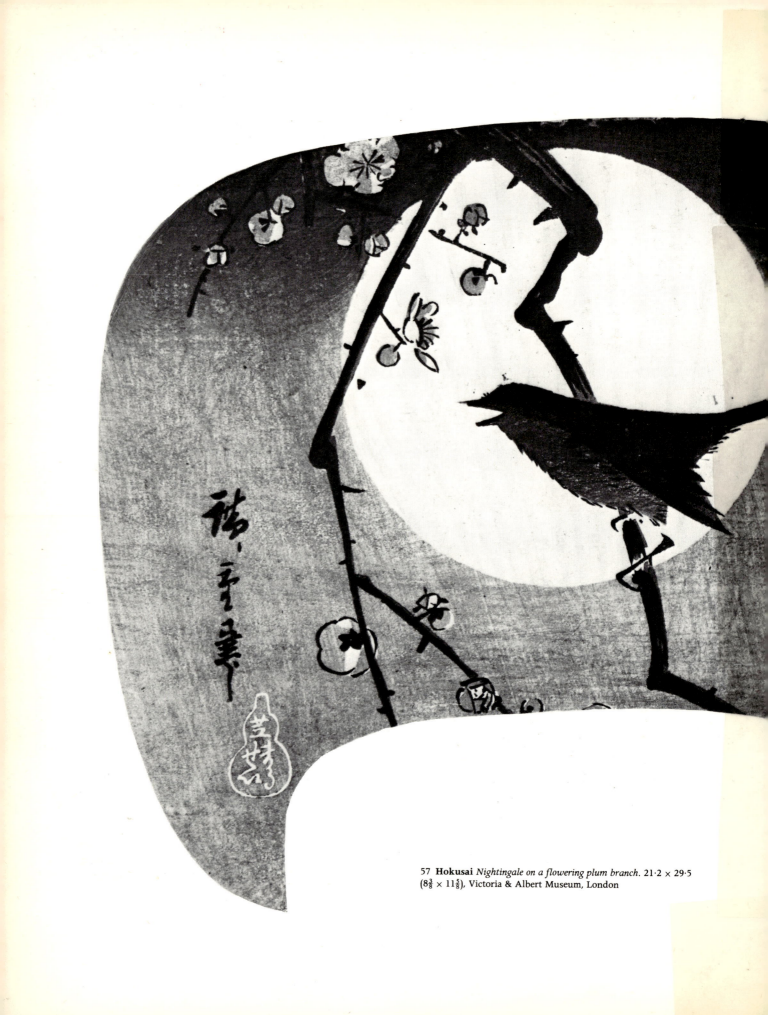

57 **Hokusai** *Nightingale on a flowering plum branch*. 21·2 × 29·5
(8¾ × 11⅝), Victoria & Albert Museum, London

European Knowledge of Japan

Japan's self-imposed isolation from the rest of the world until the mid-nineteenth century did not result in total ignorance of Japan in Europe. Just as some Japanese intellectuals continued half-secretly to find out what they could of Western science and managed to lay their hands on Dutch books, so too did reports reach Europe of Japanese life, Japanese manufactures and Japanese art.

Throughout the seventeenth and eighteenth centuries, the Dutch had kept Europe supplied with Japanese porcelain and lacquer, which were popular and even imitated by European craftsmen; but they were accepted not as specifically Japanese, but simply as products of the Orient. It took some time, even after the opening-up of the country, for Japan to become established as a separate entity in the European imagination: for years it was regarded as a vague adjunct to the Chinese Empire.

One of the earliest books about Japan was Kaempfer's *History of Japan,* which first appeared in English translation in 1727. It has numerous illustrations, many of them copied from Japanese books owned by Sir Hans Sloane, the London surgeon. All Sloane's collections passed to what became the British Museum, which possessed a remarkable collection of Japanese art and manufactures long before the Perry expedition. But curiously, in spite of the wealth of material, interest in Japan remained dormant.

Most reports naturally came through the Dutch trading station on Dejima. Although the Dutch were forced to live, as in a ghetto, on this man-made island, the consul had to make an annual visit to Edo, more than a thousand kilometres away, to pay homage and bring gifts to the Shōgun. The journey, made on horseback, lasted about two weeks, and many impressions could be formed and recorded of life along the way. There were, moreover, regular close contacts between the Dutch and some members of the Nagasaki intelligentsia, who risked their lives whenever they invited the foreign barbarians into their homes.

Some of the most vivid records of Japan in the early nineteenth century are furnished by the writings of P. F. von Siebold, a German doctor, who entered the country disguised as a Dutchman and then began to work for the Dutch. His description of the Kabuki in Osaka has already been quoted. He not only went on several of the annual visits to Edo, but was also one of those to have regular contact with some of the Nagasaki aristocrats.

Siebold and other members of the Dutch East India Company in Japan kept their friends in Holland informed of life in the mysterious country. They also brought back to Holland Japanese art and manufactures, some of which they deposited in museums. The extensive von Siebold collection, of about five thousand pieces of various kinds, was acquired by the Dutch government in 1837, and led to the foundation of the Rijksmuseum voor Volkenkunde at Leyden. During von Siebold's second tour of duty in Japan between 1859 and 1862 he assembled another collection of objects, prints, drawings and paintings, which is now in the Ethnographic Museum of Munich.

Knowledge of Japanese art and of the country itself was therefore available before Japan opened itself to the outside world. But it was not extensive, being limited to those who had been there and to a small number of scholarly specialists. The collections at, for example, Leyden remained little known and less used.

After the Perry expedition there was, of course, a stream of books about Japan. Of obvious importance was the official report, *Narrative of an American Squadron's Expedition to the China Seas and Japan,* edited by the Reverend Francis Hawks and published in 1856. Hawks not only mentions and enthuses about woodblock prints, but illustrates the text with three colour facsimiles and two in black and white. Three years later, Laurence Oliphant, Lord Elgin's secretary, published a record of Elgin's mission to China and Japan, illustrated with a few dozen woodcuts and four full-page colour prints. Sherard Osborn, the captain of Elgin's ship, also broadcast his impressions in a series of magazine articles which were published in a book in 1861. This has the distinction of including eighteen hand-coloured facsimiles of woodcuts,

most of them landscapes and all of them of high quality. But perhaps the most detailed account of life in Japan at this time is provided by *The Capital of the Tycoon,* a factual record written by Rutherford Alcock and published in 1863.

Alcock developed a genuine understanding of Japanese works of art and assembled an impressive collection, including woodblock prints. His books contain passages about art which reflect an obvious enthusiasm, even though they also reveal his innate artistic prejudices. He wrote, for instance, that

No Japanese can produce anything to be named in the same day with a work from the pencil of a Landseer, a Roberts, or a Stanfield, a Lewis, or Rosa Bonheur, whether in oil or watercolours; indeed, they do not know the art of painting in oils at all, and are not great in landscape in any material. Their knowledge of perspective is too limited and aerial effects have scarcely yet entered into their conception. But, in figures of animals, I have some studies in Indian ink, so graphic, so free in outline and true to nature, that our best artists might envy the unerring touch and facile pencil so plainly indicated.[14]

The two countries which first succumbed to the cultural influence of Japan were England and France. Some English craftsmen were fired with enthusiasm for things Japanese soon after the Perry expedition had made the country famous. The Museum of Ornamental Art (the forerunner of the Victoria and Albert Museum) possessed Japanese furniture and lacquer as early as 1852. In 1854 an exhibition of Japanese applied art was held on the premises of the Old Water Colour Society on Pall Mall East, and in 1858 the Manchester firm of Daniel Lee produced a printed cotton design based on Japanese prints. Even *nishiki-e* were known in England before Whistler brought the craze for them from France in 1859. Several English collectors seem to have been interested in Japan as early as 1850, when prints could be bought from several London shops. A grocer near London Bridge is said to have given away a free *ukiyo-e* print with every pound of tea.[15]

The second great International Exhibition in London in 1862 was the first occasion on which Japanese art was

exhibited anywhere outside Japan on any scale, and it was this exhibition that directly brought about the general enthusiasm in England for the arts and crafts of Japan. It included the splendid Alcock collection, and Alcock was responsible for designing the entire Japanese section. The contents of this remain a mystery to us, but they were impressive enough to inspire the High Victorian painter Lord Leighton to deliver a discourse on Japanese art. The exhibition attracted even the medievalist William Burges, and soon after he saw it, he began to collect prints. 'To any student of our reviving arts of the thirteenth century,' he wrote, 'an hour or even a day or two spent in the Japanese Department will by no means be lost time for these hitherto unknown barbarians appear not only to know all that the Middle Ages knew but in some respects are beyond them as well.'[16]

Burges' friend the architect and designer E. W. Godwin, who was later an intimate of Whistler, was also profoundly influenced by the London exhibition. He also began to collect prints, decorating his house in Bristol with them and dressing his mistress Ellen Terry and their children in kimonos. One of those children became the artist and theatrical designer Edward Gordon Craig, whose own woodcuts, produced around the turn of the century, clearly owe much to his childhood introduction to *nishiki-e*.

After the exhibition closed, some of the Japanese exhibits were taken to Farmer and Rogers' Great Shawl and Cloak Emporium on Regent Street, which opened an Oriental warehouse next-door to their main shop and quickly established a reputation as purveyors of things Oriental, and especially of prints. One of the two young men chosen to staff the new branch was Arthur Lasenby Liberty, who became manager and then set up business on his own in 1875. Already at Farmer and Rogers, Liberty got to know the artists who were to become the most celebrated customers of his own shop: Burges, Whistler and the other collectors of blue-and-white porcelain, and the Pre-Raphaelite painters, who were less interested in Japanese prints than in Indian silks, in which they liked to drape their models. In 1863 a large consignment of Japanese goods which had arrived from Japan too late for the International Exhibition was disposed of by

auction, and this too helped to establish many collections.

After the Meiji Restoration of 1868, the complete lack of trade restrictions between Britain and Japan resulted in a rash of 'Oriental warehouses', 'bazaars' and 'curio shops' all over London. Big stores like Debenham and Freebody, and Swan and Edgar, also opened Oriental departments. The professor of botany who had become a designer, Christopher Dresser, who went to Japan in 1877 to report on Japanese manufactures and to advise the Japanese on exports, opened his own Japanese warehouse in 1879 in Farringdon Street.

It was above all Liberty's in Regent Street, however, which fed the fire of the popular enthusiasm for Japan in England. It was this firm too that was almost entirely responsible for making Japan and the Aesthetic Movement virtually synonymous in the popular imagination. When Liberty opened up in 1875, he and his assistants (among whom was a sixteen-year-old Japanese boy) at first sold only Oriental silks, but very soon they began to import Japanese porcelain, prints, fans, screens, *tatami* mats, *netsuke*, sword guards and other articles. Liberty, moreover, began to commission Japanese workshops to produce 'curios' (as he called them) especially for the London firm. As E. W. Godwin relates in an article of 1876, Liberty's was a tremendous success:

> There was quite a crowd when we arrived. A distinguished traveller had button-holed the obliging proprietor in one corner; a well-known baronet, waiting to do the same, was trifling with some feather dusting-brushes; two architects of well-known names were posing an attendant in another corner with awkward questions; three distinguished painters with their wives blocked up the staircase; whilst a bevy of ladies filled up the rest of the floor space. It was some time before I could get sufficiently near to catch the eye of the master of this enchanting cave, and then only to learn, to my disappointment, that the case [of fans] would not arrive until late that evening.[17]

In the same article, however, Godwin also criticizes the quality of some of the goods. Already the Japanese and their English retailers were selling things made especially for the foreign market, and already the initiators of the fashion were regretting its popularity. It

58 Cartoon from *Punch* after a drawing by George du Maurier, 20 October 1894. Victoria & Albert Museum (Library), London

did not take long for the cartoonists and satirists to discover that the Oriental vogue, and Liberty's itself, provided them with a rich vein of humour (Plate 58).

By 1886 the enthusiasm for Japan had still not dimmed. In that year William Anderson published his monumental work *The Pictorial Arts of Japan* in four volumes, and sold his collection of prints and drawings for £3,000 to the British Museum. Reviewing Anderson's book, *Blackwood's Magazine* commented:

It is not too much to say that no event in the artistic world has of late years attracted so much attention as the discovery of the wonderful skill in painting possessed by the people of that strange empire in the Western Pacific.[18]

With the exception of Whistler and Albert Moore, however, the influence of Japan by-passed British painters almost completely. In Britain it was above all the applied arts, rather than painting or sculpture, that were vital forms open to change and external influence, and it was in this area that the major fashion for Japan during the 1870s was reflected.

In Germany also, and more especially in Austria, it was the applied arts which succumbed most obviously to the impact of Japan. The Austrian Museum for Art and Industry (modelled on the South Kensington Museum) was founded in 1863. At the end of 1869 the Museum began to buy large numbers of Oriental manufactures and art objects and named Alexander von Siebold (the son of P. F. von Siebold) as its representative in Tōkyō. Japan sent a section to an international exhibition held in Vienna in 1873. It was almost inevitably a success, and helped several Austrian designers to escape from the overblown historicism beneath whose heavy hand they had laboured for so long. But the influence of Japan did not emerge in Austria in the work of major artists until the turn of the century, when the Vienna Secession and the Wiener Werkstätte were founded.

It was in Paris that painting first began to register enthusiasm for Japanese models. Japanese art had filtered through to France before 1853, as it had to England. Japanese objects had been sold by auction in Paris before 1850 and the Bibliothèque Nationale had acquired a number of illustrated Japanese books as early as 1812.

The date usually given to mark the beginning of the vogue for Japanese prints in Paris is 1856, when three facsimiles of Japanese drawings appeared in *Le Magazine Pittoresque* and the engraver Félix Bracquemond discovered a volume of Hokusai's *Manga* in the workshop of his printer, Delâtre. Bracquemond at the time was delivering the plate for an etching. He found the tiny images in the *Manga* bewitching and begged Delâtre to let him have the book. The printer, who treasured it himself, refused, and a year passed before Bracquemond was able to lay his hands on another copy. It was owned by Lavielle, the wood engraver, who exchanged it for Papillon's classic and very valuable book on wood engraving.

Although the only evidence for this story, set down a decade after the event, is Bracquemond's memory, and although Bracquemond's own work does not betray any Japanese influence until about ten years later – in the porcelain designs after Hokusai (Plate 59) – there is clearly some truth in the account. It is possible that this was the first occasion on which Japanese prints entered the consciousness of a European artist. Certainly Bracquemond's enthusiasm for Hokusai was contagious. Bracquemond was well-liked in the artistic circles of Paris, and he was also well-connected. He showed his treasure to fellow artists, dealers and collectors with the conspiratorial air of someone who has made single-handed a major scientific discovery. Most of those who saw Bracquemond's copy of the *Manga* recognized its potential importance. Before long, artists and collectors were looking for their own copies and beginning to search for single prints.

Those artists who were not introduced to Hokusai's work by Bracquemond might have discovered it in a book published in 1861 which, as Jacques de Caso claims,[19] was surely an important factor in the enthusiasm for Japan in Paris at this time. The book is *Notes sur le Japon, la Chine et l'Inde, 1858–1859–1860* by Baron Charles de Chassiron, who had helped Baron Gros prepare the first Franco-Japanese treaty. Included in de Chassiron's book was a bound folio containing fifteen facsimiles of woodcuts, printed in colour on imitation Japanese paper. No less than nine of the thirteen plates are from Volume I of the *Manga*, two more are from

59 **Bracquemond** Two plates from the 'Rousseau' service, 1867. The motifs are based on images from Hokusai's album *Ukiyo Gafu*. 24·4 (9⅝) diameter, Victoria & Albert Museum (Bethnal Green), London

Hokusai's *One Hundred Views of Mount Fuji*, and one more is of a page from Volume I of another work by Hokusai, entitled *Ukiyo Gafu*.

Collectors were assisted in their search for *nishiki-e* by the opening of several shops specializing in Japanese art. The most famous of these was situated in the rue de Rivoli, and was owned by Mme Desoye, who registered the business in 1862. The shop immediately attracted a large number of artists and writers, the most frequent of whom appear to have been Manet, the Goncourts, James Tissot, Whistler, Fantin-Latour, Degas, Burty, Zola and Bracquemond himself. There are several accounts of the shop, with details of its owner and its merchandise, and the most vivid of them is that by Edmond de Goncourt, in his journal entry for 31 March 1875:

How many stops I've made lately at this shop in the rue de Rivoli, where enthroned in her jewels like a Japanese idol, sits the fat Mme Desoye: almost an historic figure in our own time, for this shop has been the place, the school as it were, from which this great Japanese movement has evolved which today extends from painting to fashion.

The prints remained cheap for several years, and this fact obviously enhanced their popularity. The first to arrive in France after the Perry expedition had probably come as ballast or wrapping paper. Indeed, Monet, who discovered *nishiki-e* independently as a young man in his native le Havre, remembered buying cheese wrapped in prints.[20] In Paris, according to Chesneau, they could be bought 'at an average price of ten centimes',[21] and in the 1880s van Gogh was still able to buy prints for a few sous each. William Michael Rossetti, the brother of the painter and a regular visitor to Paris, soon discovered that prints were cheaper and more plentiful in France than in London, and acquired them in large numbers. In 1863 he even sent a volume of landscape prints to Ruskin, who replied, rather unconvincingly, that 'the book is delightful. . . . I should like to go and live in Japan.'[22]

In spite of the cheapness of prints in France, several Japanese dealers made fortunes selling them. The most successful of these was Tadamasa Hayashi, who mobilized junk dealers all over Japan to collect all the prints they could. For good prints the dealers were offered prices ten times above the current market value. In Paris, they were sold at a profit of several hundred per cent, but even so they remained cheap by French standards.

From the beginning there was something extraordinary about the French vogue for Japan. It not only attracted collectors and artists, it also appealed to the finest critical minds of the time, writers who began to produce essays in praise of Japan and to acquire prints themselves. Baudelaire was one of these. As early as 1861, he mentions in a letter to Arsène Houssaye a packet of prints which he had split up and sent to various friends as gifts, and there, as later, he likens them to the popular *Images d'Epinal* – the simply-coloured and very cheap French prints. In 1862 the brothers Goncourt noted in their journal that 'Japanese art has beauties, no less than French art', and four years later Zacharie Astruc contributed a series of articles about 'L'Empire du Soleil Levant' to the journal *L'Etendard*.

The Goncourts claimed to have been the first to perceive the beauty of the prints, to have collected them, and to have awakened in other artists an awareness of their qualities. The claim is certainly exaggerated, but it is true that they were the most influential writers on Japanese art for a time. Their enthusiasm for Japan comes out in their fiction as well as their criticism. In *Manette Salomon* (1866) the whole of Chapter 47 is devoted to the Oriental daydreams of the hero as he browses through an album of woodcuts. There are also pages devoted to things Japanese in *Idées et sensations,* and Edmond de Goncourt even drew upon Japanese art and life as a source of unusual similes. In *Frères Zemgano* (1879), for example, the shadows cast by chairs in a park are compared to a legion of crabs scaling a page in a Japanese picture book. There is, moreover, a striking parallel in subject matter between Utamaro's album recording the life of the Japanese courtesan and Edmond de Goncourt's *La Fille Elisa* of 1877.

The flood of information about Japan was augmented by the great exhibitions of 1862 and 1867 in London and Paris. Japanese prints were shown at both. In 1871 Théodore Duret, the great critic, publisher and art dealer, travelled to Japan with his colleague Cernuschi. They stayed there for almost two years and brought back

with them examples of every kind of Japanese art, including countless *nishiki-e*. Soon after their return in 1873, the symptoms of the vogue for Japan become too numerous to document. By this time, no artist could be unaware of Japanese art, and most artists were actually influenced by it.

Some of the art historians who have investigated the phenomenon of Japanese art in France during the nineteenth century have perceived at least two distinct phases and types of influence at work.[23] The first was a vague and uncritical enthusiasm for things Japanese. This left its mark on the art of the 1860s and 1870s in the form of a repertoire of Japanese objects included in paintings as exotic props. Thus, a painter like Alfred Stevens might dress a model in a kimono for the sake of the pleasurable Romantic associations it evoked, and many of his contemporaries often included fans, screens, porcelain and lacquerware in their compositions for the same reason. Indeed, most studios at this time were now furnished with fans, prints and costumes in case they were required for inclusion in compositions. The second phase of Japanese influence identified by art historians arrived when attempts were made to absorb not so much the subject matter of Japanese art as its stylistic features, above all its use of strong, unbroken contour lines, solid areas of colour and the decorative disposition of shapes. Thus, it is possible to see Gauguin modify his style under the influence of Japan from about 1888 onwards, and van Gogh was applying some Japanese principles to his work at about the same time.

While a division into two such phases does provide a useful framework for an examination of Japan's influence on European art, it is far too simplistic and even misleading. There was in fact no chronological development from *japonaiserie* to *japonisme*, as art historians conveniently call the two types of influence – that is, from paintings of exotic objects in familiar styles to a new style partly based on Japanese aesthetic principles. *Japonaiserie* and *japonisme*, rather, existed side by side. The first major artist to absorb the principles of Japanese style was Manet, and the technique even of some of his early work owes something to *nishiki-e*. Monet (whose portrait of his wife in a kimono is perhaps the most

brilliant example of *japonaiserie*) similarly allowed his style, as well as his subject matter, to be subtly altered – both at the same time but in different paintings – by Oriental art. There were two separate phases of deep and subtle influence, or *japonisme*, and both occurred while a superficial interest in exotic subject matter was equally widespread.

Each phase of *japonisme* spans a moment of crisis in nineteenth-century French painting: the first was caused by the decline of that kind of pastoral symbolic Realism best represented by Courbet and Millet, the second by the flagging of Impressionism. Both phases began, therefore, as a direct result of an urgent need to re-think existing principles. This was a question of subject as well as of style. Most historians of nineteenth-century French painting have been concerned with the latter at the expense of the former, and have under-estimated the impact made on French painters by the honesty with which Japanese artists chose their subject matter. Paradoxically, it was not because they were wildly exotic that the prints were appealing, but because they seemed to depict everyday urban life. Manet and his Impressionist friends, weary of the didactic, idealized, conventional subjects prescribed by the Academy, perceived in Japanese prints not only an exciting new aesthetic, but also a refreshing concern for everyday life and for ordinary experience.

Critics such as Duret, Zola and the Goncourts liked Japanese art for somewhat different reasons, and the Goncourts' interpretation of its iconography was especially subtle. They attributed to *ukiyo-e* a double nature, which put them in mind of their own position between the camps of Realism (represented by Courbet and Millet) and the aristocratic symbolism of the Academy. The print artists, in their view, had found everyday equivalents for the iconography of court painting, transposing traditional subjects into a contemporary realistic context. They used *ukiyo-e* motifs in both allegorical and realist ways. Moreover, the Goncourts also identified in *ukiyo-e* a striking parallel with the contemporary situation in France. These were the years of the declining power of Napoleon III and of the beginning of the Third Republic. Associated with this political change,

there also occurred a change of direction in French art. The Academy was coming to be seen as the repository of aristocratic standards of painting which, because they were so rigorously applied, had ossified the work of those artists who subscribed to them. A painter such as Degas was reacting to this by substituting his own, very different standards, based on a more direct experience of life. The similarity between these combined social and aesthetic developments in France and the background of the emergence of *ukiyo-e* is marked. *Ukiyo-e* was an art form created by artists who had experienced and expressed in their art the end of a decadent, feudal system and the start of a period of new national consciousness. It was a popular form, sharply distinguished from the exclusive art that was developed for and by aristocrats at court. Here, therefore, was another point of contact between *ukiyo-e* print artists and nineteenth-century French painters.

Perceiving this affinity, Edmond de Goncourt describes Hokusai, in a monograph of 1896, as an artist of the people, the founder of the vulgar school of art. Utamaro, on the other hand, is characterized in *Outamaro, le peintre des maisons vertes* (1891) as a Japanese Watteau, on account of his more fanciful subjects and his appeal to a more sophisticated taste. The quality which Hokusai and Utamaro have in common is suggested by Goncourt's definition of *ukiyo-e* in terms reminiscent of Baudelaire: 'life in flux, seen strictly as it presents itself to the eyes of the artist'.[24] That some Japanese prints should have been admired for their realism is but one of the many paradoxes which complicate the relationship between Japanese and European art during the nineteenth century. But the largest paradox is also the most obvious: how was it possible for painters to draw more from the woodblock prints than, initially, French print makers did? For, in spite of the importance of Bracquemond as godfather and midwife, it was the French painters who used their enthusiasm for Japan most intelligently. Not until the 1890s were graphic artists of the stature of Toulouse-Lautrec and Bonnard able to achieve a convincing synthesis of East and West in print making.

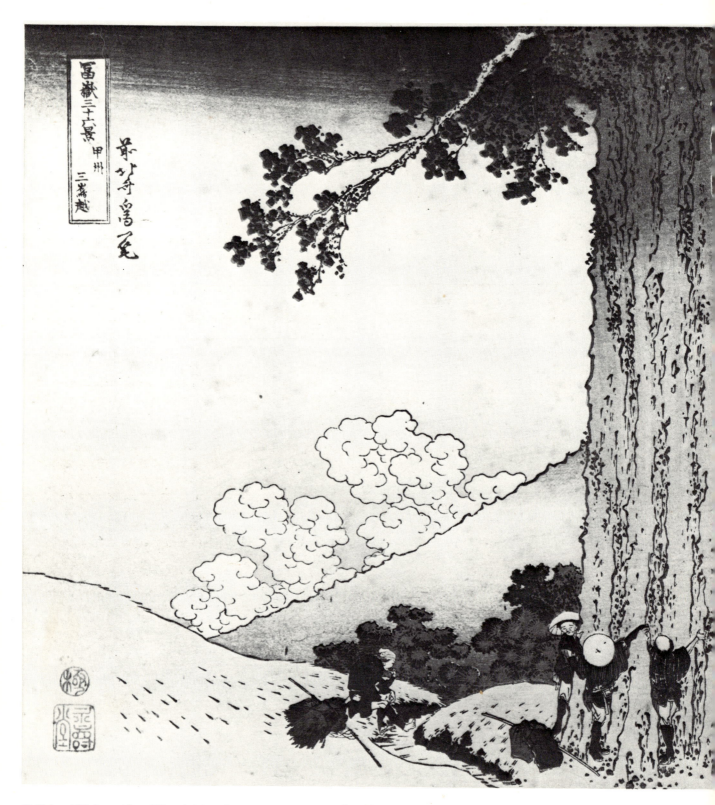

60 **Hokusai** 'Hodogaya' from *Thirty-six Views of Mount Fuji*. 26·0 × 38·7 (10¼ × 15¼), Victoria & Albert Museum, London

The Japanese Aesthetic

Before we embark upon a more detailed examination of the influence of Japanese prints on specific European painters, some general observations are required on kinds of composition and subject common in Japanese art. The major compositional devices which most appealed to Western artists were: the extreme vertical format; the polyptych; the truncation of major parts of the subject; the division of the whole composition, or parts of it, into large, simple, sometimes even regularly geometric areas; the use of the large, empty space; and the adoption of unusually high or low viewpoints to bring foreground and background towards the same plane.

The extreme vertical format derives originally from the *kakemono*, or tall scroll painting. Japanese houses were made of wood, plaster and paper. They contained little furniture, and only those objects which are essential for day to day living. It was usual for each wealthy home-owner to have a large, fire-proofed warehouse next door to the house in which most of the family's possessions were stored. In the sparse environment of the house itself, decoration was therefore kept to a minimum, and because of the paper-screened walls, framed pictures in the Western sense would have been out of place and impossible. Instead, *kakemono* were hung in rooms from small hooks (or stored in a tube when out of use). Many of them stretched from floor to ceiling, and on most of them the painted image was framed by a generous border of brocaded silk. *Kakemono* and the prints which adopted related formats therefore tended to be composed, and demanded to be read, from top to bottom, rather than from the edges towards the centre as is usual in Western composition.

Japanese artists were also interested in other, more irregular formats. Images were designed in the shape of fans (Plate 57). And many prints contained major parts of their motif within ovals and other unusual shapes suggested by the subject (see Plates 63 and 112).

Many prints were published as polyptychs. The parts

Far left
61 **Eisen** *Woman fastening her hair-ornament*, *c.*1830. 73·7 × 24·8 (29 × 9¾), Victoria & Albert Museum, London

Left
62 **Koryūsai** *Courtesan as Jurōjin* (the god of longevity). 66·6 × 11·7 (26¼ × 4⅝), Victoria & Albert Museum, London

Right
63 **Hokusai** 'Laughing Hannya' (a devil figure who murders children), from *The Ghosts*, *c.*1830. 25·8 × 18·3 (10 × 7¼), ex. Vever Collection, Sotheby's

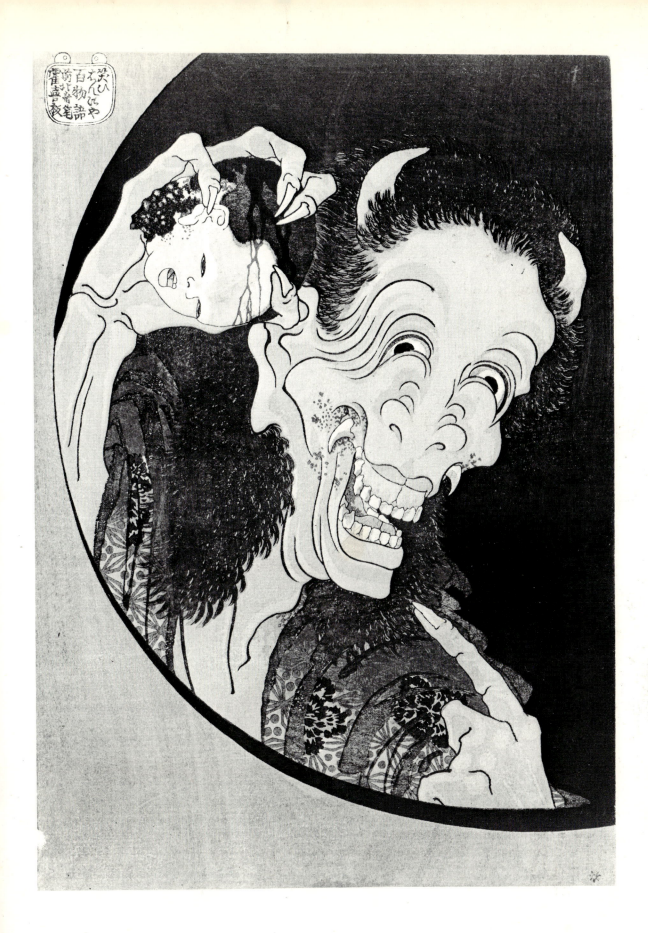

of these polyptychs, although composed in terms of the whole, nevertheless make sense on their own, even though important parts of the motif are often cut by the edges of each panel. The idea of composing in terms of panels, of extending a motif across a grid of regular verticals, comes from the *byōbu,* or folding screen. Screen painting was one of the most important activities for a Japanese painter and the screen itself one of the most important pieces of furniture in the Japanese household.

A Japanese house was not divided into rooms in the Western fashion. Sliding wood and paper screens, the *fusuma* and *shōji,* delimited certain areas, but eating, sitting and sleeping generally took place in the same room. The screen was therefore necessary for privacy, for marking the area between, for example, one bed and another. Rich families would have a hand-painted, richly decorated *byōbu;* the less well-off would make do with something less ostentatious or even plain. Many owners decorated these plain screens with woodblock prints.

The most striking result of having to split up the motif into regular vertical areas was the frequent division of major parts of the motif across several panels of the screen. This happened not only with screen paintings but also with prints, which, when seen individually, showed figures dramatically truncated. Many print artists introduced such truncations into single sheets, obviously aware of the interesting compositional possibilities this opened up. Thus, Hiroshige in his single-panel view of Fukagawa has introduced an eagle which dominates the scene but is cut off by the top of the print (Plate 17). In 'Ferry at Haneda', another print of the same series, the true subject of the work, a temple, is glimpsed in the middle distance in the triangle created by an oar, a rope and a man's shin (Plate 64). All that can be seen of the man, who dominates the foreground, are his wrists, hands and lower leg. The effect of these startling devices is powerful but difficult to define. When a figure or object is brought close to the viewer, and radically pruned by the edge of the print, the effect is to provide an internal, decorative, asymmetrical frame, and at the same time to help create an illusion of space. Like a flat in a stage-set, it creates a point of reference, somewhere between the spectator and the background,

64 **Hiroshige** 'Ferry at Haneda' from *One Hundred Views of Edo,* c. 1858. 35·3 × 24·0 (13$\frac{7}{8}$ × 9$\frac{1}{2}$), British Museum, London

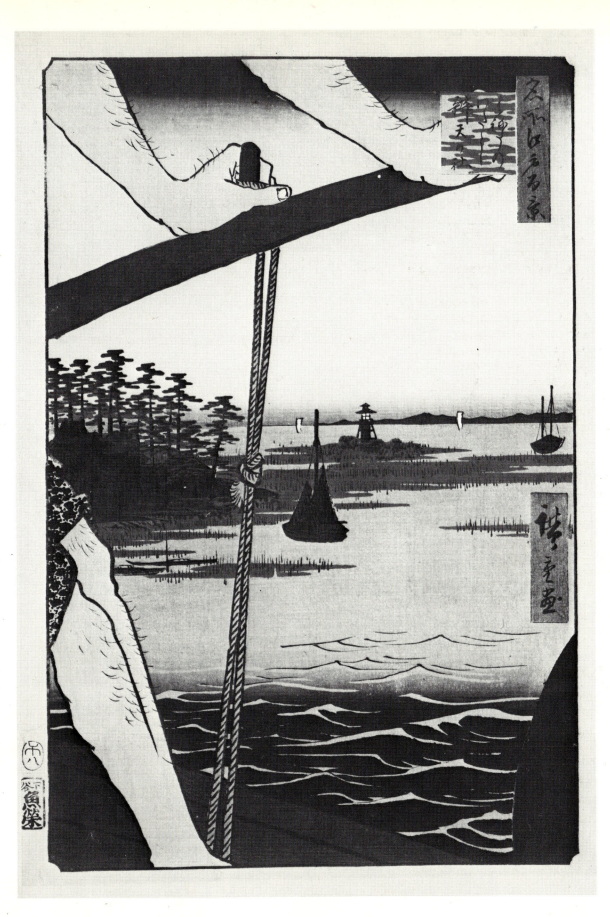

and allows the background to be more easily read in terms of space and distance. This effect is present in these prints by Hiroshige, and in other prints like them. Without the truncated eagle or boatman framing the landscape itself, the motif would have seriously lacked both depth and compositional interest.

It is common, in fact, for landscape prints to be organized in terms of two planes, the close and the distant. The foreground frequently consists of one or more tree-trunks, beyond which the rest of the landscape can be seen (Plate 60). Often a view is glimpsed between upright iris plants (Plate 65), or through the branches of a fruit tree (Plate 120). Mount Fujiyama in a famous print by Hokusai is seen in the distance across the trough of a great wave. When such a device is absent, others are brought into play. These can best be demonstrated by reference to works by Hiroshige.

In 'Landspar in Tango' (Plate 66), the narrow spit of land divides the print from top left to bottom right with a gentle curve. The spit, covered with trees, has sea on either side of it. The view adopted is from an impossibly high angle, which does not correspond to that from which the boats are seen. Spatial progression has been suggested symbolically, and a compositional scheme imposed on the print, by the narrow bands of dark tone which cut the picture in two. Dark bands used in this way appear in prints of all kinds. The eye moves from one dark band to the next, taking in the details on the way. It is a device which parallels the use of fixed-viewpoint perspective in Western painting, for both techniques persuade the eye to explore a composition in a pre-arranged way, so that it finally comes to rest on a particular point.

One of the most common Japanese compositional devices and one of the strangest to Western eyes is the use of large empty areas. Often, and especially in screen painting, an empty space will provide the focal point of the composition, or else it will be used to emphasize the detail of a smaller, painted area. The empty space was not regarded by the Japanese artist as a negative element. On the contrary, he saw it as a component that was just as active as the other elements in the composition. The ground and the contrasting figures imposed on it are held

Colour 9 **Kuniyoshi** *Enshi and the Hunter*, 34·2 × 24·5 (13½ × 9⅝), British Museum, London

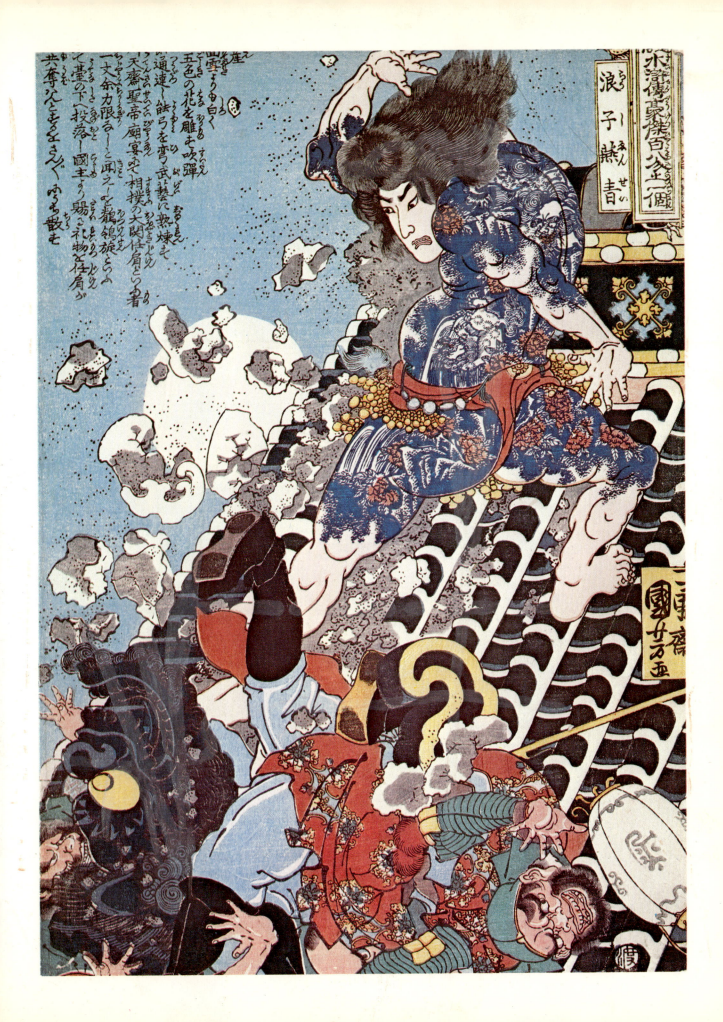

Right
66 Hiroshige 'Landspar in Tango' from *Famous Views from More Than Sixty Provinces*. 34·3 × 22·9 (13½ × 9), Victoria & Albert Museum, London

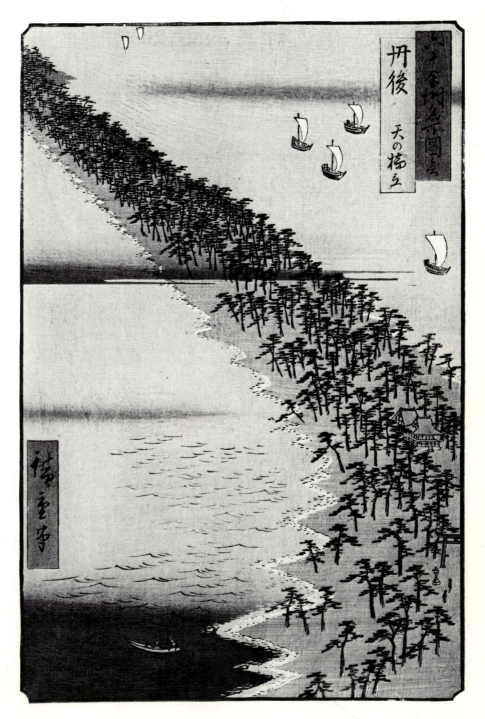

Left
65 Hiroshige 'Irises at Horikiri' from *One Hundred Views of Edo, c.*1857. 35·9 × 24·0 (14⅛ × 9½), British Museum, London

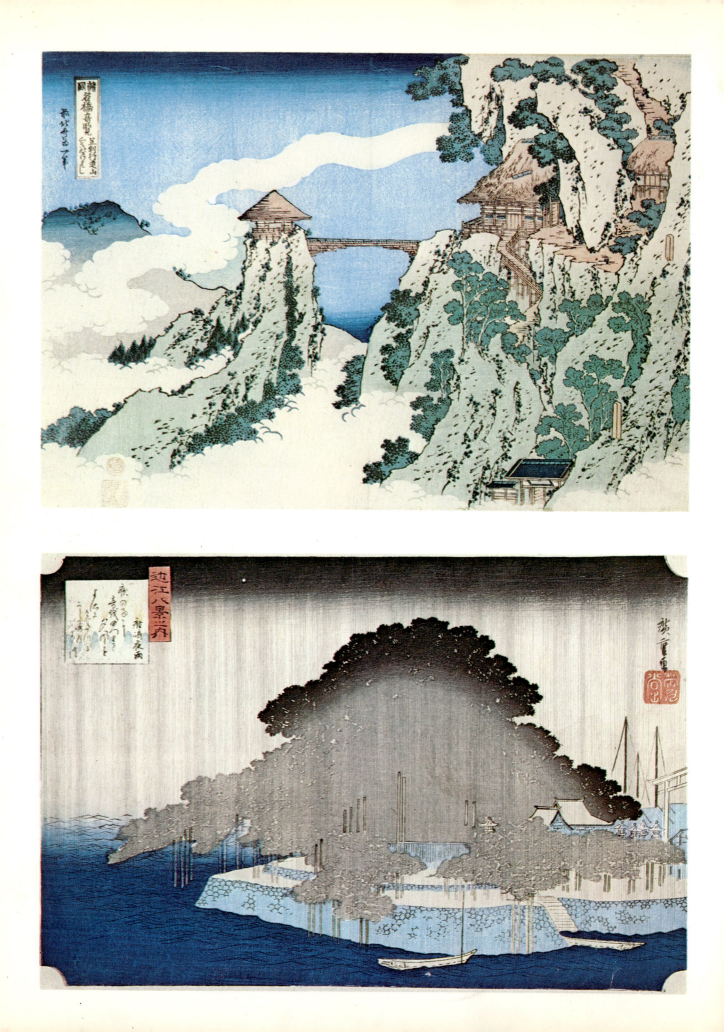

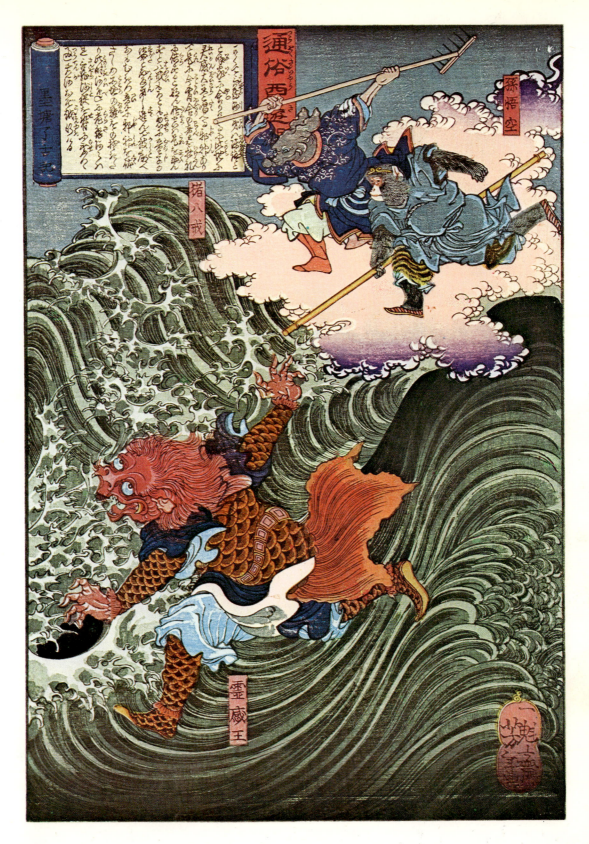

Above
Colour 12 **Yoshitoshi** A sheet from *Tsūzoku Saiyūki* (a story of a monk's journey to India). 35·6 × 25·4 (14 × 10), Victoria & Albert Museum, London

Opposite above
Colour 10 **Hokusai** 'Shimotsuke Province, the Bridge Hanging in the Clouds, Mount Gyōdō, Ashikaga' from *Unusual Views of Famous Bridges in the Provinces*, 1827–30. 25·1 × 38·1 (10⅛ × 15), Victoria & Albert Museum, London

Opposite below
Colour 11 **Hiroshige** 'Night rain at Karasaki', from *Eight Views of Lake Biwa*, 1830–5. 22·8 × 34·9 (9 × 13¾), Victoria & Albert Museum, London

67 **Shunsen** *Courtesan on parade, c.*1820. 76·2 × 25·3 (30 × 9¼), Victoria & Albert Museum, London

together in tension, and this is one of the most important Japanese compositional techniques. There is no such thing as background and foreground in the Western sense. Empty space and painted area are equally assertive, and play equally important roles in the creation of effects.

European artists were excited not only by these compositional devices, but also by some of the motifs regularly used in Japanese painting and print making. The most important of these was the kimono. Many of the prints of beautiful courtesans are not so much portraits of the women themselves, as of the kimonos they are wearing. The women have become mere tailor's dummies, showing off the richness of their dress (see Plate 67 and Colour Plates 4 and 5).

There are rituals associated with all traditional every-day activities in Japan, and the wearing of the kimono is no exception to this. The daughters of wealthy families have always attended classes on the correct way to dress, with special instruction on how to don the undergarment, how to put on the kimono itself, how to tie the *obi,* or belt, how to choose the right *tabi,* or socks, and finally how to walk and stand properly in a kimono. There are also certain poses and gestures associated with the wearing of the kimono, and these can be seen clearly in the prints. Although Western painters were excited by these gestures and by the shape of the kimono itself, they were especially stimulated by its patterning. The most extravagant and impressive kimonos are made from hand-woven, brocaded silk. Each is a unique object, and the fabric designer treats the silk for each one more like a painting than a piece of cloth: he will rarely use an all-over, regular, repetitive pattern, but instead will distribute the various elements of his design across the silk in an irregular, asymmetrical way. Some designs are naturalistic, some abstract, while some are combinations of both.

The kimono and other motifs from Japanese prints, together with such characteristic *nishiki-e* devices as the foreshortening of perspective, entered the repertoire of a number of French painters in the second half of the nineteenth century. The first French artist to modify his style under the influence of the prints was Manet.

Manet's use of Japanese motifs is not at all straightforward, however, but complex and problematic, and raises some important questions about the development of nineteenth-century French art.

Manet

All historians of modern art have had difficulties with Manet. How can the precocious proto-Impressionism of *Music at the Tuileries gardens* or the brilliant evocation of a single moment, *A bar at the Folies-Bergère* be reconciled with the compositional cunning and the esoteric references to other art found in paintings such as *Olympia, The balcony* or *Déjeuner sur l'herbe*? How can the various enthusiasms – for Caravaggio, for Velazquez, for Hals, for Japanese art – be teased out, weighed and compared? And how – perhaps the most difficult question of all – can Manet's attitude towards his subjects be discovered? Is his art Realist, Naturalist, or proto-Impressionist? Or was he, on the contrary, the first painter since the Renaissance to take up problems of form and colour for their own sake?

Manet's use of Japanese elements in his paintings may help to provide an answer to these questions. Unlike many of the Impressionists, he was not content to draw upon Japan merely as a source of exotic props, but he absorbed the Japanese aesthetic too, and allowed it to emerge, in a modified form, in his own art. The precise extent of his debt to Japan, however, is difficult to calculate, for the qualities associated with the *nishiki-e* – a flat-looking presentation of the subject, strong tonal contrasts, bright colour – are shared by some of the works of Caravaggio and Velazquez, which Manet also admired.

The complication is cleared up to some extent, however, by Manet's known enthusiasm for Japanese art, which was obvious to all his friends. Whistler described him as 'the head and front of Japonerie', and spoke of his interest in the 'Japanese theory of drawing'.[25] He was almost certainly introduced to Japanese art by his friend Bracquemond, who advised him on printing techniques. They were both members of the Société des Aquafortistes, founded in 1862 and led by Cadart, and under the auspices of this society Manet produced his first etchings. The Société published etchings monthly, and both Manet and Bracquemond contributed to the first publication. In

Colour 13 **Manet** *Nana*, 1877. 150·0 × 116·0 (59¼ × 45¾), Kunsthalle, Hamburg

Manet's etchings we find that mixture of Spanish and Oriental elements which so distinguishes his most characteristic painting. *Les gitanos* has the flattening out of space and strong contrast between black and white which became even more pronounced in later prints such as the etching *The cat and the flowers* and the lithographic poster *Rendezvous des Chats*.

Manet's drawings also show an interest in Japan, especially those brush studies of plants and flowers with which he occasionally decorated his correspondence (Plate 68). A pen and ink drawing of a standing Spanish figure (now in the Rouart Collection, Paris), probably executed in 1862, shares much with Japanese brush sketches which Manet must have seen, and his illustrations to Mallarmé's *L'Après-midi d'un faune* are adapted from Hokusai's *Manga*.

The painting usually singled out as the best example of Manet's interest in Japanese art is the portrait of Zola (Plate 69). Zola, the champion of Manet and of Impressionism, also collected and wrote about *ukiyo-e*. George Moore remembered the staircase of Zola's house in Médan hung with 'Japanese prints of furious fornications', which seemed to him 'a rather blatant announcement of Naturalism'.[26] Photographs of the writer's study show many Oriental objects. Zola, who wrote several articles about Manet's art (notably those of 1866 and 1867) once compared it with the 'strange elegance' and the 'magnificent strokes' of Japanese woodcuts. Like most contemporary critics, Zola considered Manet to be a Realist. The unity of tone, the simplified use of colour and the elegant line which the writer perceived in Manet's style were the expression of a concern for reality, free from all ulterior motives grounded in morality, philosophy and literature.

Manet shows Zola at a book-laden writing desk, with part of a *byōbu* in the manner of Kōrin on his left, and a Japanese ceramic serving as an ink-well. In a frame on the right are a print of a *sumō* wrestler by Kuniaki II with a copy of *The drinkers* by Velazquez and a photograph of the painter's own *Olympia*. Two peacock feathers have been stuck behind the frame. On the desk is a Japanese book. But these details are not so interesting, from the point of view of Manet's debt to

Above
68 **Manet** *Page of a letter with bindweed*. Watercolour on paper, Louvre (Photo: Musées Nationaux, Paris)

Opposite
69 **Manet** *Portrait of Zola*, 1867–8. 146·0 × 114·0 (57½ × 44⅞), Louvre (Photo: Musées Nationaux, Paris)

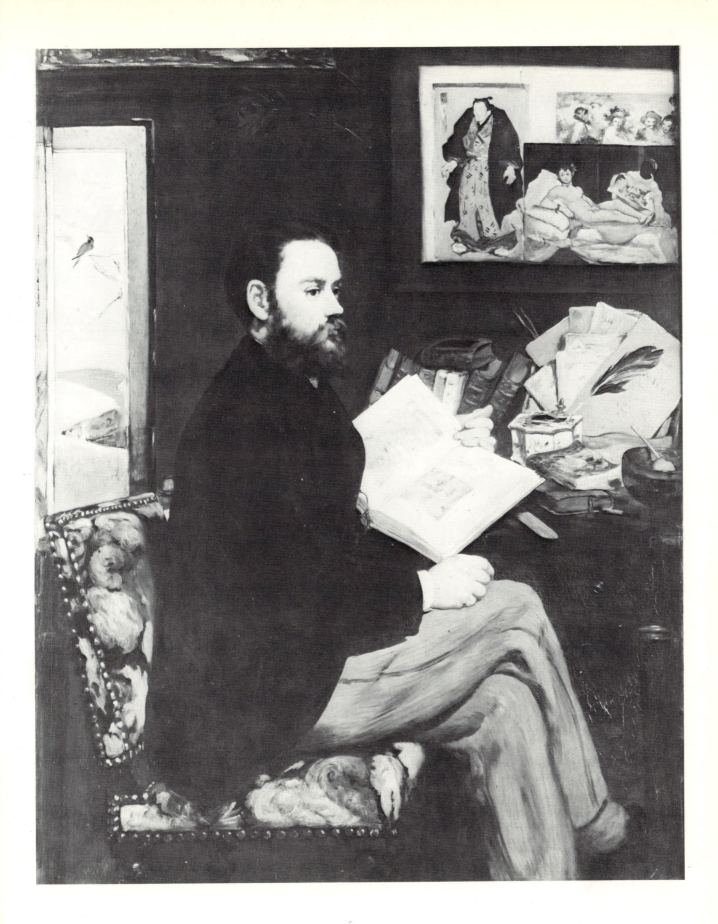

Japan, as the compositional devices he uses in the painting. Zola is shown in profile against a background of mostly dark tones. His jacket is so dark that the top half of his body is little more than a silhouette. The background is composed with the aid of three picture-frames, the edges of which are exactly parallel with the edges of the real canvas. These devices, supported by the generally subdued use of colour, virtually eliminate all sense of space and suppress the description of volume. Everything contributes to an essentially decorative treatment of the subject.

But the portrait of Zola was not the first painting of Manet's to come out of an enthusiasm for Japanese art, nor is it the most obvious example of its kind. The portrait of another critic with a love of things Japanese, Zacharie Astruc, was executed as early as 1863 (Plate 70). The writer sits directly facing the spectator, with a Japanese book among a casually arranged pile on a table at the left. On the book, just legible, is the dedication 'Au poète Z. Astruc son ami: Manet 1864'. Astruc's clothes are identical in tone with the background, so that his hands, face and collar stand out sharply. To the left above the books is a view through what looks like a doorway into a brightly lit room. This, at least, is what logic tells us it must be. For it looks less like a piece of reality than a hanging painting, a Western *kakemono* in fact, and this impression is reinforced by the patterned edge of the drape behind Astruc, which functions as the decorative border all *kakemono* have. Read as a hanging painting, the view past the sitter becomes as flat as everything else in the composition. It is a daring device.

Some scholars, most notably Sandblad,[27] have argued that an even earlier phase of *japonisme* can be discerned in Manet's work. Certainly *Music at the Tuileries gardens* (*c.* 1860) exhibits that sharply contrasted tonality and daring use of small areas of colour which in later works can be traced back partly to Japan. Nevertheless – and this is always the problem with Manet – it is difficult to decide how far the qualities of *Music at the Tuileries gardens* are Manet's own, how far, that is to say, he has painted in an individual style whose essential characteristics accidentally correspond to some of the features of Japanese art. The German art historian Julius Meier-

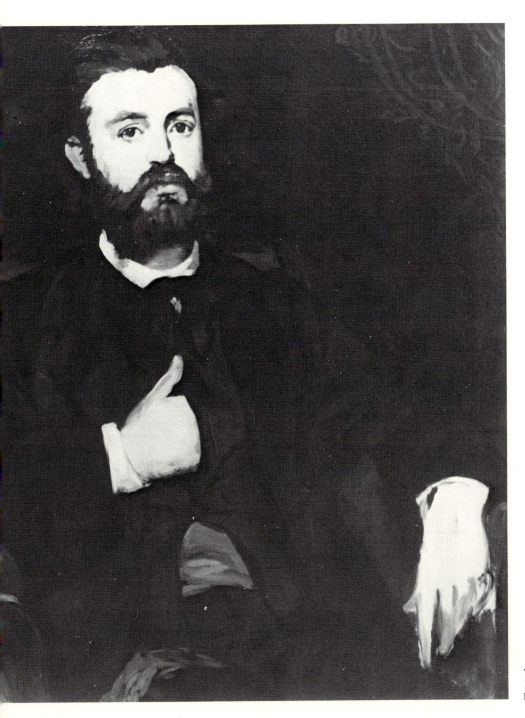

70 **Manet** *Portrait of Zacharie Astruc,*
1863. 90·0 × 116·0 (35½ × 45⅝),
Kunsthalle, Bremen

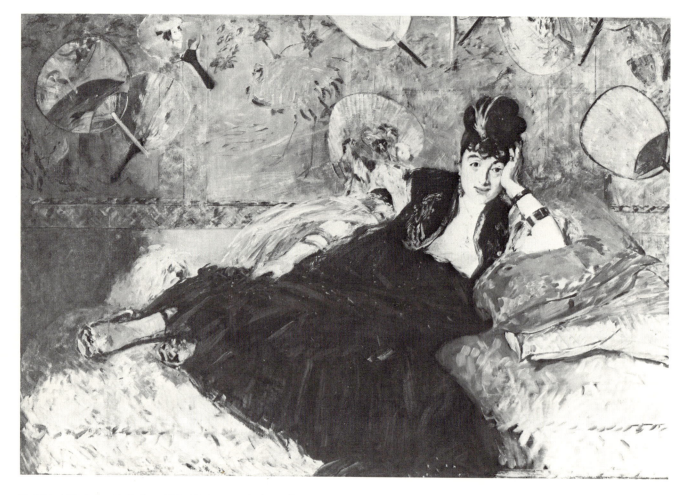

71 **Manet** *The lady with the fans*, 1873. 113·0 × 166·5 (44½ × 65½), Louvre (Photo: Musées Nationaux, Paris)

Graefe put his finger on the core of this difficult problem when he wrote: 'Manet liked Japanese things no less than he did the Spanish dancers. They enriched many of those ideas about colour which had been given him by the Spanish and by Hals.'[28]

The street singer of 1862 is a good example of Manet's treatment of Japanese elements: he employs them so subtly that they are scarcely recognizable as such, and they are already absorbed here by a strongly personal style. Nevertheless, Manet confers on Victorine Meurent, the model for this painting (as, later, for *Olympia*), a quality clearly reminiscent of some full-length *nishiki-e* of women. In spite of the obviously European dress, the model is shown as an unbroken silhouette, framed by louvred doors which look like a Japanese screen (Plate 72). Significantly, Manet's critics disliked this painting because of the apparent absence of half-tones.

Japanese objects appear not only in the *Zola,* but also in later works. In the portrait of Berthe Morisot known as *Repose* (1870 or 1871) Manet placed his signature in a corner of a large Japanese landscape triptych in the background. In *The lady with the fans* (1873), the fans are obviously Japanese (Plate 71). In *Le Chien Tama* (an ironic title, for *tama* is a standard Japanese name for cats) Manet depicts a lapdog and a doll brought back from Japan by his friend Cernuschi. In *Nana* (1877) part of the wall is covered with a large blue and green painting of a crane in the Japanese style (Colour Plate 13). Most striking here, however, is the seated gentleman in evening dress, who has been cut off by the frame. This obviously Japanese device was used most dramatically by Manet's friend Degas, and for similar reasons: it enables the picture to be used more easily in a decorative way, and transfers the major interest away from the conventional focal points towards the edges of the composition.

Paintings like *The fifer* (Plate 73), *The lady with the parrot, The balcony* (Colour Plate 14) and *Olympia* show that the example of Japanese prints has been absorbed, distilled and mixed with other elements to produce a mature and unique style. It is the style of a manipulator of reality, of a constructor of paintings who realizes that art and life are not the same. In these works Manet rejected the kind of modelling so important to Courbet in favour of bright coloured areas without shadows; and these areas are disposed in a very shallow space so that the fifer, for example, does not stand on firm ground so much as float or hover against a misty background. It is this combination of brightness and flatness which led contemporary critics to dismiss these paintings as nothing more than posters or playing cards, and which led Zola, in a striking oxymoron, to describe Manet's chief quality as a 'brutalité douce' – a sweet brutality.

In *The fifer, The lady with the parrot* and *The balcony* characteristics drawn from Japanese prints prints exist side by side with Spanish elements. The tonalities recall Velazquez, while the subject of *The balcony* obviously derives from Goya. Nevertheless, in the latter painting, the flatness forced on to the composition by the green railings is a Japanese feature, produced by a familiar Japanese device, and the louvred shutters parallel with the edge of the canvas, which first made their appearance in *The street singer* of 1862, add a decidedly Oriental touch here too. Roskill writes that *The balcony* is an example of *japonaiserie*, a painting given a faintly Oriental look by means of accessories like the fan and the folding shutters. But in fact the compositional role played by the shutters and the railings elevate the picture to the higher level of *japonisme*.

Manet's eclecticism, by which his indebtedness to Japan was combined with older, more respectable influences, is hinted at in Fantin-Latour's large canvas, *Manet's studio at les Batignolles*, painted in 1870, which is now in the Louvre. On the table to the left of the easel stands a classical statuette beside a black lacquer tray. Between them is a French pot done in imitation of a Japanese ceramic. This juxtaposition recalls (as Sandblad points out) the arrangement of objects in the picture-frame in the top right-hand corner of Manet's own portrait of Zola, which provides a more exact summary of his artistic borrowings. Here, the great European tradition is represented by Goya's print after Velazquez's *The drinkers*, Japan by the woodcut, while a synthesis of the two is supplied by a photograph of *Olympia*.

In a sense, it was the debt to Japan which was most crucial in Manet's work, for the qualities Manet chose to take from the woodcuts provide a clue to his

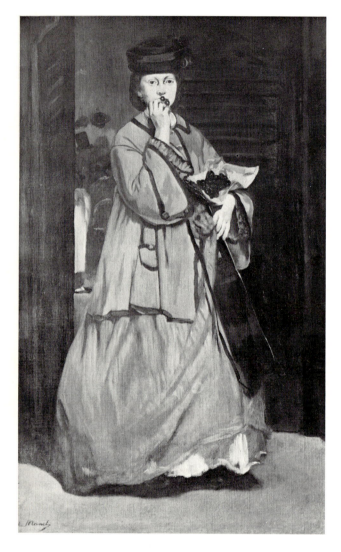

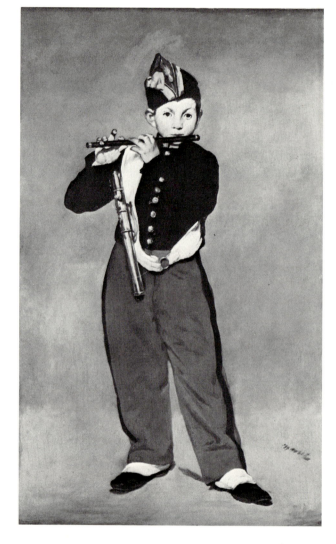

72 **Manet** *The street singer*, 1862. 175·0 × 109·0 (69 × 42⅞), Courtesy of the Museum of Fine Arts, Boston

73 **Manet** *The fifer*, 1866 160·0 × 97·0 (63 × 38¼), Louvre (Photo: Musées Nationaux, Paris)

artistic purpose in general. They reveal him to be neither
Realist nor Naturalist in any conventional sense. They
show him to be a painter who shifted the emphasis,
however slightly, from the traditional pre-eminent con-
cern with subject matter towards an appreciation for
form and colour for their own sake. To be aware of his
debt to Japanese art and to perceive his subtle use of it is
to see Manet in a clear light: not as the precursor of
Impressionism he is so often made out to be, but as a
painter who precociously anticipated the problems of the
Post-Impressionists. It is significant that they too – with
the major exception of Cézanne – relied heavily on
Japanese examples in the development of their styles.

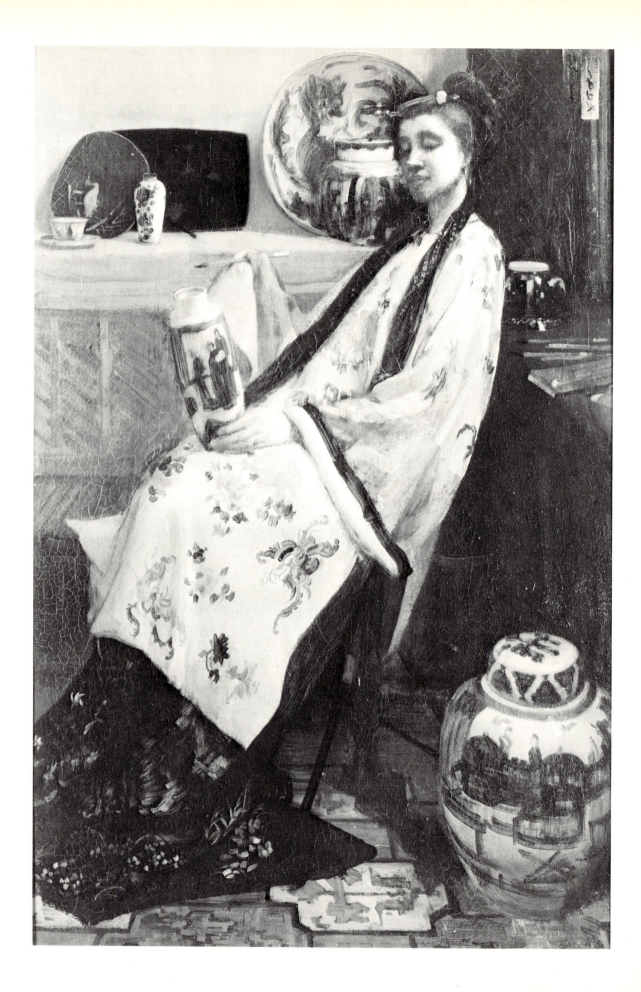

Whistler

In 1865 James McNeill Whistler posed in a kimono for Fantin-Latour's group portrait of some of his favourite contemporaries, *The toast* (now destroyed). The choice of dress was more than mere eccentricity. Fantin-Latour specifically asked for the kimono, for Whistler had already become known as the most ostentatious enthusiast of Japanese art in Paris at that time. Although Whistler is not universally regarded as one of the most important painters of the French avant-garde circle to which he belonged, he is still credited with a major role in the introduction of Japanese prints into Britain. Whistler, indeed, provides the strongest link between the advanced ideas of Paris and the more provincial and timid attitudes of London. He was an intimate of Courbet and of Manet, a painter distinguished in the salons and cafés, in high society and the *demi-monde* alike, by his witty and elegant manner. During the 1860s no other artist became so helplessly enamoured of the art and culture of Japan.

Whistler's passion for the Orient led initially to the introduction into his work of Japanese motifs, and later to a modification of his style in terms of compositional devices adapted from woodblock prints and screen and scroll paintings. In *The Large Lijzen of the six marks* (1864) only the accessories are Japanese (Plate 74). About a decade later, in his *Nocturne* of Battersea Bridge (Plate 81), and in the portraits of his mother and Thomas Carlyle (Plate 77), it is not the details that are Japanese but rather the very organization of the compositions themselves. The handling of the paint in the *Lange Lijzen* is conventional, whereas in the later works the thinly-washed, shimmering quality of the paint calls to mind the look of some Japanese paintings on silk, where the effects are not chromatic but entirely tonal. Indeed, Whistler's assimilation of Japanese elements is as complete as Manet's, even though his use of them is less adventurous.

Whistler was born in Massachusetts, educated in St

74 **Whistler** *Purple and rose: the Lange Lijzen of the six marks*, 1864. 91·0 × 56·0 (35⅞ × 22⅛), John G. Johnson Collection, Philadelphia Museum of Art

Petersburg and at West Point, and worked at first in Paris and then in London. The biographies of artists are seldom as cosmopolitan and varied as Whistler's, and the internationalism of his outlook certainly helped form his style. Having made up his mind in 1855 to become an artist, Whistler went immediately to Paris, knowing it to be the centre of the art world, and quickly identified himself with the avant-garde. Possibly because Whistler was a relatively minor figure in the extensive circles of Paris and preferred to move in, and to dominate, a smaller milieu, he began to take an interest in England. From 1859 on, Whistler was a more or less permanent resident in London, although he maintained close contact with artists in Paris and frequently paid extended visits there. Whistler's work straddles the Channel: no other artist played such a significant role in the artistic lives of both Paris and London during the 1860s and 1870s, and put London in such close touch with contemporary French ideas. And no other artist in London explained so thoroughly as Whistler did the significance of Oriental art.

During the early years of his life in London, Whistler became notorious for his ostentatious interest in things Oriental. He slept in a Chinese bed and became known in Chelsea as 'the Japanese artist', the description by which he was first pointed out to the London painter Walter Greaves. In a letter of 1864, Whistler's mother reported as follows:

> This artistic abode of my son is ornamented by a very rare collection of Japanese and Chinese. He considers the paintings upon them the finest specimens of art and his companions (artists), who resort here for an evening's relaxation occasionally get enthusiastic as they handle and examine the curious figures portrayed. . . . He has also a Japanese book of paintings, unique in their estimation. You will not wonder that Jemie's inspiration should be (under such influence) of the same cast.[29]

By the 'very rare collection of Japanese and Chinese', of course, Whistler's mother means porcelain, and it was for his porcelain collection that Whistler was best known in London. But the 'book of paintings' is clearly a book of prints, and the artist's passion for *nishiki-e* was as

strong as his enthusiasm for Oriental porcelain. He was enthusiastic about the delicately executed prints of Hiroshige, but differed from most of his friends in his almost equal love for the prints of the early periods.

Whistler was one of the first artists in Paris to take an interest in *nishiki-e*. Like so many of his friends, he was probably introduced to Japanese art by Félix Bracquemond, with whom he shared the printer Delâtre. While there is some controversy about whether Whistler's first important painting, *At the piano* (1859), already reflects an interest in Japanese art, there can be little doubt that Whistler was aware of the prints before this time. Not until 1864, however, is Japan celebrated unmistakably in Whistler's work, in a series of paintings. The most impressive and sumptuous of the series is *The golden screen* (Colour Plate 16). This shows a woman with vaguely Oriental features, dressed in a kimono, sitting on the floor looking at a number of landscape prints in the style of Hiroshige. Behind her is a splendid *byōbu*, the screen of the title. This painting, like the *Lange Lijzen*, parades a series of rich Oriental accessories before the spectator's gaze, accessories which are intended to impress for their own sake and to induce dreams of far-off places. The Lange Lijzen themselves (this is the Dutch name for the kind of pots, often decorated with six marks, that the girl in the picture is handling) are in fact from Whistler's own porcelain collection. But *The golden screen*, unlike the *Lange Lijzen*, also shows some interest in Japanese compositional principles. The screen itself, which extends the length of the painting, creates a regular pattern and formal rhythm across which the figure and the incidental details play, a device frequently employed by the designers of the polyptych *nishiki-e*.

The golden screen, however, remains primarily a costume painting, an example of *japonaiserie*, as does the *The little white girl: symphony in white no. 2*, painted in the same year (Plate 75). Here, the Oriental props (the porcelain, the fan, the azalea in the bottom right) are held together by a tight system of rectangles and by the sharp outline of the girl, who is seen in profile; but to attribute these features, and the truncation of parts of the figure on the left, entirely to Japanese prints, is to over-emphasize the point. Nevertheless, similar features, refined and purified,

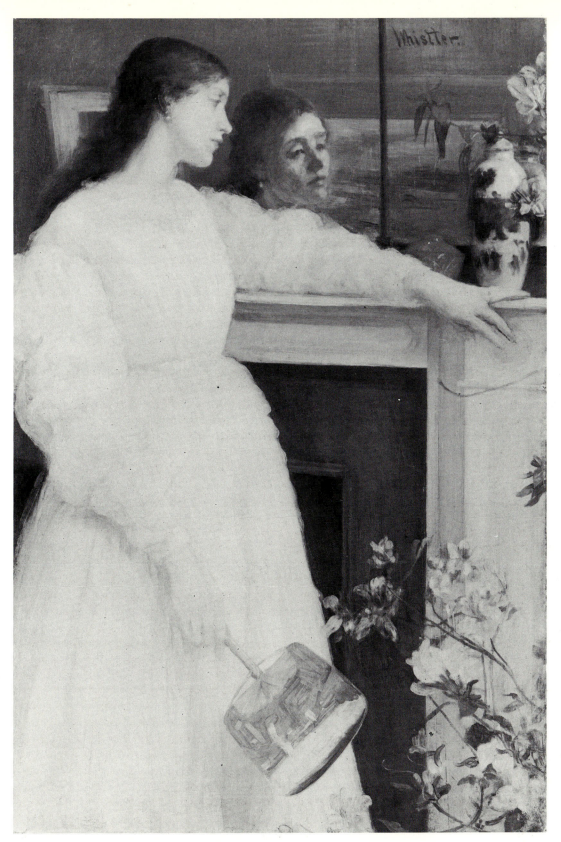

75 **Whistler** *Symphony in white no. 2: the little white girl*, 1864. 76·0 × 51·0 (29⅞ × 20¼), Tate Gallery, London

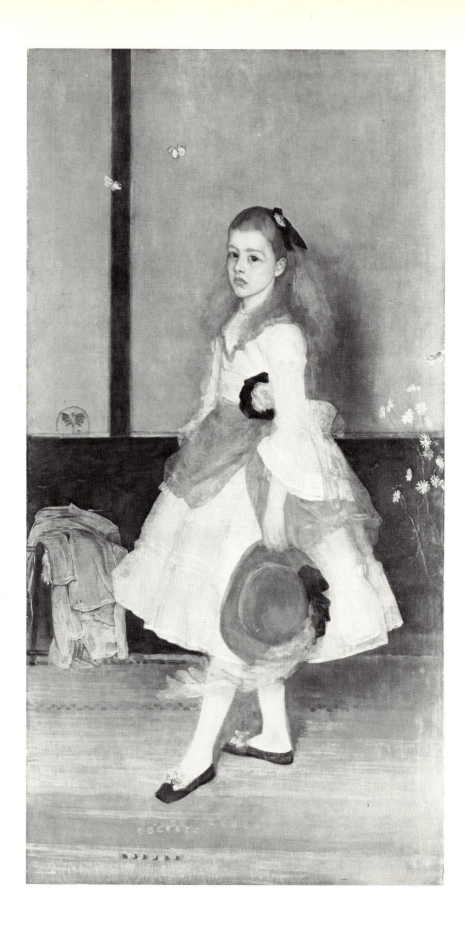

76 **Whistler** *Harmony in grey and green: Miss Cicely Alexander*, 1872–3. 218·4 × 99·0 (86 × 39), Tate Gallery, London

do give an unambiguously Japanese character to works such as the portraits of Miss Cicely Alexander (1872–3), of the artist's mother and of Thomas Carlyle. The format of the painting of Cicely Alexander illustrated here (Plate 76) is a pronounced vertical. The composition sub-divides the canvas into two vertical and two horizontal rectangles. The background looks like a Japanese reed blind. Although the treatment is by no means as radical as the earlier, and in some ways similar paintings of single figures by Manet (such as the *Zola* portrait), space is nevertheless restricted to a narrow relief, and the edge of the figure is clearly defined.

What James Laver describes as the 'moment when the decorator threatened to engulf the artist' – 'Backgrounds become flat, a love of the silhouette replaces the earlier interest in modelling learned from Courbet'[30] – was in fact the moment at which Whistler finally assimilated the rules of Japanese composition. The portrait of Carlyle (*Arrangement in grey and black no. 3*, 1872–3) is an especially fine example of this procedure (Plate 77). The compositional arrangement is similar to that of the Alexander portrait, but the simplification and elimination of details have been taken further. By 1874 only Manet and Degas had absorbed as completely as Whistler, and had put to better use than he had, the lessons of Japan-ese art.

One of the most obviously Japanese features of the portrait of Carlyle is the butterfly monogram signature which Whistler developed from his initials, J. M. W., and regularly used, either in a circle or rectangular cartouche, from 1870. This attractive device is clearly derived from the Japanese heraldic *mon* and from the *inkan* (or signature seals on prints and paintings). It can be compared with the monogram which Toulouse-Lautrec developed later in imitation of the *inkan* seals and which was used to similar ends – as a decorative element adding a final corrective compositional balance and emphasizing the flatness of the design (see Plate 134).

The rectangular version of the signature, within which the butterfly has been made especially like a Chinese Kanji character, appears in the *Nocturne in blue and silver: Cremorne lights* of 1872 (Plate 78). Although there is nothing Oriental about the format, this is one of the

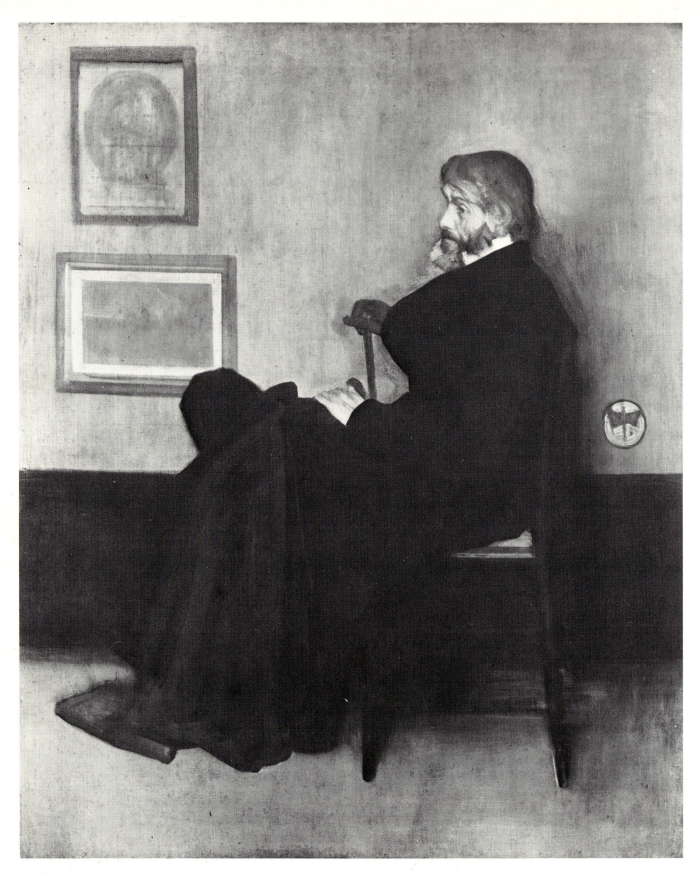

Above
77 **Whistler** *Arrangement in grey and black no. 3: Thomas Carlyle*, 1872–3. 171·0 × 143·5 (67½ × 56½), Glasgow Museum and Art Gallery
Opposite
Colour 14 **Manet** *The balcony*, 1868. 170·0 × 124·5 (67 × 48⅞), Louvre (Photo: Musées Nationaux, Paris)

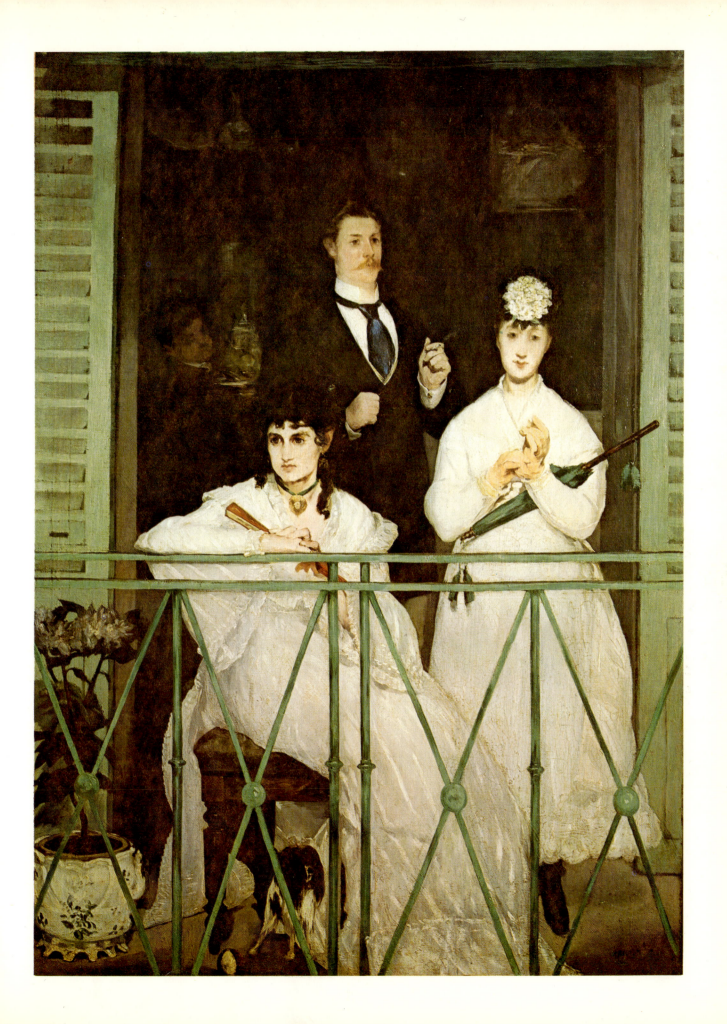

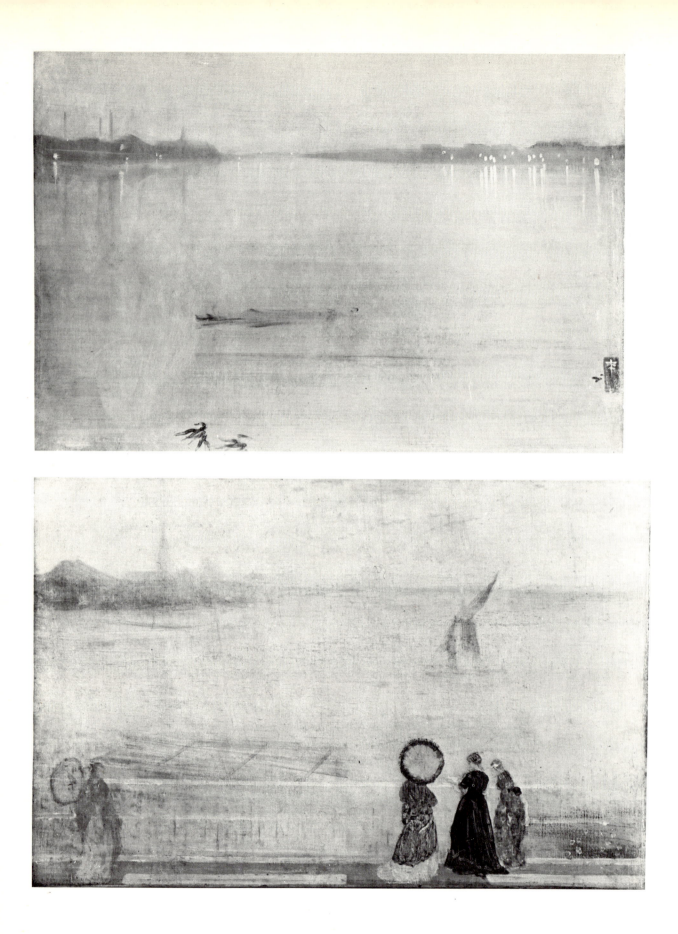

Opposite above
78 **Whistler** *Nocturne in blue and silver: Cremorne lights*, 1872.
49·0 × 74·0 (19½ × 29⅛), Tate Gallery, London

Opposite below
79 **Whistler** *Battersea Reach from Lindsay House*, c. 1871. 50·8 × 76·2
(20 × 30), University of Glasgow, Birnie Philip Bequest

Below
80 **Whistler** Study for *The balcony*. 62·8 × 50·0 (24¾ × 19¾), University
of Glasgow, Birnie Philip Bequest

most Japanese pictures Whistler ever painted. The monogram and the sparse leaves of bamboo-like reed at the bottom are all that intervenes between the spectator and the view across to the reflections of light on the water. As in a Japanese print, lines and smudges of darker tone lead the eye towards the horizon. But the shimmering paint quality, which is one of Whistler's characteristic features, owes nothing to woodblock prints. Whistler is not interested in flat areas of a single colour bounded by a sharp contour, which are a major feature of the prints and which intrigued so many of his contemporaries. Nor is he concerned with the bright, penetrating colours which made such an impact on a younger generation. Whistler is obsessed rather by atmosphere, by elusive effects of light and shadow, in a way which at times brings him close to Turner. The technique which this obsession demanded for its expression – the ability to suggest, evoke and allude – is the very antithesis of the qualities of *ukiyo-e* prints and co-exists uneasily with the tight, formal constructions Whistler employs elsewhere. This evocative style does have similarities, however, with Japanese painting on silk with water-based pigments and soft brushes.

Battersea Reach from Lindsay House (c. 1871) pictures a similar view across the water, punctuated by shapes of dark tone, which are here provided by a sailing barge (Plate 79). This picture, like the better-known *The balcony* (illustrated in a study in Plate 80), is furnished with a foreground: a group of women with their backs turned towards the spectator. They are very Japanese, and indeed there is no doubt that they are derived, like the group in *The balcony*, from a print, most probably from one of Utamaro's compositions showing some courtesans looking out across the harbour of Shinagawa.

Between 1872 and 1875 Whistler painted his *Nocturne in blue and gold: old Battersea Bridge* (Plate 81). Although bridges appear often (but treated very differently) in Whistler's drawings and etchings, they are not common in his paintings. This subject is especially Japanese: Hiroshige's Kyōbashi bridge (Plate 82) has been transferred to London. Although the tonal range is narrow, the bridge itself, obviously exaggerated and curved to look like a Japanese construction, stands out

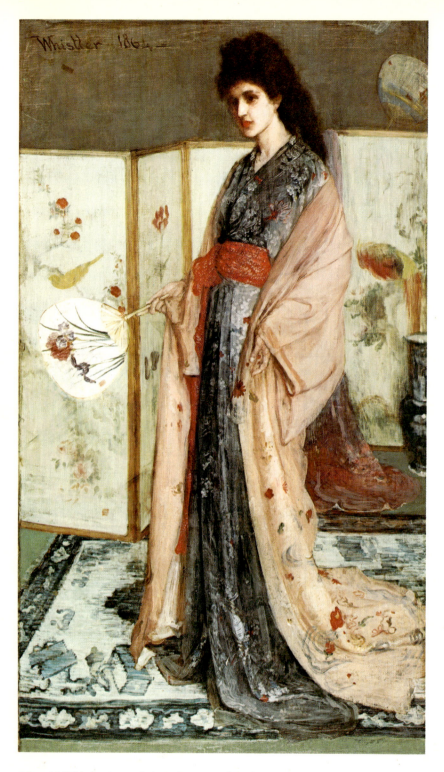

Colour 15 **Whistler** *Rose and silver: the Princess from the Land of Porcelain*, 1864. 199·2 × 114·8 ($78\frac{3}{4}$ × $45\frac{3}{4}$), Courtesy of the Smithsonian Institution, Freer Gallery of Art, Washington D.C.

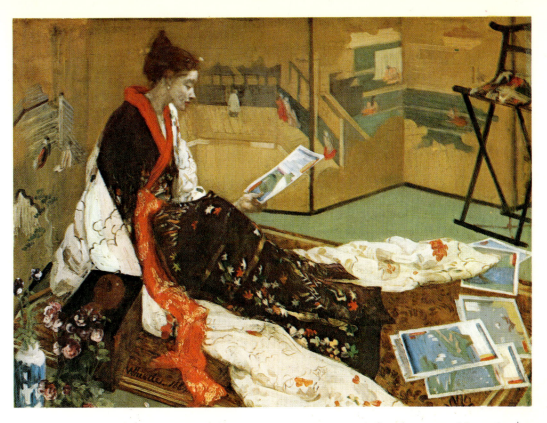

Colour 16 **Whistler** *Caprice in purple and gold: the golden screen*, 1864. 50·0 × 68·4 (19¾ × 27), Courtesy of the Smithsonian Institution, Freer Gallery of Art, Washington D.C.

Colour 17 **Degas** *Woman with chrysanthemums*, 1865. 73·6 × 92·7 (29 × 36½), The Metropolitan Museum of Art, Bequest of Mrs H. O. Havemeyer

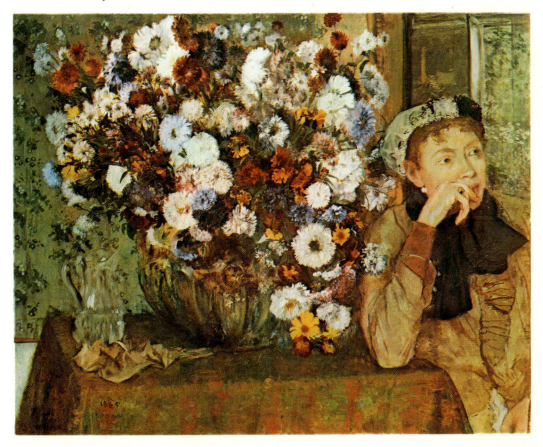

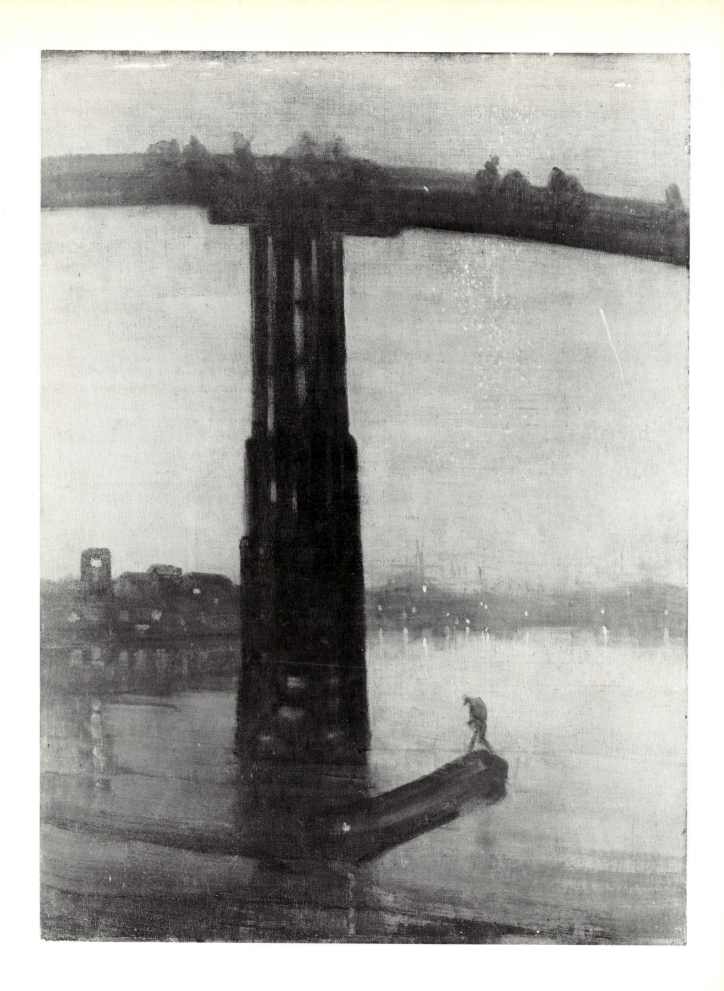

solidly against the background like a Chinese calligraphic character. Even the barge passing beneath the bridge has been made to look Japanese. There is a painting related to this, executed a little later, in the collection of Glasgow University (Plate 83). This features precisely the same motif, but on a two-piece screen, made and lacquered in the Japanese manner. The motif looks even more Japanese in this later version, partly of course because of the divided composition, but also because of the positioning of the moon and, even more so, the calligraphic quality of the brushstrokes.

In 1876–7 Whistler's enthusiasm for the Orient broke out in a way which was both sensational and very unsatisfactory for all concerned. One of Whistler's wealthiest London patrons was the shipping magnate F. R. Leyland, to whom he had been introduced by D. G. Rossetti and who had bought *The Princess from the Land of Porcelain,* one of Whistler's most Japanese confections (Colour Plate 15). When Leyland bought a house in Prince's Gate, London, he had the inside completely redesigned and redecorated by, among others, Norman Shaw. Whistler was asked to work on the staircase, for which he painted a number of panels imitating lacquer-work and decorated with rose and white flowers. The mish-mash of styles in the house was offensive to Whistler. The dining-room, where Whistler's own *Princess from the Land of Porcelain* was hanging, and which had been redesigned and refurbished by a man called Jeckyll, seemed especially to be a lapse of taste. It had been turned into a room from an Italian palace: the ceiling had been panelled and the walls covered with old Spanish leather, said to have once belonged to Catherine of Aragon. Whistler insisted on modifying the decoration, and after the Leylands had left London at the end of the season in 1876, he painted out the leather and covered it with peacocks and feathers, continuing his design across the window-shutters and doors. The effect was over-powering, not only because of the size of the individual elements in the design, but also because the colours were gold and lapis-lazuli blue. This was Whistler's Peacock Room (Plate 84).

No doubt the idea for the peacocks came from an Oriental painting (the connection between peacocks and

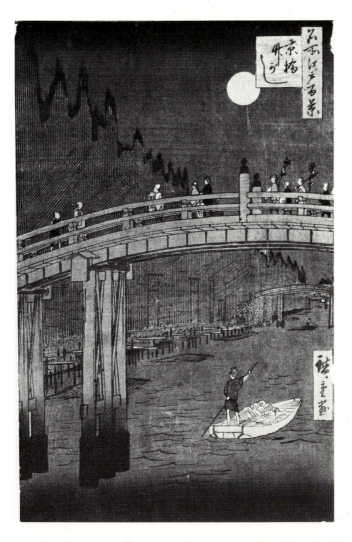

Above
82 **Hiroshige** 'Kyōbashi Bridge' from *One Hundred Views of Edo, c.*1857. 35·3 × 24·0 (13⅞ × 9½), British Museum, London

Opposite
81 **Whistler** *Nocturne in blue and gold: old Battersea Bridge, c.*1872–5. 66·2 × 50·2 (26⅛ × 19¾), Tate Gallery, London

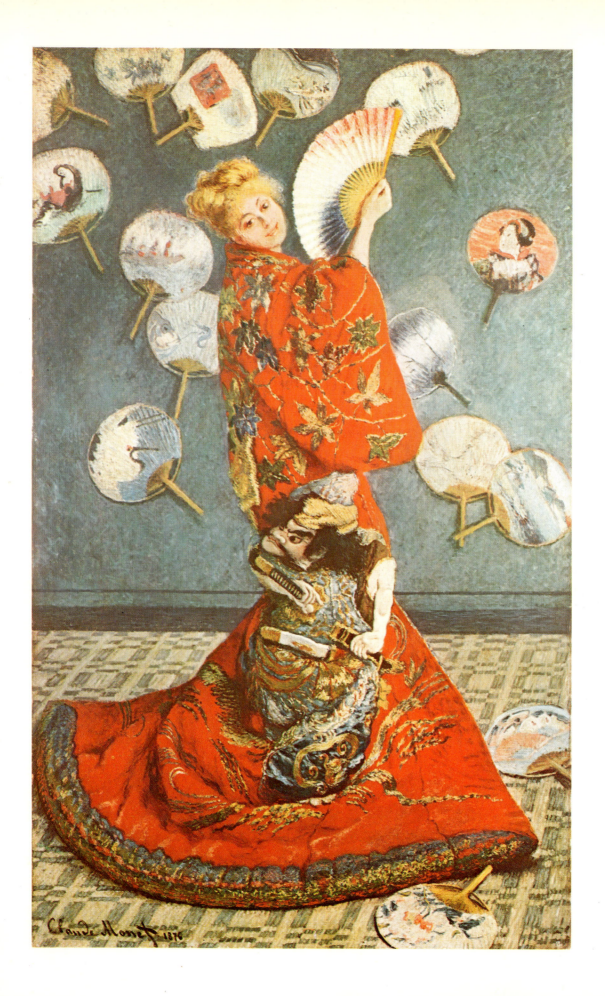

Above
83 **Whistler** *Painted screen*, 1872. Each panel 177·8 × 88·9 (70 × 35), University of Glasgow, Birnie Philip Bequest

Opposite
Colour 18 **Monet** *La Japonaise*, 1876. 231·0 × 142·0 (91 × 56), Courtesy of the Museum of Fine Arts, Boston

84 **Whistler** *The Peacock Room*, 1876–7. Courtesy of the Smithsonian Institution, Freer Gallery of Art, Washington D.C.

Oriental art had been made by Manet in his portrait of Zola). Certainly the inspiration for the design derived from the East, but the Peacock Room shows the negative side of Whistler's spiritual relationship with the Orient: it is all pompous show, horrifyingly unforgettable – a kind of Far Eastern *kitsch*. There is nothing of the reticence or precision of the Cicely Alexander portrait, qualities that are truly Oriental. And although these qualities do appear in a number of paintings by Whistler, they do not represent the whole artist. There was a New World brashness about him, a love of bravado, an inclination to pose, which ultimately prevented him from understanding Japanese art completely and from allowing its spirit to transform all his work. As Walter Sickert, the English Impressionist, said of Whistler and his love of Japan: 'Whistler, instead of the cobra who had swallowed the goat, was rather like a cobra who wondered whether he hadn't better become a goat.'[31]

One might argue, as Meier-Graefe did, that Whistler cannot be regarded in every sense as a modern artist, that he 'transformed inherited materials' and was 'not indispensable to the development of modern art'.[32] Certainly Whistler had no important disciples and his work, seen as a whole, is peripheral to the development of advanced painting, but in those few of his compositions where he most intelligently used elements learned from his study of Japanese art, Whistler seems authentically modern. Abstract or musical titles (*Arrangement in grey and black, Symphony in white*, etc.) confirm that Whistler was, at his most elevated, in pursuit of the same elusive quarry as Manet: an autonomous kind of painting which would concern itself with pure aesthetic problems before all else.

85 **Degas** *Beach scene*, 1876–7. 46·0 × 81·0 (18½ × 32½), National Gallery, London

Degas

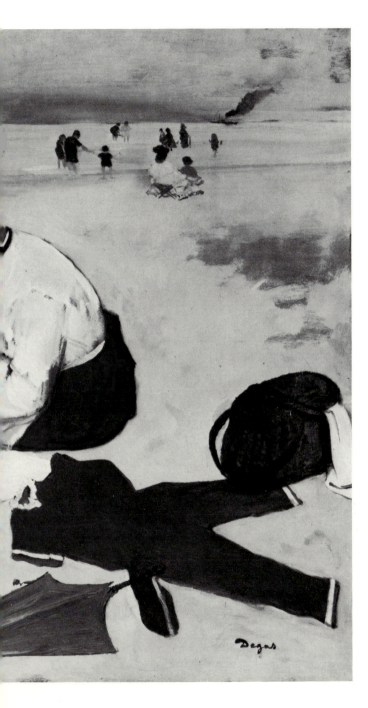

In his monograph on Degas, the great German art historian Julius Meier-Graefe recalls the following anecdote of his friend Jäger, a collector of *nishiki-e:*

> At the beginning of the 1890s Jäger grew determined that Degas would receive him. This was not easy, especially for a stranger. Jäger made a bet that he would not only talk to Degas, but would also be permitted to inspect the painter's private rooms that were richly endowed with artistic treasures. Jäger won his bet. He was received by Degas and was entertained in the painter's 'holy of holies'! One day Jäger revealed to me how he had done it. He had taken two portfolios with him. In one were a few drawings by Ingres, which he had borrowed; in the other a dozen of his best Japanese prints. The Ingres drawings had got him into the living quarters on the rue Victor Massé; the prints into the studio itself.[33]

Ingres and Japanese prints: these were possibly the two most important influences on Degas, whose art manages to create the illusion of spontaneity and direct observation by means of artifice and extreme deliberation. His boundless admiration for Ingres is well documented, both in his work and his writing, yet there is only one reference to Japanese prints in his letters, and that is sarcastic. He seems to have deprecated the inability of Europeans to discriminate between Japanese art of true quality and worthless *kitsch,* and to have regretted the uncritical adoption by some French painters of Japanese subject matter. In a letter to his friend Bartholomé (dated 29 April 1890), he lamented the influence of the Japanese exhibition at the Beaux-Arts: 'Alas! Alas! The fashion is everywhere.'[34] Yet he clearly believed that a judicious use of compositional devices drawn from Japanese prints would help to refine his style, and that the world of the *ukiyo-e* was similar to that which he wished his own paintings to mirror.

Degas, yet another of Bracquemond's intimates, was one of that small group of artists who 'discovered'

Hokusai, and Japanese prints in general, during the early 1860s, soon after he had returned from Italy in April 1859 and had become acquainted with Manet. Degas was a reserved, aloof person who disliked the kind of social life, centred on cafés, that was preferred by almost all the artists with whom he later exhibited as an Impressionist. He understood Manet, however, a man of similar social background, and admired his work. The admiration was mutual, although almost nothing of it can be perceived in the work of either artist. Manet was a colourist; Degas was concerned with the quality of his line. Manet frequently had difficulty with his compositions; Degas' pictorial structures are as tight as Chinese boxes. What the styles of both do share, however, is a reliance on both Japanese and distinguished European models, and the mixture in Degas of Japan, Ingres and Italy is as subtle as Manet's synthesis of Japan, Flanders and Spain.

Japanese prints confirmed for Degas, as they did for Manet, the direction in which he was already travelling. Soon after he returned from Italy, Degas completed the large portrait of his relatives, *The Bellelli family* (Plate 86). The influence of Ingres is very noticeable here, in the sober colour scheme and the deliberation with which every detail has been placed in the composition. The head of the household, however, is seen in a way which contrasts sharply with the stiff formality of his wife and daughters. He is caught almost in motion and his blurred face reveals almost nothing about his character or even his looks. Already, in this youthful work, Degas has combined that rigidity of structure and that seeming casualness of observation which are everywhere apparent in his later paintings.

The earliest example in Degas' work of compositional devices arguably borrowed from Japan is the portrait of Madame Hertel, entitled *Woman with chrysanthemums,* of 1865 (Colour Plate 17). The ostensible subject stares absentmindedly out of the picture to the right, while the scene is dominated by a huge vase of flowers on a table, viewed from a high angle. Here are at least two of those traits which can be associated with Japanese art: the decentralization of the most important parts of the subject (this is the first instance of Degas' use of asymmetrical composition) and the adoption of unusual points of view

in order to see objects as interesting flat shapes with clearly defined edges.

Another Japanese trait, an abrupt transition from foreground to middleground or background, appears in a later composition, the *Beach scene* of 1876–7 (Plate 85). Here the treatment of space is uncertain, suggesting, perhaps, a throwback to the less confident Degas of the 1860s. The two foreground figures, surrounded by their paraphernalia, seem to float in mid-air, existing in a space quite different from that occupied by the relatively tiny people in the sea and on the shoreline.

The portrait of Jacques Tissot of 1868 (Plate 87) provides an instructive comparison with Manet's painting of Zola, executed in the same year. The conception in each case is very similar: a personal friend of the artist, surrounded by objects which are dear to the friend, to his portraitist or to both, and which serve as signs for their personalities and interests. Both Zola and Tissot were interested in *nishiki-e,* and Tissot produced several pictures and prints of Japanese subjects before leaving for England and becoming one of the best-known anecdotal painters of High Victorian society. Degas points to Tissot's interest in things Japanese by including at the top of his portrait the bottom of one of Tissot's own 'Japanese' pictures. But the similarities between the *Tissot* and the *Zola* end there. Manet's picture is Japanese in composition as well as detail. The Degas is more conventional, more concerned with the portrayal of personality in the traditional Western sense. He had still not completely absorbed the lessons of the Japanese aesthetic.

The slightly later portraits of Madame Camus (1870) and of Hortense Valpinçon (1871–2) are of interest in this context for the inclusion in them of some modest pieces of Japanese decoration. Madame Camus holds a plain, white Japanese fan; while the young Mlle Valpinçon leans on a table covered with a piece of Oriental fabric (Plate 88). The use of such accessories is extremely rare in Degas' work. The painter did, however, continue to experiment with Japanese compositional devices, and soon employed them with a magisterial certainty of their effect. *Musicians in the orchestra* (1872) is but one of a series of identical subjects and similar

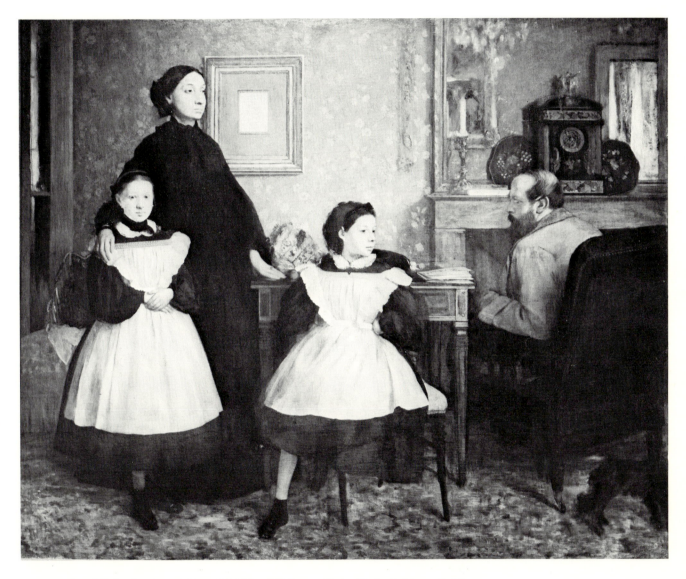

86 **Degas** *The Bellelli family*, 1860–2. 200·0 × 253·0 (79 × 99½), Louvre (Photo: Musées Nationaux, Paris)

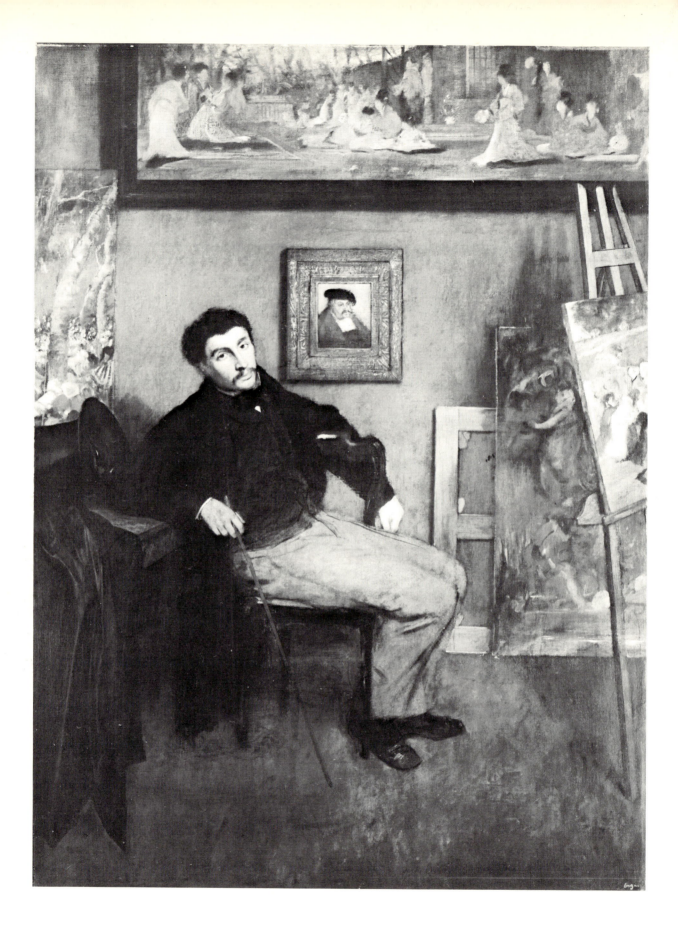

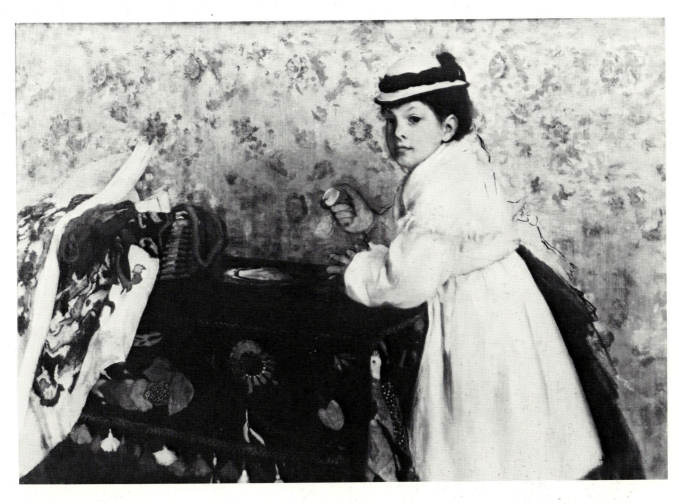

Above
88 **Degas** *The young Mlle Valpinçon*, 1871–2. 73·0 × 110·0 (29⅞ × 43⅝), The Minneapolis Institute of Arts

Opposite
87 **Degas** *Portrait of Jacques Joseph Tissot*, 1868. 151·0 × 112·0 (59⅝ × 44), The Metropolitan Museum of Art, Rogers Fund

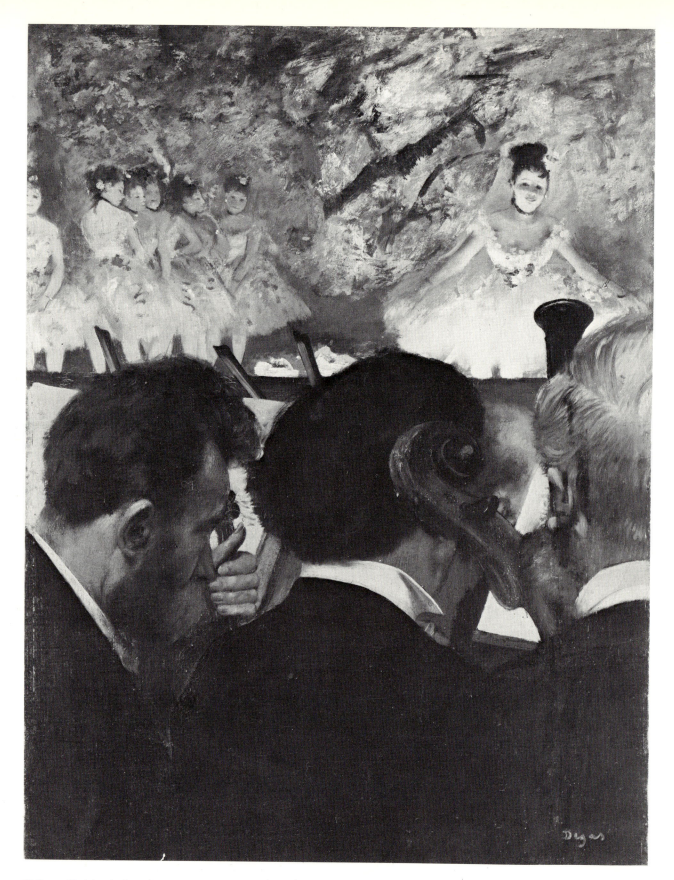

89 **Degas** *Musicians in the orchestra*, 1872. 69·0 × 49·0 (27⅛ × 19¼), Städelsches Kunstinstitut, Frankfurt

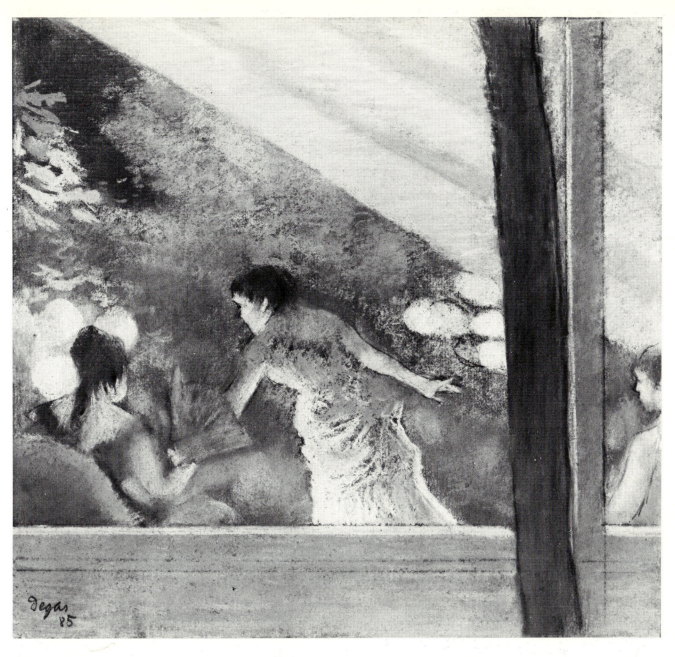

90 **Degas** *Café concert*, 1885. Pastel, 26·0 × 29·0 (10¼ × 11⅜), Louvre (Photo: Musées Nationaux, Paris)

compositions: dancers on a brightly-lit stage, seen across the heads of an orchestra playing in the pit (Plate 89). The composition consists of three horizontal·bands, parallel to the picture plane. Part of the double-bass player at the right of this picture has been cut off by the frame, and Degas' frequent use of truncation, much of it more radical than it is here, is another stylistic device which can be ascribed to the influence of Japan.

In *Café concert* (Plate 90), painted thirteen years later, devices endebted to the *ukiyo-e* aesthetic are no less

evident. The compositional framework supplied by a low horizontal, a strong vertical to the right-hand side and the diagonal of the awning; the feeling of intimacy created by the position of the spectator, who is outside looking in; and the division of the canvas into two unequal parts by the tree-trunk and wooden pillar – all these features are characteristic of many Japanese prints depicting the world of sophisticated entertainment. The extreme flattening of the motif and the truncation of the figure to the extreme right are also suggestive of *nishiki-e*.

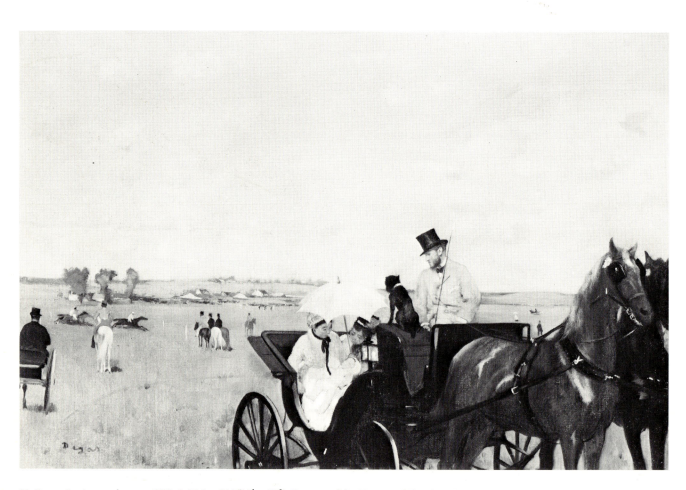

91 **Degas** *Carriage at the races*, 1871–2. 36·0 × 55·0 (14¼ × 21¾), Courtesy of the Museum of Fine Arts, Boston

Radical truncation of a major part of the motif is especially obvious too in *Carriage at the races* (1871–2), in which the major part of the composition consists of more or less empty spaces (Plate 91). In the middle distance the race itself is in progress and the horses are shown running in the old spread-eagled way which painters used until photography taught them how horses really move. In another, almost contemporary painting of a similar subject, however – *At the race-course* (1869–72) – the composition is based on a triangle created by the space between the horses, and the bolting horse at the apex of this triangle is moving its legs in a way that is completely convincing and true to nature (Plate 93). It is possible that Degas looked at photographs before painting this animal, but it is much more likely that the source is Volume VI of Hokusai's *Manga*. In this, a double-page spread is devoted to tiny, extremely lively action-studies of riders on horse-back. Without benefit of photography, Hokusai has captured horses in several stages of motion, one of which is extremely close to that of the bolting horse in the Degas (Plate 92).

Other cases of identical poses in Hokusai and Degas have been pointed out by Taichirō Kobayashi in his excellent book *Hokusai to Dega* (Osaka 1946), which is

Right
92 Hokusai Page 12 from Vol. VI of the *Manga* (detail). Cambridge
University Library

Below
93 Degas *At the racecourse*, 1869–72. 46·0 × 61·0 (18⅛ × 24¼), Louvre
(Photo: Musées Nationaux, Paris)

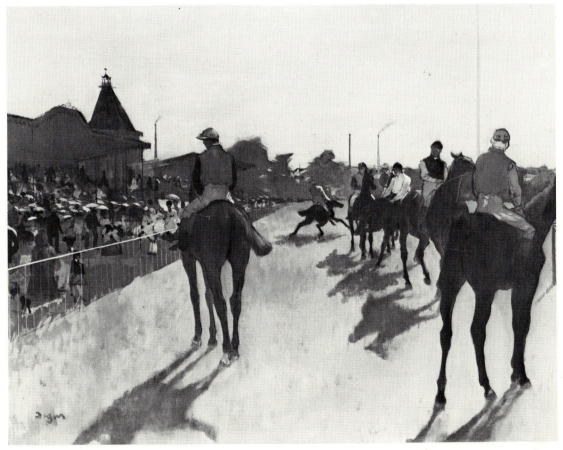

94 **Hokusai** Page 7 from Vol. III of the *Manga*. 18·0 × 13·0 (7 × 5),
Cambridge University Library

Below
95 **Degas** *Before the ballet*, 1888. 40·0 × 89·0 (15¾ × 35), National Gallery
of Art, Washington D.C.

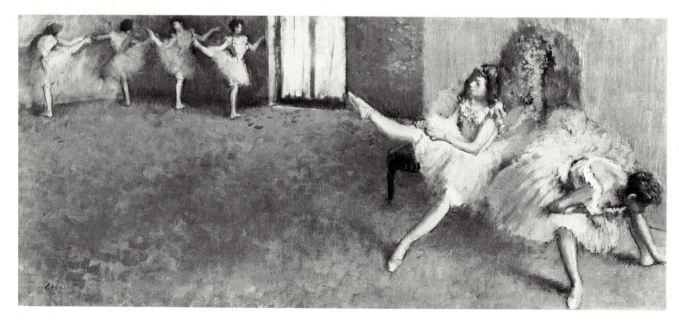

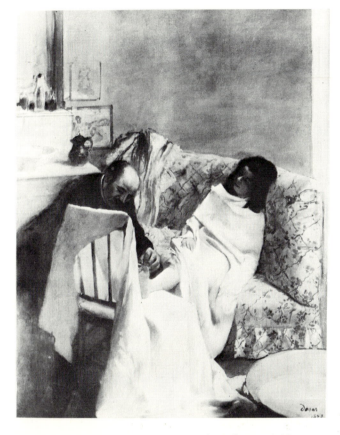

96 **Degas** *The pedicure*, 1873. 61·0 × 46·0 (24¼ × 18⅛), Louvre (Photo: Musées Nationaux, Paris)

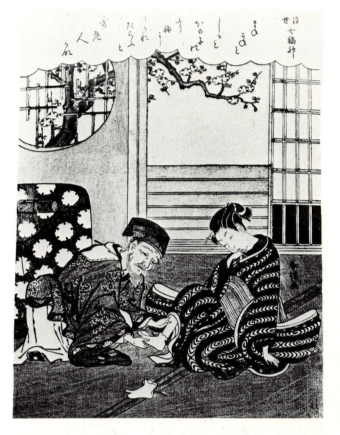

97 **Harunobu** 'Jurōjin' (the god of longevity) from *The Seven Gods of Fortune*, c.1769. 27·9 × 20·3 (11 × 8), Art Institute of Chicago, Clarence Buckingham Collection

unfortunately not available in English. Typical of these resemblances is that between Degas' *Before the ballet* (Plate 95) and the figures from the *Manga* illustrated in Plate 94. Illustrated also are Degas' *The pedicure* and the print by Harunobu on which it was almost certainly based (Plates 96 and 97). Such identifications must modify the conventional view of Degas as an artist who combined direct, sharp observation of the fleeting attitude with a highly developed sense of composition. Occasionally, even those poses for which preliminary drawings exist and which seem to have been so freshly, so precisely observed, turn out to have been lifted from

another source; or at least such poses seem to have appealed to Degas because they reminded him of something he had seen in a print or illustrated book.

This is certainly true of the series of paintings, drawings and prints of Mary Cassatt in the Louvre, which Degas produced around 1880 (see Plate 98). The sheer number of versions of this image – the elegant American painter with large hat and furled parasol seen from the rear – testifies to its importance for Degas. The similarity between Cassatt's black silhouette, in all versions, and that of the woman with rearing horse from the *Manga* (Plate 99) cannot be fortuitous.

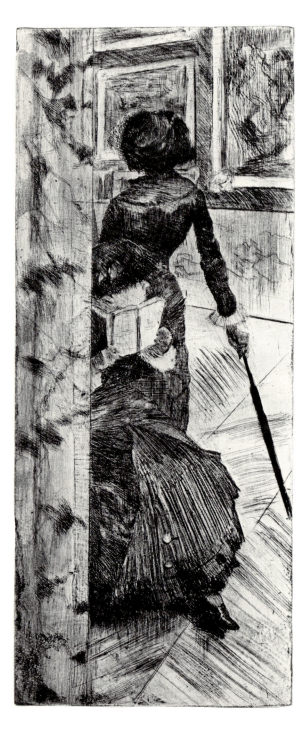

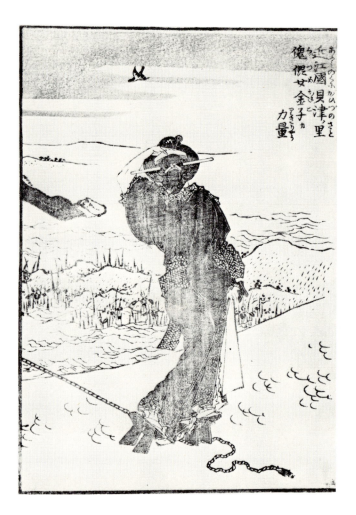

Above
99 Hokusai Page 5 from Vol. IX of the *Manga*. To the left of the picture is the hoof of a rearing horse. 18·0 × 13·0 (7 × 5), Cambridge University Library

Left
98 Degas *At the Louvre: the painter Mary Cassatt*, 1879–80. Etching and aquatint, 30·1 × 12·5 (11⅞ × 5), The Cleveland Museum of Art, gift of Leonard C. Hanna Jr

The precise nature and importance of the influence of Japanese prints is difficult enough to weigh in the case of Manet; it is even more difficult with Degas. To what extent were the casual effects produced accidentally by the new art of photography responsible for Degas' interest in key-hole views and unusual croppings of major parts of the motif? The photographer's necessary concern with the fleeting scene, observed apparently in passing, is obviously much closer to Degas' interest in the unguarded moment than anything he might have found in Hokusai or Harunobu. The problem is pinpointed by a picture such as the portrait of Carlo Pellegrini (1876–7), which has several factors in common with Japanese prints (Plate 100). The subject's body, caught in a characteristic, vital pose, is a solid shape of almost uniform dark tone, the contour of which has been made lively and interesting. Pellegrini, what is more, has been seen from a high angle which brings up the ground on which he stands close to the picture-plane. There is clearly much of Japan here, but it has been absorbed and distilled by so European a sensibility that it is impossible to measure precisely the strength of the ingredients.

The situation is clearer when we come to the subject matter. Degas, perhaps even more than Manet, broke new ground by portraying a world utterly foreign to that depicted by the Academic painters. Cabanel, Bouguereau, Gérôme, Meissonier and the other regular exhibitors at the Salon variously addressed themselves to morally edifying episodes from Roman history, Greek myths with erotic possibilities, touching morality plays in modern dress or martial tableaux exhibiting the manly virtues. In comparison with them, Manet seemed to many critics to be a muck-raker and Degas a gutter-snipe. To bring Manet and Degas together in this way seemed at the time to involve no distortion of their aims: too concerned with stylistic development at the expense of content, modern commentators tend to forget that the battle between the avant-garde and the Academy was as much about subject matter as technique, and that the enormous stylistic differences between those who rejected Academic values appeared negligible when the similarities between their preferred subjects were considered.

Even a critic as catholic and perceptive as Huysmans

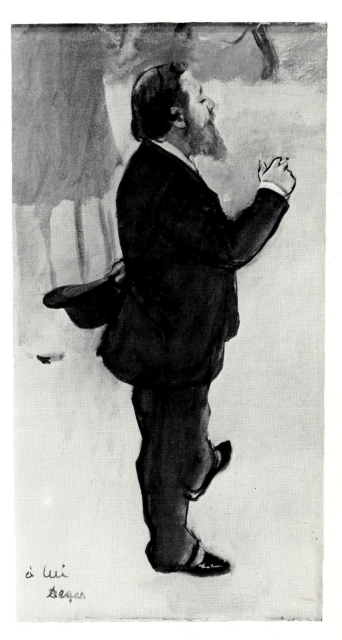

100 **Degas** *Carlo Pellegrini*, 1876–7, 61·0 × 33·0 (24⅛ × 13⅛), Tate Gallery, London

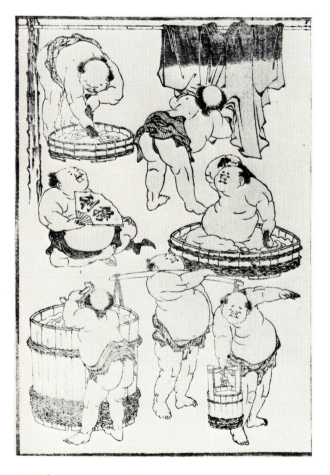

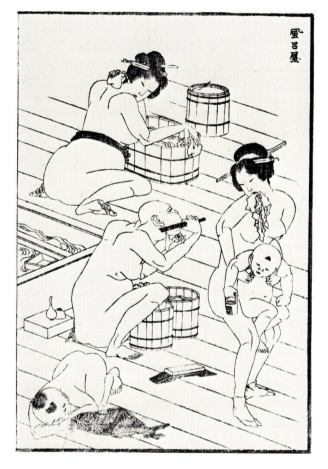

101 **Hokusai** Page 11 from Vol. IX of the *Manga*. 18·0 × 13·0 (7 × 5), Cambridge University Library

102 **Hokusai** Page 27 from Vol. XII of the *Manga*. The central figure is a nun shaving. 18·0 × 13·0 (7 × 5), Cambridge University Library

was disturbed by Degas' subject matter: 'He threw the greatest possible insult in the face of his own century by debasing womankind . . . by showing them in the bathtub . . . and at their most intimate toilet.'[35] Degas, who prized natural, casually intimate themes above all others, remained true to his principles, however. He felt that he no longer needed to call a woman bathing a *Suzanna* in order to justify his choice of subject.

Intimate scenes of men shaving, women ironing or having their hair done and their toe-nails clipped, or perching themselves over a bidet, were subjects which were anathema to the Olympian Academicians and their fastidious apologists. But several volumes of the *Manga,* all of them obviously well-known to Degas, are concerned almost entirely with just these kinds of subject, and they are shown with humour and imagination as well as with great honesty (Plates 101 and 102).

In the popular imagination Degas is the painter of the ballet and the racecourse, but he was equally the observer of the bathroom as well as the artist of the milliner's shop and laundry. The Goncourts at this time were demanding that contemporary artists should search out and focus on contemporary phenomena and seek in them that kind of beauty peculiar to their age. Degas was doing precisely this. Towards the end of the 1860s he began to describe in his notebooks the kind of contemporary subject matter he felt he ought to paint: musicians and instruments; bakeries with bread, cakes and tarts; the smoke of cigars, locomotives and chimneys. This list may owe something to what the Goncourts say in *Manette Salomon* but it relates even more clearly, once again, to Hokusai's *Manga,* which might even be seen, anachronistically, as a realization of the Goncourts' programme. These volumes do in the Japanese fashion what Degas intended to do in his European way: they provide – among other things – a full and accurate record of the necessary trivia of everyday life in the contemporary metropolis.

Monet and the Impressionists

According to Meier-Graefe, the Impressionists used Japanese art to add incidental exotic interest to their occasional figure-compositions, and were not interested in it on any deeper level. 'Japan,' he wrote, 'was the stage-prop of Impressionism.'[36] This view is supported – in most curious fashion – by Monet's *La Japonaise* (1876), a full-length portrait of the painter's wife, Camille, dressed in a blonde wig and extravagantly patterned kimono, and posing against a background of massed fans (Colour Plate 18). Although this painting was an immediate success when first shown in public (at the second Impressionist exhibition it was sold for the remarkably high price of 2,000 francs), Monet was not again inclined to parade exotic stage-props in his work and quickly came to hate *La Japonaise,* describing it much later as trash ('une saleté').

Monet and his fellow Impressionists had, after all, created a style which, in its pursuit of absolute visual truth and apparent lack of artifice, was the very antithesis of the *nishiki-e* prints. Determined to capture the look of the fleeting moment, the Impressionists neglected the compositional, structural aspect of their painting. In order to describe atmosphere, they developed the broken paint-surface, the loose, flickering brushwork which was versatile enough to describe both fog and heat-haze. Compositional looseness and the use of broken surfaces to describe atmosphere are qualities notably absent from Japanese woodblock prints. In short, the principles of Impressionism were totally different from those of the *nishiki-e,* and it would not be at all surprising to find that the Impressionists had not been interested in Japan and the art of the print makers.

Nevertheless, they *were* moved by Japan, and were deeply convinced that there was an intimate relationship between the *ukiyo-e* and what they themselves were attempting. Pissarro's letters to his son Lucien provide clear evidence of this. On 2 February 1893, he wrote that he had met Monet at an Utamaro-Hiroshige

103 **Monet** *Poplars on the Epte*, 1890. 93·0 × 76·0 (36¾ × 30), Tate Gallery, London

104 **Monet** *Belle-Ile-en-Mer*, 1886. 61·0 × 74·0 (24¼ × 29⅛), Bridgestone Museum, Tōkyō

exhibition at Durand-Ruel's gallery:

> The show is really astonishing and is admirably arranged: little rooms of faded rose and pistachio-green. It is exquisite, and the prints are wonderful. It is an artistic event. . . . Damn it all, if this show doesn't justify us! There are grey sunsets that are the most striking instances of Impressionism.[37]

A day later Pissarro again wrote to Lucien: 'Hiroshige is a marvellous Impressionist. Monet, Rodin and I are enthusiastic about the show. I am pleased with my effects of snows and floods; these Japanese artists confirm my belief in our vision.'[38]

Pissarro believed that the Japanese had anticipated the discoveries of the Impressionists in some ways. This belief, however shaky it might seem to us now, was shared by Zola. 'All this is the achievement of the Impressionist painters', Zola claimed:

a precise investigation of the sources and effects of
light, which have equally influenced drawing and the
rendering of colour. It has been rightly held that they
have taken as their example Japanese graphics, which
today are so widely distributed.[39]

Monet was one of the earliest *nishiki-e* enthusiasts of
all. 'Their refinement of taste has always pleased me,' he
wrote, 'and I approve of the implications of their aesthetic
code: to evoke presence by means of a shadow, the whole
by means of a fragment.'[40] He came across the prints, not
through Bracquemond or even his friend Manet, but
independently during his youth in le Havre where they
were being used by one shop to wrap cheese. From then
on Monet remained an enthusiast, allowing himself to be
influenced from time to time and usually in ways more
subtle than in *La Japonaise*. Indeed, Japanese prints left
their mark more indelibly on Monet's work than on that
of any of the other Impressionists.

It seems to have been the brilliance of the colours and
the everyday character of the subjects of the *ukiyo-e*
prints, as well as their evocativeness, that Monet
admired: not so much the kimonos, fans and other
paraphernalia, however, as the colourful elements of
landscape – the trees and the outcrops of rock – and the
relationships between them. As early as 1871, Monet
painted a few landscapes with flat areas of bright colours
which clearly owe something to the Japanese prints.
These landscapes were produced during an extended trip
to Holland, where Monet also added more *nishiki-e* to his
collection.

It was during the 1880s, though, that Monet used the
example of Japanese landscape prints in especially
telling ways. There are striking similarities between the
descriptions of rocks in the sea in Hokusai's *Manga* and
some of the seascapes with rocks which Monet painted at
Etretat on the Normandy coast in 1883 and 1886. For
example, in *Belle-Ile-en-Mer* (now, most appropriately, in
a Japanese collection), there is the same emphasis on
silhouettes and on the jagged edges of the rocks and the
patterns made by the boiling sea as we find in
Hokusai (see Plates 104 and 105). In *Rocks at Belle-Ile*
(now at the Pushkin Museum, Moscow) the dramatic
needles of Port-Coton are depicted, rocks of bizarre

105 **Hokusai** Page 18 from Vol. VIII of the *Manga*. 18·0 × 13·0 (7 × 5),
Cambridge University Library

proportions that are so close to those shown in the *Manga* that Hokusai must have come to mind when Monet first saw them. The series of paintings of poplars on the Epte, showing a row of vertical poplars on a river-bank, exploits a radical and simple compositional device that is equally reminiscent of certain landscape prints (Plate 103).

Clearer examples of Monet's enthusiasm for Japan are provided by the garden he built for himself in Giverny and by the paintings it inspired. Monet moved to Giverny in 1883, bought a strip of marshland beyond his flower garden in 1890 and began to work on his water-garden soon after. By blocking the River Epte he created a lake which he planted with waterlilies and spanned with a bridge. The shape of the bridge was based on Japanese examples seen in prints (see Colour Plates 21 and 22). Wisteria was planted to grow across the bridge so that its blue flowers would hang down like tassels on both sides. All around, irises, bamboo and willows were set to add the finishing touches to this Japanese paradise.

The series of *Waterlilies* which Monet painted in this garden in the last twenty years of his life are rightly seen as the climax of the Impressionist vision: miraculous creations of air, light and atmosphere which seem to capture even such evanescent qualities as temperature and perfume. But the *Waterlilies* are also remarkable for a further reason: they question traditional kinds of pictorial structure more radically than any painting was to do for almost half a century more. The 'composition' of some of the *Waterlilies* consists of two basic elements only: the lilies and the vast expanse of water around them. In other paintings in the series, Monet divides the canvas neatly in two by placing the trunk of a willow in the centre. In most of the *Waterlilies* there is a balance between large areas describing one kind of substance or atmosphere (the lilies, the vapour hanging close to the surface), and equally large areas describing contrasting elements (the bank of the lake, the reflections of light). Although these areas are minutely articulated and full of minor incident, from a distance they appear as solid or open shapes. These methods of constructing a picture recall Oriental devices, and especially the careful manipulation of large, open shapes, created either by

solids or by the spaces between them. A further connection with Japanese art is the way in which the *Waterlilies* treat the same subject in a series of images, among which are several polyptychs.

Ultimately, however, it must be admitted and stressed that Impressionism and *nishiki-e* derive from two totally different aesthetics. While Impressionism is descriptive, the prints are decorative. The enthusiasm of Monet and Pissarro for Japanese art sprang from a fundamental misunderstanding of it. When Pissarro saw in Hiroshige's work 'grey sunsets that are the most striking instances of Impressionism', he falsely took the lightness of Hiroshige's colour and the subtle modulations of the coloured background areas to be a representation of *plein air* effects. Nothing could have been further from Hiroshige's mind.

It was Renoir who most quickly recognized the essential incompatibility of the two styles, and Cézanne too turned his face against the vogue for Japan and the Orient in a most resolute fashion. When interviewed by Vollard in 1919, Renoir called the influence of Japan 'malheureux', and regretted his own brief surrender to it. This surrender had been most clearly recorded in *Madame Charpentier and her children* (1878, now in the Metropolitan Museum, New York), which depicts the group in a room decorated with a *kakemono,* and a Japanese screen. The picture later horrified Renoir, whose dislike of Japanese art came from having seen too much *japonaiserie*.[41] Meanwhile, Cézanne showed great scorn for Gauguin who, in Cézanne's view, had stolen from him parts of his style, which he subsequently vulgarized. According to Cézanne (who, like so many of his contemporaries, thought that Japan was part of China), Gauguin was merely a painter of 'Chinese images'.

A slight relaxation of the passion for Japan and the Orient that had been so obvious during the previous decade can be sensed in the Impressionists, then, and in the general atmosphere in Paris in the 1870s. Owing, perhaps, to the war with Prussia and the collapse of the Second Empire, which resulted in a new concern with matters purely French, artists and intellectuals preferred to turn in upon themselves and to redefine their aims in all areas of creative activity.

The influence of Japan, relatively dormant during the 1870s, returned during the 1880s more vital than ever, and was now absorbed in ways that were more sensitive and informed than before. One of the most important manifestations of the new wave was a periodical, *Le Japon Artistique,* first published in 1888 by the pioneer salesman of *japonisme,* and future impresario of Art Nouveau, Samuel Bing. This periodical, which appeared simultaneously in French, English and German, printed texts of uniformly high standard and many plates of decorative motifs as well as reproductions of prints. Japanese sword guards, fabric designs, architecture and ceramics, as well as prints, were discussed mostly by writers such as Duret who had been to Japan and could read Japanese.

Bing also organized exhibitions, which were both popular and influential. The most important of these were the show in 1888 at his own premises in Paris and another in 1893 at the Durand-Ruel gallery which consisted entirely of works by Hiroshige and Utamaro. There was another very large exhibition (also organized by Bing) at the Ecole des Beaux-Arts in 1890. A year later Edmond de Goncourt published his *Outamaro, le peintre des maisons vertes,* a book which in fact reveals more about the nature of the French infatuation with Japan, with its romanticizing concentration on anecdotal descriptions of Oriental life, than it does about Utamaro.

This second wave of enthusiasm for Japan coincided with, and indeed helped to form, the variety of styles known collectively as Post-Impressionism. With the exception of Cézanne, all the major Post-Impressionist painters loved and collected Japanese prints and drew from them some of the pictorial methods with which they directed their work away from the pursuit of objective reality and towards other, more abstract kinds of truth. Even Seurat, more concerned than either van Gogh or Gauguin with what the eye sees, derived from *nishiki-e* some of his compositional devices.

Gauguin

If not the painter of Chinese images Cézanne said he was, Gauguin was certainly the creator of savage and exotic icons. Even his paintings of Brittany are descriptions of a wild and foreign country where the customs are strange and the art strong and primitive.

Although Gauguin never liked to admit having been influenced by anyone, his mature style was the result of a magpie-like enthusiasm for anything that intrigued him, a mixture which at times included elements drawn from Cézanne; the popular *Images d'Epinal* (a kind of commercialized folk art, in the form of woodblock prints); Emile Bernard; Egyptian art; Degas; Polynesian woodcarving; and Japanese prints, to which he was certainly introduced by the Impressionists or perhaps even Bracquemond himself. Gauguin was a regular visitor to the ethnographical collection of the Musée Guimet, and a large exhibition of Mogul art in Paris in 1878 is also reported to have fascinated him. His interest in such areas may first have been awakened by the large collection of foreign articles which his parents are said to have owned. The most important of the various influences on Gauguin's aesthetic were the exotic ones, the art forms created by non-European (and therefore, for Gauguin, vital) cultures, which had been developed to communicate religious beliefs or deeply felt emotions. Something of their meaning for Gauguin emerges from the letter he wrote to Emile Bernard in 1890:

> The entire Orient – its lofty thought inscribed in gold letters in all its art – is well worth studying and I believe that I shall find renewed strength there. The West is decadent now, but everything that is Herculean can, like Anteus, gain new power by touching the soil of the East.[42]

The belief that the West could regain its vitality by drinking deeply at the wells of the East was central to Gauguin's thinking. This feeling lay behind his interest in Japanese art, which was reflected in his own painting earlier than any of his other exotic enthusiasms. As early

106 **Gauguin** *Still-life with three puppies*, 1888. Oil on wood, 92·0 × 62·7 (36⅛ × 24⅝), The Museum of Modern Art, New York, Mrs Simon Guggenheim Fund

as 1884 he carved a small box with pictures of ballet dancers and copies of *netsuke,* and in 1885 he included in his *Still-life with horse's head* two Japanese fans and a puppet. Gauguin's intentions in painting this enigmatic work have never become clear. The connection Gauguin seems to be making between the doll, the fan and the horse's head (one of the Elgin marbles, from the fifth century B.C.) remains rather a puzzle. It has been suggested that the still-life is a reference to the conclusion of Whistler's *Ten o'Clock Lecture,* which was given not only in London but also in Dieppe, where Gauguin may have heard it. Certainly, Whistler mentions the Parthenon and Hokusai in the same sentence, but such comparisons were not unusual at the time. It was fashionable, even in quite conservative scholarly circles, to see Greece and Japan as parallel classical cultures and to believe that the Orient would provide modern artists with models and examples for their own work, just as Greece and Rome had done for earlier generations. This was the tenor of an article entitled 'Grèce et Japon' which appeared in the *Gazette des Beaux-Arts* in August 1890.[43]

Whether or not the allusion to Whistler was intentional, the subject of Gauguin's picture is reminiscent of a special kind of *nishiki-e,* the *surimono.* This is a luxury print, usually produced in a very small edition, and often as a private commission for a New Year greeting card. It is usually roughly square in shape and demands the attentions of a virtuoso printer. Over-printings, *gaufrage* (a method of embossing) and similar techniques, and even collages of silk, are all common. The subject of a *surimono* is often a still-life of a figure surrounded by large and apparently unconnected objects, the meaning of which is provided by Oriental astrology and is connected with the arrival of the New Year. It is easy to make out a case for *Still-life with horse's head* as a Western *surimono* in oil paint. The proportions are right, and the relationship between the various parts is appropriately enigmatic.

When Gauguin abandoned the fractured, directional brushwork which he had derived from the Impressionists and developed a style characterized by large, unbroken areas of a single colour bounded by strong, ultramarine contours, Japanese prints helped him on his way. While he was still employed at the stock-broker's office which he had joined as a clerk in 1871, he not only enthusiastically collected the work of his contemporaries, but also bought prints. These were an important part of the personal 'museum' which he carried around with him until circumstances forced him to sell. In Pont-Aven in 1888, Gauguin decorated his studio with prints by Utamaro, and in 1890 in le Pouldu he hung with *nishiki-e* the attic where he painted. Prints even accompanied him to the South Seas and, in a most extraordinary cross-cultural gesture, were tacked to the walls of his primitive hut among reproductions of Manet, Degas, Puvis de Chavannes, Rembrandt, Raphael and Michelangelo. Of the scant possessions remaining after his death, Japanese objects were the most numerous: a samurai sword, a Japanese book, and a number of prints.

The qualities that attracted Gauguin to the prints were almost the same ones that had already appealed to the painters Louis Anquetin and Emile Bernard. By 1888 these two men had achieved a highly simplified, almost emblematic style which recalls stained-glass decoration in its flat, decorative shapes, its bright colours and stark outlines. This style owes an obvious debt to *nishiki-e,* to which they may have been introduced by Toulouse-Lautrec, who was a fellow student at the Atelier Cormon, or by van Gogh in 1886. They certainly visited the informal exhibition van Gogh organized at the Café Tambourin in 1887. Their indebtedness was recognized by contemporary writers like Edouard Dujardin, who, comparing Anquetin's work to cloisonné enamel techniques, coined the word *cloisonnisme* to describe the new manner, which he identified as deriving from folk art and Japanese prints. Van Gogh, who had read Dujardin's article, wrote to his brother that 'In the Japanese style young Bernard has perhaps gone farther than Anquetin.'[44]

Both painters influenced Gauguin, Bernard's *Breton women in a meadow* of 1888 (Plate 111) serving as the immediate stimulus for *Vision after the sermon* (Colour Plate 19). Not only was Japanese art one among many influences on Gauguin, therefore, but its impact on him was made still harder to weigh by the fact that he was affected by two artists whose style owed almost everything to *nishiki-e.*

It is customary to isolate *Vision after the sermon: Jacob wrestling with the angel* (1888) as the most important composition of the early stages of Gauguin's artistic maturity. From this time on, Japanese prints began to influence the painter's method decisively. Here, in *Vision after the sermon*, are all the marks of the familiar Gauguin style, with its strong resemblance to the devices of *nishiki-e*: especially the use of a flat, decorative composition and of very strong, unrealistic colours. The tree, which divides the composition into two major areas, would be more at home in the East than in Brittany, and the pose of the wrestlers themselves was derived from Hokusai (not, as is often thought, from the pages of the *Manga,* but from a single *ōban* print). It is interesting to consider how and why Gauguin employed these elements in his composition. What the painting shows are two levels of reality: on one level, the 'real' peasants; on the other, the vision they are experiencing after hearing a sermon about Jacob's epic battle with the angel. It is above all the scarlet ground that signals what is visionary, but this function is also filled by the tree. Bisecting the composition, it serves as a dividing line between the audience and the image in their minds.

Vision after the sermon was the most advanced work Gauguin had ever painted, and it is not surprising that it should have taken him some time before he produced another statement as radical as this one. *La Belle Angèle,* a portrait of a Breton girl, was painted in 1889, but the technique recalls both pure Impressionism and Cézanne (Colour Plate 20). The composition of this curious painting could have been suggested only by a *nishiki-e* print such as Hokusai's *Laughing Hannya* (Plate 63) or Hiroshige's landscape of Sekiya, in which the subject is shown in a semi-circular frame (Plate 112). This is a common *ukiyo-e* device, enabling the artist to combine two pictures in one and to establish relationships by implication between two totally unconnected persons or sets of circumstances. Although Gauguin does not exploit this possibility, but simply uses the circle as an interesting device, Theo van Gogh immediately recognized the source and wrote to his brother on 5 September 1889: 'It's a portrait in a circle like the large heads in Japanese prints.'[45]

After 1888, partly because of Bing's exhibition of prints in the same year, explicit references to *nishiki-e* prints become frequent in Gauguin's work. *Wrestling boys,* which Gauguin described in a letter to Schuffenecker as 'completely Japanese',[46] was based on a pose in the *Manga*. The enigmatic *Still-life with three puppies* (Plate 106) is derived, ironically, from a print of cats by Kuniyoshi. Prints themselves appear in the background of several paintings, moreover: in *Apples and vase,* the *Portrait of the Shuffenecker family* (Plate 107) and in *Still-life with head-shaped vase and Japanese woodcut* (Plate 108). The latter is especially interesting, for it combines the influence of Japanese compositional methods with the results of a highly personal interest in Pacific tribal art: the vase is a self-portrait in what Gauguin took to be the primitive style.

Gauguin was also fond of using the shape of the Japanese fan for his paintings. He produced many fan-shaped works, including (another example of Gauguin's astonishing disregard for cultural propriety) a copy of a Cézanne landscape, painted as early as 1885. In some of the paintings of 1888 and 1889 the mixture of Breton subject matter and exotic detail is uneven, as though Gauguin were unsure of the kind of personality he wanted to adopt. This was noticed by a number of contemporaries, among them Theo van Gogh, who in October 1889 wrote to his brother about the 'reminders of the Japanese' in Gauguin's work. 'As far as I am concerned,' Theo wrote, 'I prefer to see a Breton woman from Brittany than a Breton woman with the gestures of a Japanese.'[47]

One of the most remarkable of Gauguin's borrowings from *nishiki-e* is the lithograph illustration of Poe's story 'A descent into the maelstrom', executed in 1889 (Plate 110). Although the fan shape has been inverted to suggest the sloping sides of a whirlpool, the way in which the seething water has been depicted, and even perhaps the whole conception, have been derived from Sadahide's fan print of a seaweed gatherer (Plate 109). Gauguin was one of the first artists to allow Japanese prints to influence the technique and subject matter of his own graphic work as well as his paintings. He was one of the first, indeed, to re-introduce the colour woodcut, a

107 **Gauguin** *Portrait of the Schuffenecker family*, 1889. 73·0 × 92·0 (28¾ × 36¼), Louvre, Jeu de Paume (Photo: Musées Nationaux, Paris)

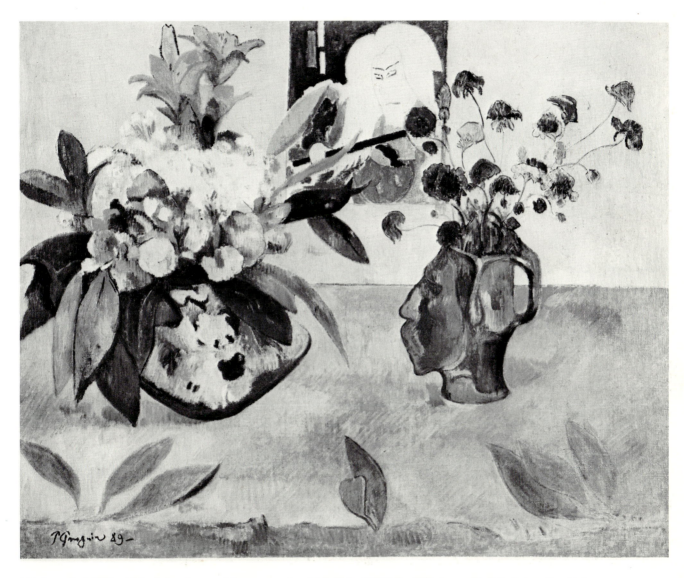

108 **Gauguin** *Still-life with head-shaped vase and Japanese woodcut*, 1889. 72·4 × 92·7 (28½ × 36½), Acquavella Galleries Inc., New York

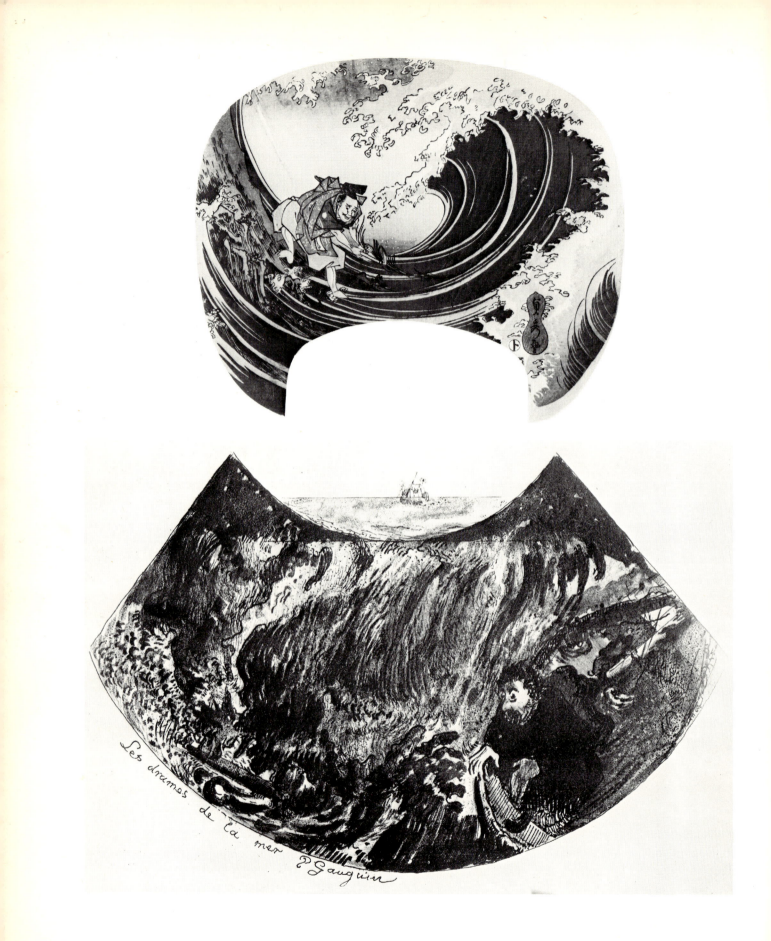

Les drames de la mer P Gauguin

109 **Sadahide** *Seaweed gatherer, c.* 1850. 22·9 × 28·6 (9 × 11¼), Victoria & Albert Museum, London

110 **Gauguin** 'A descent into the maelstrom' from *Dramas of the Sea*, 1889. Lithograph, 17·8 × 27·3 (7 × 10¾), The Metropolitan Museum of Art, Rogers Fund 1922

method which had been forgotten for centuries, and the ten prints he made in 1893 to illustrate his Tahitian journal *Noa Noa* betray a little of the influence of Japan, although Gauguin's entirely self-taught technique was necessarily crude. There is no doubt that he had Japan in mind while writing *Noa Noa,* for he stuck two pages from albums by Hokusai into the notebook in which he wrote the journal. Gauguin also pasted three single female *ukiyo-e* figures into his manuscript of *Avant et après*, which includes the essay 'Le Vase cloisonné'. This piece describes a Japanese peasant family making an enamel vase, and clearly carries memories of the Exposition Universelle which Gauguin had seen in Paris in 1889.

Gauguin's style developed several Oriental features before he left France for the Pacific for the last time. He developed a shorthand, graphic symbol for water which he took directly from Japanese models and used in many compositions. Major parts of his subjects were brought close to the spectator so that they dominate the composition. He also often adopted a high viewpoint, slightly distorting the subject in order to create unusual, decorative shapes.

Two portraits of 1888 show the way in which Gauguin was often able to assimilate the Japanese influence without leaving too obvious traces behind: *Vincent van Gogh painting sunflowers* (Plate 113) and the *Self-portrait, Les Misérables*. In the first, the high viewpoint has been adopted so that the flowers and van Gogh himself appear flattened. Moreover, these two objects of major interest have been pushed out to the left and right of the composition leaving a large, roughly triangular shape, the centre of which is bridged by van Gogh's painting hand. Gauguin, still subject to a *horror vacui,* did not have the courage to leave an entirely blank space in the centre of the picture, as a Japanese artist would have done. Instead, he divided it into areas of unbroken colour which hardly work in a descriptive way at all, but simply function as bands of decoration.

Les Misérables, the title of which is taken from Victor Hugo's novel, is a more accomplished painting and, with its sketchy portrait of Emile Bernard on the wall, more obviously Japanese in conception. In 1888 van

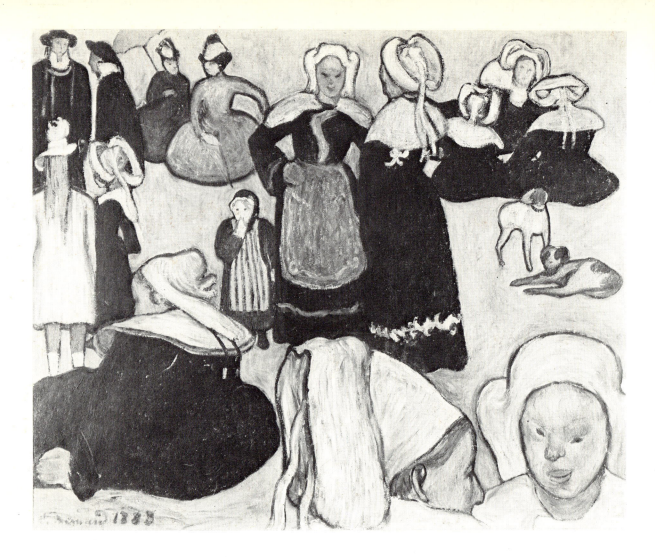

Above
111 **Bernard** *Breton women in a meadow*, 1888. 71·4 × 92·1 (28⅛ × 36¼),
Ancienne Collection Maurice-Denis

Right
112 **Hiroshige** 'View of the hills of Sekiya from Masaki' from *One
Hundred Views of Edo*. The landscape is seen through a circular window.
Part of a flower arrangement is seen to the left, and outside, to the right,
is the edge of a *shōji*. 33·3 × 22·2 (13⅛ × 8¾), British Museum, London

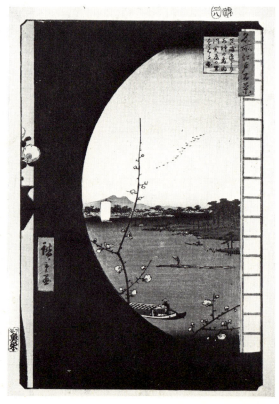

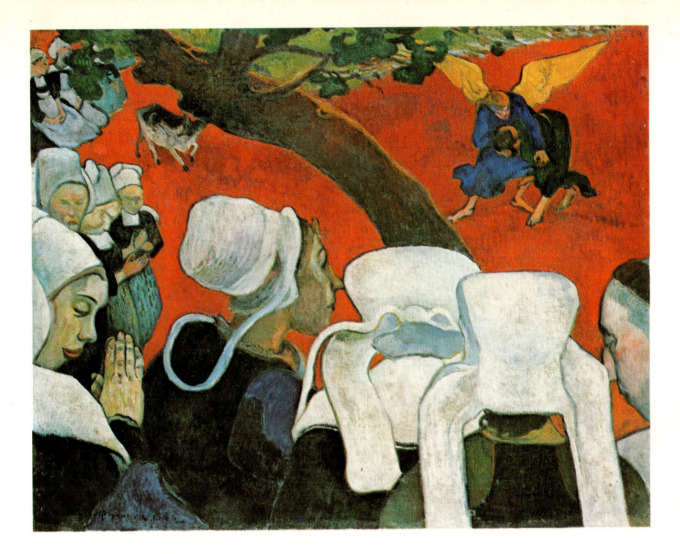

Above
Colour 19 **Gauguin** *Vision after the sermon (Jacob wrestling with the angel)*, 1888. 73·0 × 92·0 (28¾ × 36¼), National Gallery of Scotland, Edinburgh

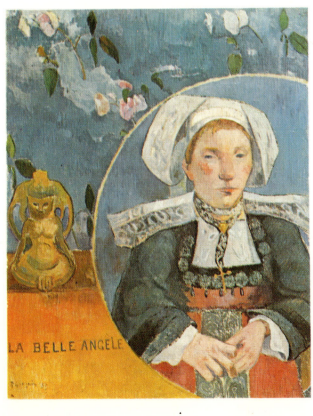

Left
Colour 20 **Gauguin** *La Belle Angèle*, 1889. 92·0 × 72·0 (36¼ × 28¾), Louvre (Photo: Musées Nationaux, Paris)

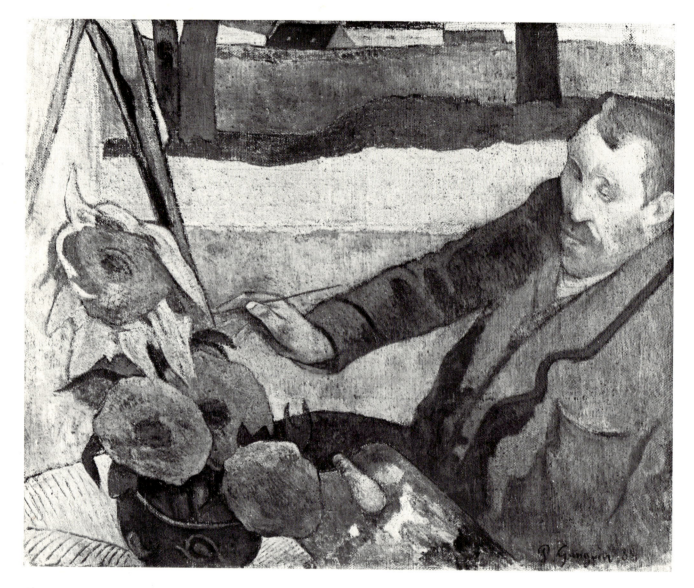

Above
113 **Gauguin** *Vincent van Gogh painting sunflowers*, 1888. 73·0 × 92·0 (28¾ × 36½), Van Gogh Museum, Amsterdam

Opposite
114 **Bernard** *Self-portrait*, 1888. 45·0 × 56·0 (17¾ × 22¼), Van Gogh Museum, Amsterdam

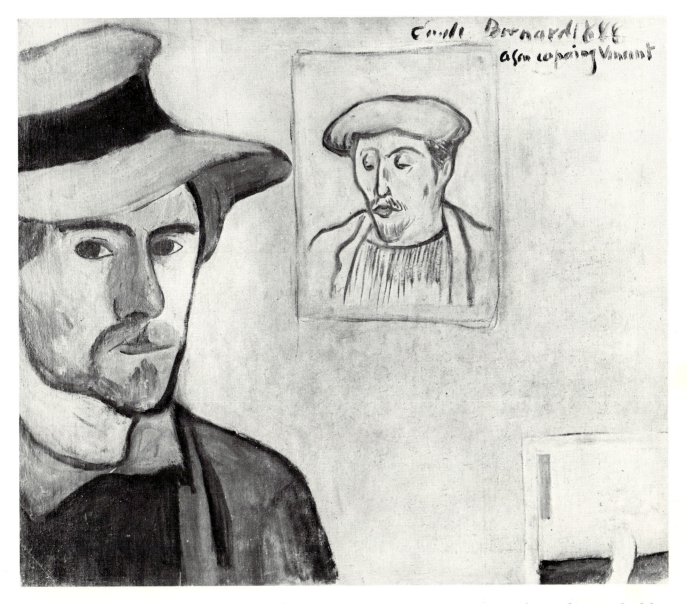

Emile Bernard 1888
a son copaing Vincent

Gogh urged Bernard, Gauguin and Charles Laval to exchange self-portraits with him. 'Japanese artists used often to exchange work among themselves,' van Gogh explained to Bernard; '. . . the relationship between them was evidently brotherly . . . The more we can copy them in this respect the better for us.'[48] Illustrated in

Plate 114 is the portrait Bernard painted as a result of the suggestion. On the wall is a portrait of Gauguin, and the flat, Japanese-like composition is underlined by the presence in the bottom right-hand corner of a part of a landscape print. *Les Misérables* is the picture sent to van Gogh in Arles by Gauguin (Plate 115); except for the

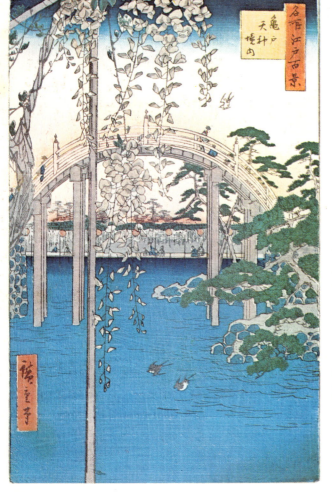

Colour 21 **Monet** *The water-lily pond*, 1899.
88·2 × 92·1 ($34\frac{3}{4}$ × $26\frac{1}{4}$), National Gallery, London

Colour 22 **Hiroshige** 'Wisteria blooms over water at Kameido' from *One Hundred Views of Edo*, *c.*1857. 35·3 × 24·0 ($13\frac{7}{8}$ × $9\frac{1}{2}$), British Museum, London

Colour 23 **van Gogh** *Copy of Hiroshige's 'Blooming plum tree'*, 1888. 73·0 × 54·0 (28¾ × 21⅜), Van Gogh Museum, Amsterdam

115 **Gauguin** *Self-portrait, Les Misérables*, 1888. 45·0 × 56·0 (17¾ × 22¼), Van Gogh Museum, Amsterdam

careful modelling of the head, it powerfully evokes the qualities of a Japanese print, even down to the sharp, acidic yellow of the wallpaper. Also relevant here is the decorative background and the strong, unbroken outline which unites Gauguin's cheek and shoulder and contradicts the strong modelling of the face. The portrait of Bernard, inserted as a vertical shape bled off at the top right-hand edge of the picture, is, of course, like the picture of Gauguin in Bernard's own version of the theme, a reminder of the small portraits and scenes often introduced (on cartouches, books or similar devices) into the corners of *nishiki-e* prints.

The curious Symbolist self-portrait of 1889 (Plate 116), in which Gauguin shows himself with a halo and holding a snake, with a cluster of apples by his head, is, in spite of the lapsarian symbolism, strongly reminiscent of *nishiki-e* portrait heads of male actors. The curvilinear plant shapes around the neck make a pattern similar to the kimono designs commonly featured in this sort of print.

Gauguin experienced at their most extreme the frustration, the weariness and the longing for entirely new worlds which most of his contemporaries occasionally felt when they contemplated the Europe of the late nineteenth century. For him, as for van Gogh, Japanese prints meant infinitely more than a fresh and exciting aesthetic. They were the tangible evidence of another, ideal existence in a land where the sun shone all day, the cherry trees were always in bloom and everyone was one's brother. Van Gogh went to Arles, hoping to find Japan in the Midi. Gauguin alone of his contemporaries left France to realize his dream, not in Japan, but in a place the reported innocence of which touched him more. At first he thought of Java, Madagascar and China, and even attempted to secure a government post in Tonkin. Finally he decided on Tahiti, to which he travelled twice, in 1891 and 1895, before he made his final home on the wild Marquesas Islands.

116 **Gauguin** *Self-portrait with halo and snake*, 1889. Oil on wood, 79·2 × 51·3 (31¼ × 20½), National Gallery of Art, Washington D.C.

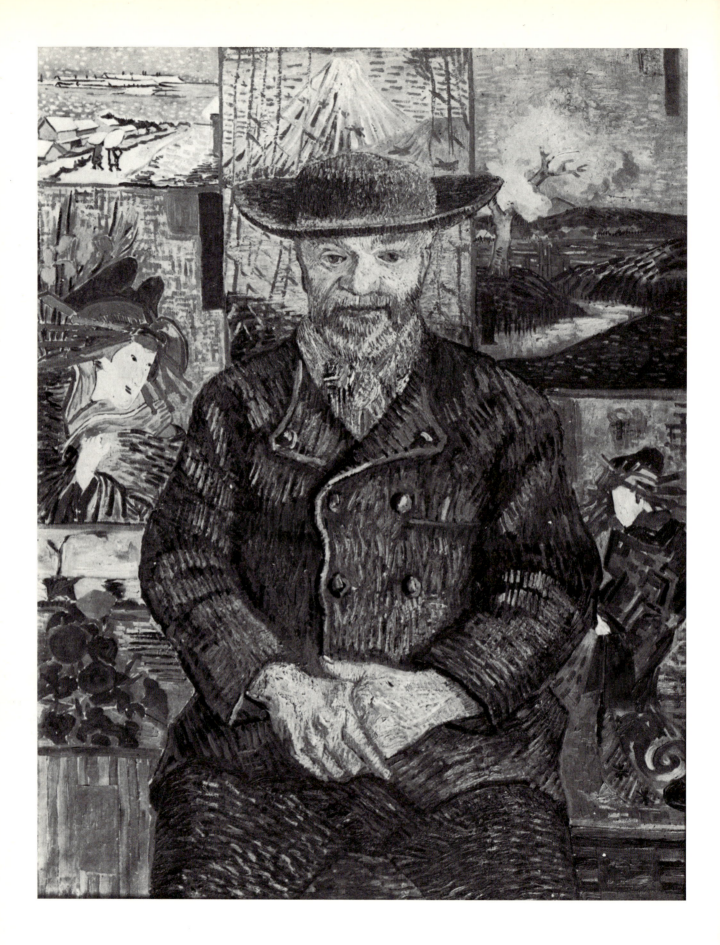

Van Gogh

Vincent van Gogh did not find his paradise in Arles any more than Gauguin found his on the Marquesas. Nor was van Gogh's conception of real life in Japan any more accurate than Gauguin's idea of life in the Pacific. Indeed, it was a good deal less so, being thoroughly romantic, sentimental and based on evidence no more satisfactory than the novel by Pierre Loti, *Madame Chrysanthème,* which was van Gogh's favourite reading for a time.

Van Gogh's enthusiasm for Japan and for *ukiyo-e* prints was greater and, thanks to his letters, is more fully documented, than that of any of his contemporaries. Although he first began to collect prints in Nuenen, the first reference to them in his letters does not occur until 1885, when he was in Antwerp, trying to make a living as an artist. 'I've put some Japanese prints up on the wall,' he wrote to his brother in December, 'which give me enormous pleasure. You know, those figures of little women in gardens, or on the beach, horsemen, flowers, knotty thorn branches . . .[49] In Antwerp van Gogh also read the Goncourt brothers, especially their writings on art, and the painter's interest in Japan must have been stimulated by this. Nor, as a Dutchman, could it have escaped his notice that the Netherlands had enjoyed uniquely close ties with Japan for several centuries. Van Gogh, the dreamer, was probably most attracted to Japanese prints, however, because of their exotic associations, their strangeness, rather than for any deeper reason. While he was in Antwerp, his style remained sombre: it was not until he moved to France that it began to benefit from the aesthetic qualities of the *nishiki-e.*

In Paris van Gogh saw prints in great numbers for the first time. He also realized that his enthusiasm was shared by many other artists, that there was a vogue for things Japanese. He now began to collect prints more seriously and often bought piles of them at a time, for no more than a few sous per sheet, from Bing's shop on the

117 **van Gogh** *Père Tanguy,* 1887. 92·0 × 75·0 (36¼ × 29⅝), Musée Rodin, Paris

rue de Provence. He was such a good customer there that he was given the run of the entire building, including the cellar and attic. 'Whatever one says,' he wrote in a letter in September 1888, 'I admire the most popular Japanese prints, coloured in flat areas, and for the same reasons that I admire Rubens and Veronese. I am absolutely certain that this is no primitive art.'[50]

Between 1887 and 1888 van Gogh's style matured, helped by Impressionism, Pointillism and Japanese prints. The *ukiyo-e* gave him the confidence to eliminate conventional kinds of modelling, to introduce larger areas of a single colour and to brighten his palette. The two portraits of the colour-maker and artists' dealer Père Tanguy (who also sold prints) which van Gogh painted in 1887 still betray his enthusiasm for Impressionism, but they show the old man against a background of prints by, among others, Hokusai, Hiroshige and Eisen (Plate 117). The lively brushwork shows that van Gogh had not yet completely assimilated the Japanese aesthetic, however; he was still interested in prints chiefly for their anecdotal properties, as fascinating exotica. Highly significant in this uncompleted process of assimilation are the three oil copies the painter made from woodblock prints: Hiroshige's 'The Ohashi bridge in the rain' from *One Hundred Views of Edo* (see Plates 118 and 119); his 'Blooming plum tree' from the same series (See Colour Plate 23 and Plate 120); and a courtesan by Eisen. All three were painted between 1887 and 1888 and therefore bridge the period during which van Gogh was making the most difficult decisions about the future of his style. They are not exact copies. Although the centrepiece of each is a fairly faithful reproduction of the original, the borders have been added in each case. Each Hiroshige has been supplied with bright borders painted with real Kanji characters and shapes like them. Although the real Kanji characters are legible, their meaning is unrelated to the subjects of the paintings. The border of the Eisen is a synthesis of three other, quite different prints. The Eisen, moreover, is copied not directly from a print but from a reproduction of one on the cover of the special 1886 Japan number of *Paris Illustré*, and it is reversed, as it was there. The general effect of these changes, and clearly the reason for the addition of the borders, is to

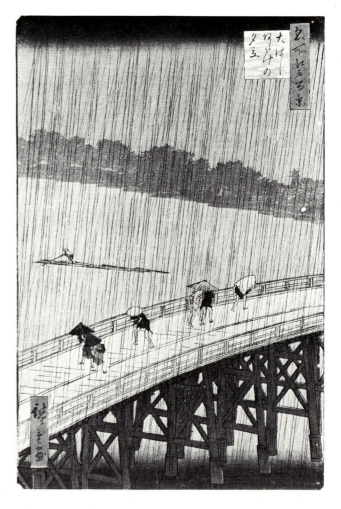

Above
118 **Hiroshige** 'The Ohashi bridge in the rain' from *One Hundred Views of Edo*, c. 1857. 33·8 × 21·8 (13¼ × 8⅝), Van Gogh Museum, Amsterdam

Left
119 **van Gogh** *Copy of Hiroshige's 'Ohashi bridge'*, 1888. 73·0 × 54·0 (28¾ × 21½), Van Gogh Museum, Amsterdam

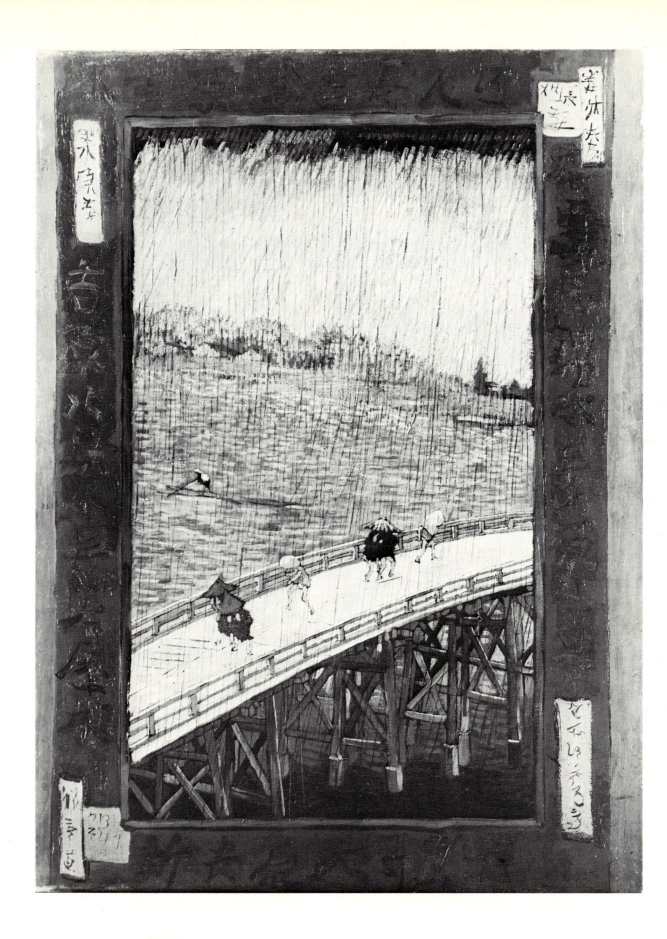

189

120 **Hiroshige** 'Blooming plum tree'
from *One Hundred Views of Edo*, c. 1857.
35·0 × 22·0 (13$\frac{7}{8}$ × 8$\frac{5}{8}$), Van Gogh
Museum, Amsterdam

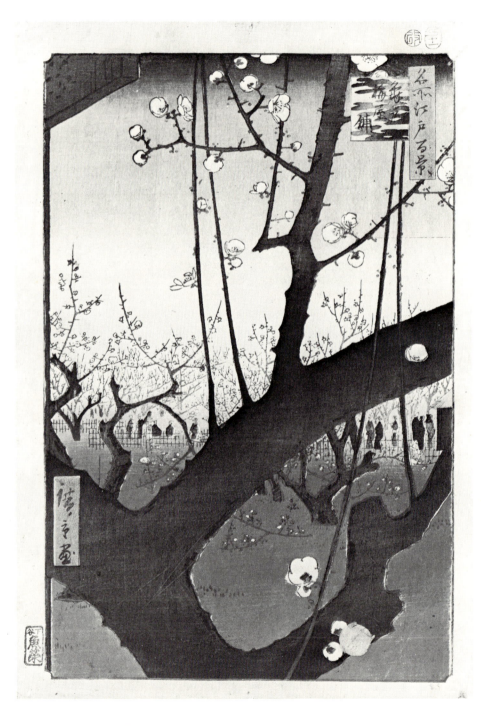

make the oil copies even brighter, even more exciting in colour, than the original prints.

In other respects, however, van Gogh went to enormous trouble to be faithful to the originals in these pictures. Two of the tracings from which the copies were made still exist. Most of van Gogh's contemporaries preferred the less subtle and less accomplished prints of later, second-rate *ukiyo-e* artists, but van Gogh was highly discriminating in his choice of models. The Hiroshige prints he singled out to copy are two of the greatest landscape prints in the history of *ukiyo-e*. There is no doubt that his copies of these taught van Gogh a great deal about using colour for its decorative rather than its descriptive potential, so that a sky, for example, could be painted red without appearing to do violence to nature. They also taught the artist about the expressive power of large areas of a single colour brushed in relatively flatly. From prints van Gogh also learned the enormous decorative power of unbroken contours, lines which he drew not uniformly in black but also in a variety of other colours chosen for the contrast they provide with the main areas they enclose.

By late 1887, Vincent's enthusiasm for Japan and Japanese prints reached a height from which it was never to descend. Partly spurred on by Loti's *Madame Chrysanthème* (which had been published that year and had become a best-seller) and partly by the wealth of prints he regularly inspected at Bing's, van Gogh was persuaded to organize his own exhibition of *nishiki-e* at the Café Le Tambourin in the Boulevard Clichy, the proprietress of which seems to have been his mistress at the time. This exhibition was clearly well-planned. It attracted visitors in considerable numbers and impressed several painters. Largely because of van Gogh's exhibition, Anquetin and Bernard began to modify their styles in accordance with the Japanese aesthetic. They also became enthusiastic collectors, exchanging prints with each other and with van Gogh. Theo van Gogh, who helped organize the exhibition, seems not to have been as firmly convinced of the artistic merit of the woodcuts as his brother was, although he did find them attractive. Continually encouraged by Vincent, he regularly acquired them, partly to have something to exchange for the work of artists in whom he was interested as a dealer.

One of the reasons van Gogh decided to go to the South, to Arles, was that he falsely imagined the landscape there would be like that of Japan, and the people like the Japanese. 'I came to the South for a thousand reasons,' he explained later, in a letter to Emile Bernard, written immediately after his arrival: 'I wanted to see a different light, I believed that by looking at nature under a brighter sky one might gain a truer idea of the Japanese way of feeling and drawing.' His expectations were not disappointed:

Since I promised to write, I'll start by saying that the place, with its clarity of light and the gay effect of its colours, seems to be as beautiful as Japan. The water forms areas of beautiful emerald green and rich blue in the landscape, like those we know in the woodcuts. The pale orange sunsets make the ground seem blue. Glorious yellow sun.[51]

Arles not only seemed to reproduce the Japan seen in the woodcuts, the Japan where the sun is so bright that shadows are eliminated, it also appeared to offer something of that serene and gentle way of life which van Gogh firmly but falsely believed was the lot of every Japanese artist. In the Land of the Rising Sun, the artist lives in brotherly fashion with his colleagues and close to the soil. He is part of nature, like the flowers, and is able to reveal the entire world in a blade of grass. All the Japanese artists, van Gogh mistakenly thought, were members of the lowest class and therefore in intimate touch with the joys and tragedies in the lives of ordinary people. He saw them almost as subjects for Millet.

This touchingly naïve picture of life in the Far East appears again and again in van Gogh's letters to Theo, to his sister, to Gauguin and to Emile Bernard. Again and again he compares his own pictures to Japanese prints. His view of Arles, for instance, shows 'a small town surrounded by a landscape in yellow and violet completely in bloom – you know, that's a proper Japanese dream.'[52] His *Barges on the Rhône* (Plate 121) is 'pure Hokusai',[53] and in the painting of his bedroom 'the shadows . . . are suppressed, the whole is painted flat in large colour areas, as in Japanese prints.'[54] Significantly, however, van Gogh no longer needed to rely on *nishiki-e*

121 **van Gogh** *Barges on the Rhône*, 1888. 55·0 × 66·0 (21¾ × 26), Museum Folkwang, Essen

in Arles. 'I no longer need to have Japanese prints,' he wrote to his sister, 'for I constantly tell myself that I am in Japan here.'[55] However, in one of his self-portraits executed at Arles in 1889, he includes a print from his collection on the wall behind him (Plate 122).

At times van Gogh even saw himself as a Japanese. In the portrait he painted for Gauguin (in exchange for Gauguin's *Les Misérables*) he gave himself an Asiatic face with high cheekbones and slanting eyes, and a bald pate (Colour Plate 24). To Theo he wrote that he 'had conceived it as the portrait of a bonze, a simple worshipper of the eternal Buddha.'[56]

Some of the first of van Gogh's paintings clearly to show an approach rather different from that which he had adopted in Paris are views of a drawbridge near Arles, executed in the spring of 1888, in which the colours are uniformly very bright, the outlines precise and sharp and the perspective flattened by the use of a strong diagonal which cuts across the lower third of the composition (Colour Plate 25). The motif is also Japanese. The *ukiyo-e* artists loved to depict bridges, which were admired in Japan not only as famous landmarks, but also as feats of engineering and carpentry. It is no longer possible at this stage, however, to talk of specific Japanese influences in van Gogh's work. His style was by now fully matured, free from any reliance on external models.

There is a crucial difference between van Gogh's mature style and that of Bernard and Gauguin. Although prints helped van Gogh to simplify his designs and to paint broad areas of colour, he was not exclusively interested in achieving the kind of expanses of flat, penetrating colour that Gauguin and Bernard set such store by. Instead he developed a graphic, rhythmical system of brushmarks which is a crucial part of his expressive language. At first sight van Gogh's method of applying dots, strokes and dashes is the very antithesis of the *ukiyo-e* style, but in fact it has a very clear Japanese source.

The *ukiyo-e* artists not only produced single prints. They also designed illustrated books, which were sometimes coloured but more usually only in black and white. In the absence of colour, they developed a highly

122 **van Gogh** *Self-portrait with Japanese print*, 1889. 60·0 × 49·0 (23¾ × 19¾), Courtauld Institute Galleries, London

123 **van Gogh** *Sailing boats coming ashore*, 1888. Pen and ink, 24·0 × 31·5 (9½ × 12⅜), Musée d'Art Moderne, Brussels

124 **Hokusai** Double-page spread from *One Hundred Views of Mount Fuji*. 12·5 × 18·3 (5 × 7¼), Victoria & Albert Museum, London

complex and effective language of textures and patterns to distinguish between various areas, and otherwise to serve the function performed by colour in the single prints. Hokusai's use of such effects is particularly impressive, not only in some sections of the *Manga,* but also elsewhere, especially in his three-volume *One Hundred Views of Mount Fuji.* At times in this book the system of larger and smaller dots seems to anticipate Pointillism, for the dots simultaneously describe light, texture, substance and depth, as well as providing a decorative disposition of colour.

Van Gogh's pen drawings use an equally complex system of marks to describe these qualities, marks which range from clusters of tiny dots to areas made rhythmic by blocks of parallel hatchings. In order to give these marks life, van Gogh used a variety of reed pens, the nibs of which gave lines of varying thickness according to the pressure used. He did not attempt to use Oriental brushes (as Toulouse-Lautrec did), but his reed pens did achieve effects similar to those produced by a brush.

Some of the most impressive pen drawings exploiting this technique are of the plain of la Crau and were executed in 1888 (Plate 125). Van Gogh describes them in a letter to Bernard:

Have done some large pen-drawings. Two. Boundless flat country – seen from the top of a hill in bird's-eye view – vines, harvested cornfields. All this is endlessly multiplied and stretches out like the sea to the horizon, which is bounded by the hills of the Crau. It doesn't look Japanese, yet it is really the most Japanese thing I have ever done.[57]

A drawing of sailing boats coming ashore, done in June 1888, clearly shows the enormous possibilities of this technique (Plate 123). The sky is rendered with stippling, the sea towards the horizon in wavy lines and the surf in the foreground in curves and squiggles that strongly recall Hokusai (Plate 124). When such a system of marks is used in painting it reinforces the effect of the energetic and highly expressive brushwork and emphasizes the bright, emotion-charged colour. Although the dots, dashes and strokes are ultimately derived from Japan, however, they contribute to a style whose aims are decidedly non-Oriental. The *nishiki-e* prints van Gogh

loved are reserved, aloof, precise. Their artificiality creates a barrier between them and the spectator. Such qualities are the antithesis of van Gogh's style, with its subjective immediacy and vigorous application of paint.

Towards the end of 1888, van Gogh produced *The sower,* a mixture of Millet (from whom, of course, the subject is derived) and Japan (Plate 126). The flattening of the motif is noticeably Japanese, as is the enormous sun. Prints are the ultimate source of the tree bisecting the composition at an angle, although van Gogh probably took it from Gauguin, whose *Vision after the sermon* includes one very similar. By this date, however, it is not helpful to isolate Japanese elements in a style which no longer relies on any external source for its vigour. In Arles van Gogh no longer needed Japanese prints for inspiration, not only because he felt that he was in a country like Japan, but also because his style was already self-sufficient and unique.

Opposite above
125 **van Gogh** *La Crau,* 1888. Pen and ink, 72·5 × 92·0 (29 × 36¼), British Museum, London

Opposite below
126 **van Gogh** *The sower,* 1888. 32·0 × 40·0 (12⅝ × 15¾), Van Gogh Museum, Amsterdam

127 **Signac** *Against the enamel of a background rhythmic with beats and angles, tones and colours, portrait of M. Félix Fénéon in 1890.* 74·0 × 100·0 (29⅛ × 36⅝), Private collection, U.S.A. (Photo: Sotheby's)

Seurat and Signac

In *D'Eugène Delacroix au Néo-Impressionisme* (1899), the painter Paul Signac enumerates the principal sources of Seurat's highly original and influential style. Most of them are the theories of those scientists whose investigations into colour and the psychology of perception provided Seurat with the intellectual framework for his Divisionist technique: namely, Charles Blanc, Ogden Rood, Helmholtz and others. At the head of all the scientific influences, however, Signac mentions the art of the Orient as an important source of Neo-Impressionism.

This, at first sight, is strange. It is difficult to imagine anything less Oriental than measured, shimmering, frozen tableaux such as the *Bathers at Asnières* or *L'Ile de la Grande Jatte,* and it is difficult to see anything in *ukiyo-e* prints that could have contributed to a style committed to the scientific analysis of light and to the creation of harmonies hallowed by the European Classical tradition.

In 1883 Louis Gonse published his two volume *L'Art japonais* and, together with the dealer and collector Hayashi, organized a major exhibition of prints at the Galerie Georges Petit in the rue de Sèze, Paris. On show were the jewels of the greatest French *ukiyo-e* collections of the period: those of Bing, Philippe Burty, Abraham and Isaac de Camondo, Théodore Duret and Charles Haviland. Seurat saw this splendid collection and was mightily impressed by it, as were his friend Camille Pissarro and the most influential avant-garde critic of the day, Félix Fénéon, who was so interested in Japanese art that he planned to write a book on the subject and peppered many of his reviews of current exhibitions with references to Hokusai and Hiroshige.

There is, of course, a tremendous difference between being impressed by Japanese art, however strongly, and being influenced by it as an artist. All Seurat's contemporaries were susceptible to the attractions of the Orient, but by no means all of them changed their styles as a result. Neither Seurat nor Signac, indeed, allowed

128 **Hokusai** 'Seascape in the Western style' from *One Hundred Views of Mount Fuji*. 18·7 × 25·8 (7⅞ × 10⅛), ex. Vever Collection, Sotheby's

ukiyo-e to affect their painting dramatically. There are, however, some Japanese elements in the work of both and, although minor, they provide interesting evidence of the variety of ways in which European artists reacted to the stimulus of Japan.

Seurat added borders, which were decorative but at the same time atmospheric, to the majority of his paintings. His intention was to provide a harmonious counterbalance not only with the predominant tones and colours of the works but also with their major shapes and compositional devices. These borders also emphasize the autonomous quality of each painting, its existence as an object in its own right. Such borders are a common feature of *nishiki-e* prints (though often in a more decorative and intricate form) and are frequently used to identify a series, and it is possible that this is where Seurat first came across the idea (see Plate 67).

One painting, *Le Bec du Hoc* (Plate 129), seems

129 **Seurat** *Le Bec du Hoc*, 1885. 79·5 × 94·2 (31¼ × 37½), Tate Gallery, London

actually to have been based on a specific print. Dorra and Askin (in an article in the *Gazette des Beaux-Arts*) have pointed out that the curious, almost curling shape of this piece of cliff is almost identical to one of Hokusai's representations of a towering wave in *One Hundred Views of Mount Fuji* (Plate 128). In both the Seurat and the Hokusai a group of flying birds is silhouetted against the sky. The identification of the source is especially persuasive in that Seurat included birds in no other landscape. Even if he did not directly copy the Hokusai he may, like Degas, have been reminded by actuality of something which had impressed him in a print.

Left
131 Hiroshige 'Waggon-wheel on the
beach at Takanawa' from *One Hundred
Views of Edo*, c. 1857. 35·3 × 24·0 (13⅞ × 9½),
British Museum, London

Opposite
130 Seurat *The Harbour of Honfleur*, 1888.
81·0 × 65·0 (31⅞ × 25⅝), Rijksmuseum
Kröller-Müller, Otterlo

203

In his landscapes, the Japanese artist whom Seurat most resembles is Hiroshige. In Seurat's paintings of seaside and harbour scenes, such as the *Fishing fleet at Port-en-Bessin* of 1888 (now in the Museum of Modern Art, New York) and the series painted at Gravelines in 1890, the composition is divided into strips of contrasting tones. The viewpoint is a high one, the distance between foreground and middleground is contracted, and the foreground is often brought towards the spectator by means of a device that recalls Hiroshige: the introduction of individual objects, such as anchors, bollards and other quayside furniture, on an unnaturally large scale. The closest Seurat comes to Hiroshige is in the *Harbour of Honfleur,* where the foreground is dominated by the prow and rigging of a sailing ship which provides an angular frame for another boat berthed further back along the quay (Plate 130). A similar arrangement is found in 'Waggon-wheel on the beach at Takanawa', from *One Hundred Views of Edo,* although here the sailing vessels framed by the shape in the foreground are themselves in the background and not in the middle distance (Plate 131).

Hints of Japan appear in other compositions by Seurat. They are especially strong in *Young woman powdering her face* (Colour Plate 26). It can be argued that the subject of this – an attractive, if pudgy girl at her toilet – is basically that of the Japanese *bijin* prints, depicting beautiful courtesans. But the most obvious Japanese element is the picture-frame behind her, not only because it is bamboo, but also because the framed picture within a picture is, as we have so often seen, a common *ukiyo-e* device. X-rays show that Seurat originally painted in his own face in the mirror, perhaps to identify the girl as his mistress. Had this face remained, the Japanese look of the whole picture would have been unmistakable.

Seurat's enthusiasm for Japanese prints, like Manet's, was combined with an intense interest in certain kinds of established European art. In particular, he had great admiration for Ingres and the Old Masters, especially those painters of the Italian Renaissance, such as Piero della Francesca, who had been concerned with geometric harmony and mathematically inspired compositional grids. Seurat, as much as Cézanne, was

determined to make of Impressionism something as permanent as 'the art of the museums', and like Cézanne he believed that the most serious disability of Impressionism was its neglect of coherent form, the sense of structure which had traditionally been one of the European painter's prime concerns. In order to supply that form, Seurat had to break some of the ties with Naturalism made by the Impressionists and to regard each final composition as something apart from nature, as the Japanese print makers did, to be planned shrewdly and deliberately with an eye to the balance of the whole. The overwhelming number of crayon and oil sketches for a composition like *L'Ile de la Grande Jatte* (1884–6) speaks eloquently of the strength Seurat drew from the direct observation of nature; but it also shows the extent to which he deviated from what he saw, and drew upon his own powers of invention. In all Seurat's works, intellect and observation combine; things perceived are transformed by a sense of harmony or by a love of design.

Félix Fénéon, writing about Hiroshige's views of Lake Biwa, noticed that many of these landscapes are basically made up of ' . . . three or four parallel lines, often horizontal, and between them sheets of gradated blue, yellow, orange and pink.'[58] This device, to be found in the work of other print artists as well as Hiroshige, enabled the *nishiki-e* designer to express distance while at the same time providing a decorative unity in the composition. Seurat used a very similar device to great effect in *La Grande Jatte* where the shadows cast by the trees in the background create a measured grid against which the figures are placed (Colour Plate 27).

Fénéon also commented upon Hokusai's stippling technique which, as we have seen, made such an impression on van Gogh. It would be bold indeed to claim that Pointillism, the method of painting in small dots which Seurat, Signac and Pissarro began to use in 1896, derived from Hokusai, but Hokusai may well have provided Seurat with an interesting parallel to Divisionism and given him clues about how to use it as a compositional as well as a descriptive element. Hokusai sometimes described the middleground in his landscapes by means of what H. Dorra calls 'tongue-like streaks of colour on which random patterns of dots in more intense, lower

value colours have been applied'.[59] This can also be said of the shadows in *La Grande Jatte,* which serve far more than a merely descriptive function, but also might be said to have a unifying effect upon the composition.

The work of Signac, who was Seurat's closest friend and disciple, is more frankly decorative. His colours are put down not in dots but in blocks, and he exploits to the full any curves or other interesting shapes suggested to him by his chosen subject. Often, especially after the turn of the century, he imposed a decorative pattern on his skies and other flat areas by dividing them up into interlocking, intricately curved shapes of different colours – a technique which can perhaps be traced back to *nishiki-e.* At least one of Signac's contemporaries – Fénéon – recognized his debt to Japan, perceiving as early as 1889 an affinity between Signac and Hiroshige.

Appropriately, the most obvious use of a Japanese source in Signac's work is the large portrait of Fénéon holding a cyclamen, painted in 1890 (Plate 127). The curious, brightly coloured background, with its series of curves radiating from a single point, to give an effect of circular motion, has a special significance apart from its obvious decorative qualities. It is an attempt to realize some of Signac's theoretical preoccupations about arrangements of certain lines, forms and colours, and their relationship with specific emotions. Nevertheless, this background, in spite of its origins in theory, has a specific source: it is based, with modifications, on the design of a kimono which was part of Signac's own collection of Japanese art.

There are other, less important and less direct borrowings in Signac's work. As Gerald Needham points out,[60] several of the painter's landscapes which include trees use the branches to create a decorative foreground trellis reminiscent of many *ukiyo-e* prints. A good example of this is *La Place des Lices, St Tropez* of 1893 (now in the Carnegie Institute, Pittsburgh).

Neither Seurat nor Signac, however, owed any large debt to Japanese art. Their work was ultimately too concerned with a perceived reality, too involved in the continuing tradition of European representational painting, to have benefited to any large extent from such an entirely foreign aesthetic.

Toulouse-Lautrec

There is a photograph of Toulouse-Lautrec, taken around 1892, which shows him dressed in a glorious ceremonial kimono, with a black court hat on his head. At the moment of exposure the painter had crossed his eyes, so that the effect of the photograph is very comic. Toulouse-Lautrec was fond of dressing up, especially in women's clothes, and of playing the fool, but the burlesque clowning in the kimono is misleading: Lautrec's respect for Japanese prints and his love for the Japan of his imagination were of enormous significance for his art. No other Western artist has come closer to the spirit of Japan in his work. Not only was Lautrec's style based on an aesthetic similar to that developed in Japan, but his subject matter too – the brothel, theatre, circus, cabaret and bar – is identical to that preferred by the *ukiyo-e* artists. Alone among the great Post-Impressionists, moreover, Lautrec created his most memorable images not in paint on canvas but on the lithographic stone. He was, indeed, pre-eminently a graphic artist, working in a commercial idiom, for reproduction and for a large and mainly undiscriminating public. If a *ukiyo-e* artist had visited Paris during the 1890s he would have instantly recognized Lautrec as a colleague.

Mark Roskill recalls that all the Post-Impressionists went through an Impressionist phase and astutely shows how several of the best-known Post-Impressionist masterpieces can be seen as re-workings of almost identical Impressionist compositions.[61] Thus, for example, Gauguin's portrait of the Schuffenecker family can be seen as a transformation of Degas' *The Bellelli family*, just as Lautrec's *Drinker* of 1889 is a translation of Degas' *Absinthe* of 1876, and his *Elles* seem to have developed from Degas' most intimate descriptions of women. Lautrec worshipped Degas and followed him in his love of Japanese art, but Lautrec belonged to a younger generation for whom Japan and its art were no longer novelties but accepted and familiar facts. When Lautrec

132 **Toulouse-Lautrec** *Bruant dans son cabaret*, 1893. Colour lithograph, 129·5 × 95·2 (81 × 37½), Victoria & Albert Museum, London

acquired the Japanese aesthetic, therefore, it was already filtered and refined by Degas' artistic sensibility. When Degas was considering *ukiyo-e* prints they were still virgin territory; for Lautrec they were already part of the common vocabulary. He could therefore afford to be more daring and extreme in his use of them.

The first evidence of an interest in Japan appears in Lautrec's work as it does in the work of so many other artists, not in the form of a stylistic device but as borrowed subject matter. *Mme Lilli Grenier in a kimono* for which a study also exists, was executed in 1888. The red and black kimono which the lady is wearing does nothing to make her seem more exotic or interesting, and only serves to show that the young Lautrec had been looking at Whistler.

The kimono in this picture may actually have belonged to Lautrec, who had begun to collect Japanese art and objects by this time, even though his style does not reflect this interest. Indeed, he had begun to collect prints as early as 1883, enthused by the same exhibition that had so impressed Seurat. In van Gogh, whom he met at the Atelier Cormon in 1886, he discovered someone else with a passion for Japan, someone, moreover, who lived in the same house in Paris – 54 rue Lepic – as the dealer in Japanese art A. Portier. Until Maurice Joyant, who later became Lautrec's closest friend, followed Theo van Gogh as manager of the Montmartre branch of the art dealers Goupil et Compagnie in 1891, Lautrec bought mostly from Portier. But after 1891 he concentrated on Goupil's, where he might daily inspect the drawings and albums of prints deposited there by Théodore Duret. Lautrec was one of the most active collectors of prints and was known even to exchange his own paintings for single prints he especially coveted. His acquisitions showed a discerning and catholic taste. His preference, unusually, was for the work of Harunobu and Utamaro rather than of Hokusai or Hiroshige. These favourites depicted the very subjects he chose to portray himself: professional entertainers and prostitutes.

It is during the early 1890s that Lautrec's enthusiasm for things Japanese begins clearly to be reflected in his art and, eventually, to affect his style. One of his *kakemono* appears in two portraits of 1891: that of

Doctor Bourges (now in the Museum of Art, Pittsburgh) and that of Paul Sescau, the photographer (in the Brooklyn Museum, New York). Both were painted in the artist's studio where the *kakemono* was obviously permanently on display. The famous monogram appeared during 1892, a brilliant transformation of the letters H.T.-L. into an Oriental signature seal, and Lautrec began to include it in his compositions with as cunning an eye for precarious balance as any Japanese artist (see Plates 134 and 135). He almost always had it printed in vermilion, the colour of Japanese *inkan*.

Lautrec was not only impressed by Japanese prints. He also admired brush calligraphy and drawing. Determined to learn as many of the techniques as he could, he had a writing-set shipped from Japan. It came complete with ink-stone, water-kettle, brushes and some sticks of *sumi* ink, and enabled him to experiment with some drawings in the Oriental manner. Some of them, like the beautifully simple *Bourges walking his dog* of 1893 and *At the Circus Fernando* (Plate 133), were actually done on real fans. Others, like the *Japanese landscape in the manner of Hokusai (c.* 1894), manage to catch the confident economy of Chinese and Japanese brush drawings. *A duck, drawn in the manner of Hokusai* (1894) also brilliantly reproduces the almost arrogant casualness of the practised calligraphic brush (Plate 136).

By 1894 Lautrec's style had fully matured. Increasingly he began to devote his time to lithography. During the last nine years of his life Lautrec produced 362 lithographs, 30 of which are posters. In lithography the image is drawn on a stone with a wax crayon, or with a brush and an oil-based ink. Printing-ink and water are applied directly to the stone after the drawing is completed. The ink is attracted to the grease in the drawing but, being greasy itself, it is repelled by the water. When paper is applied to the stone a reverse image of the drawing is therefore achieved. Only one colour can be printed at a time and so, for ease of design, a lithograph of several colours is usually begun with a black key-image which prints the outline of areas later to be filled with the other colours. This kind of lithography is therefore very close to the colour woodblock technique, and Lautrec lost no time in learning from the Japanese

Above
133 Toulouse-Lautrec *At the Circus Fernando, c.* 1888. Ink on paper,
21·0 × 66·0 (8¼ × 26), Kornfeld and Klipstein, Bern

134 Toulouse-Lautrec Signature monogram

135 Censor's signature seal from a Japanese print

Right
136 Toulouse-Lautrec *A duck, drawn in the manner of Hokusai,* 1894.
Ink on paper, 11·4 × 7·0 (4½ × 2¾), Sotheby's

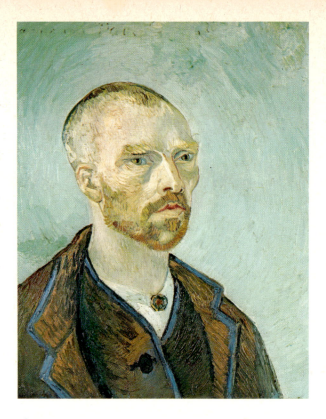

Right
Colour 24 **van Gogh** *Self-portrait*, 1888. 62·2 × 52·0 (24½ × 20½), Courtesy of the Fogg Art Museum, Harvard University

Below
Colour 25 **van Gogh** *Drawbridge near Arles*, 1888. 54·0 × 65·0 (21⅜ × 25¾), Rijksmuseum Kröller-Müller, Otterlo

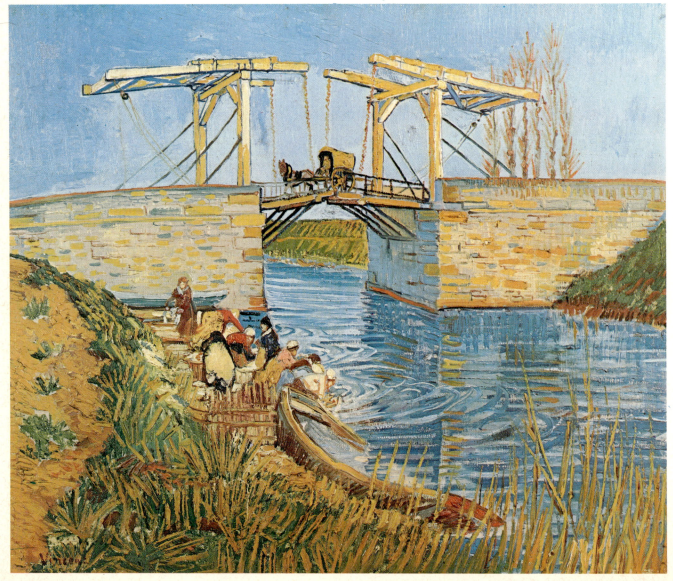

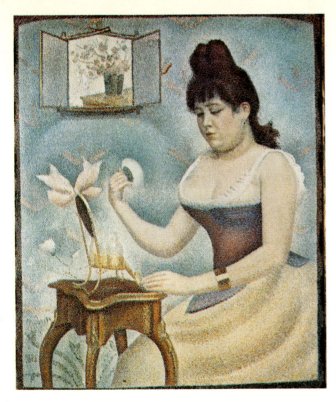

Left
Colour 26 **Seurat** *Young woman powdering her face*, 1888–9. 94·2 × 79·5 (37½ × 31¼), Courtauld Institute Galleries, London

Below
Colour 27 **Seurat** *L'Ile de la Grande Jatte*, 1884. 64·7 × 81·2 (25⅝ × 32), Collection of John Hay Whitney, New York

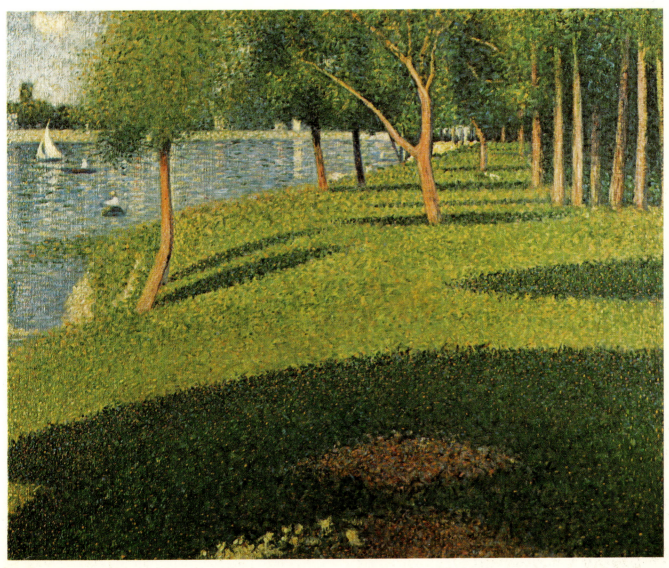

how to simplify his motifs into large, bold single-colour areas, with lively contour lines. He also acquired from the Japanese a range of subtle mixed hues with which to create colour arrangements far more delicate and arresting than the primaries in which all other Parisian posters were printed at the time. Using anything up to seven stones, Lautrec achieved a subtlety of hue which he enhanced by overprinting some areas with patterns and textures.

The famous poster for Aristide Bruant's cabaret, executed in 1893, shows how much Lautrec had learned from the prints of Kabuki actors (Plate 132). Bruant's face and the dress he used almost as a trademark have been synthesized into a single, powerfully memorable image. The simplification is dramatically effective and the lettering, kept to a minimum (Lautrec assumed everyone knew where the Bruant cabaret was situated), contributes to the design.

The lithograph of May Belfort is also closely related to Japanese prints (Plate 137). There is not only an abrupt transition from foreground to the focal point of the composition, but the pianist and the man to his right are both radically truncated. The dramatic white shape of May Belfort herself contrasts powerfully with the darker tone of the foreground.

Perhaps the most technically and artistically daring of all Lautrec's prints is the well-known lithograph of Loie Fuller of 1893. This shows the artiste in the middle of her 'fire dance', in which she flapped and flickered her filmy and copious costume in imitation of flames. Colta Feller Ives has noticed the similarity between this exciting routine and the 'lion dance', the energetic and very dramatic costume dance which constitutes the climax of so many Kabuki performances.[62] In both the fire and the lion dances, the clothes seem to take on a life of their own. Although the billowing major shape of Lautrec's lithograph has more in common with brush drawings than prints, the spectacular use of gold dust (which Lautrec applied to fifty of these lithographs) was obviously inspired by the *ukiyo-e* practice of using mica to give a polished background to some prints. Such backgrounds had been used by Sharaku, who was clearly one of Lautrec's favourite artists. The leering, snarling,

137 **Toulouse-Lautrec** *May Belfort*, 1895. Colour lithograph, 54·4 × 41·9 (21$\frac{3}{8}$ × 16$\frac{1}{2}$), British Museum, London

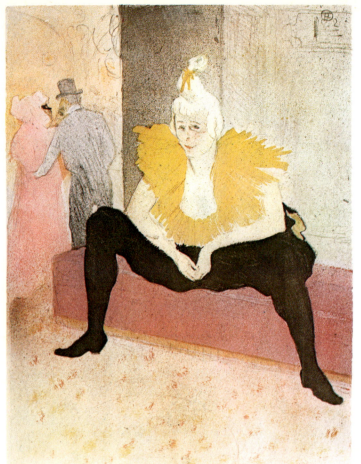

Left
Colour 28 **Toulouse-Lautrec** 'The seated clowness' from *Elles*, 1896.
Colour lithograph, 52·7 × 40·7 (20¾ × 16), British Museum, London

Opposite
Colour 30 **Schiele** *Self-portrait*, 1910. Watercolour and charcoal,
45·7 × 31·0 (18 × 12¼), Fischer Fine Art, London

Below
Colour 29 **Vuillard** 'Interior with pink wallpaper I and II' from
Landscapes and Interiors, 1899. Colour lithograph, each sheet
34·0 × 27·0 (13⅜ × 10⅝), British Museum, London

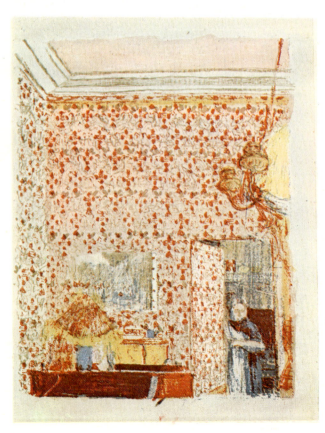

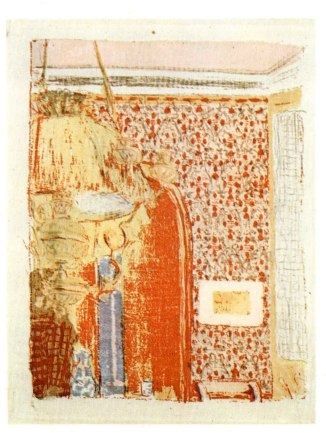

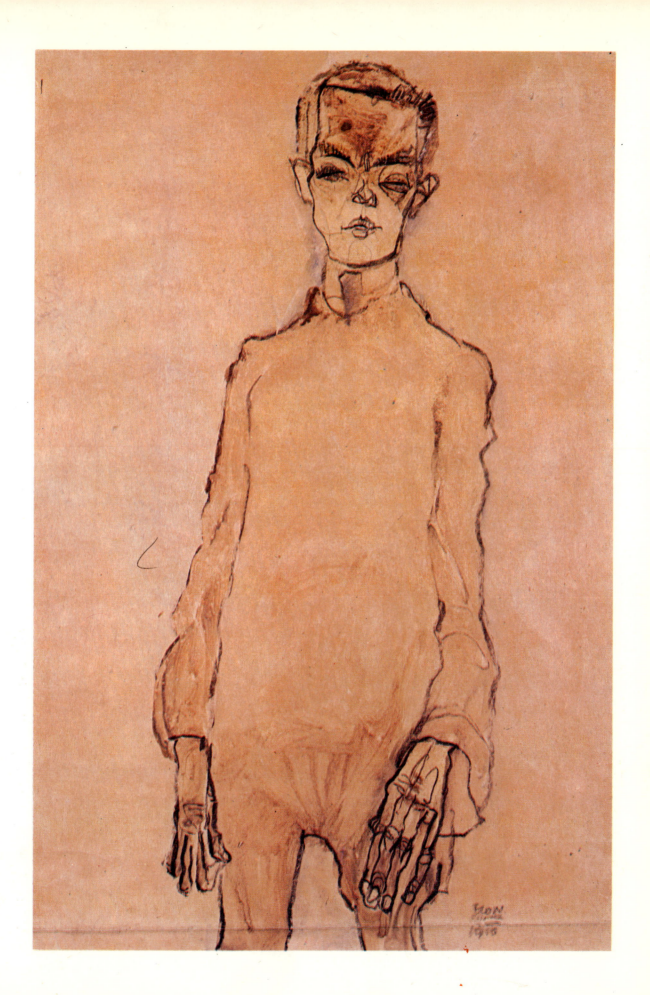

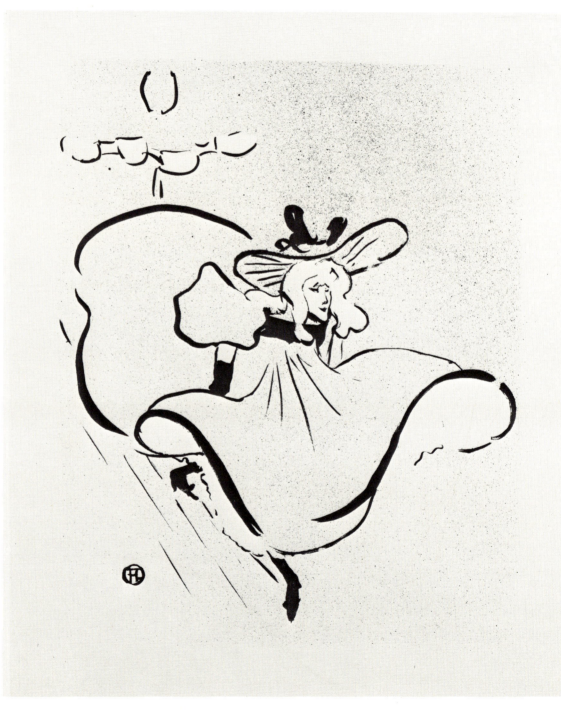

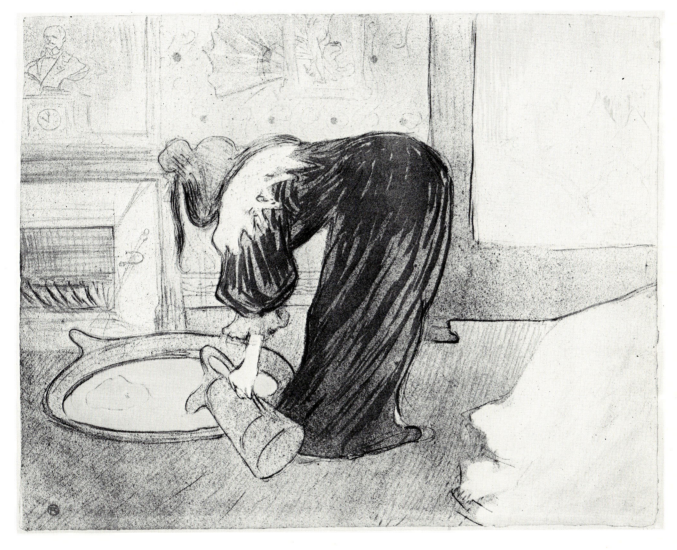

139 **Toulouse-Lautrec** 'Le Tub' from *Elles*, 1896. Colour lithograph, 40·0 × 52·4 (15¾ × 20), British Museum, London

Opposite
138 **Toulouse-Lautrec** *Jane Avril dancing*, 1893. Lithograph, 26·5 × 21·3 (10⅛ × 8⅜), British Museum, London

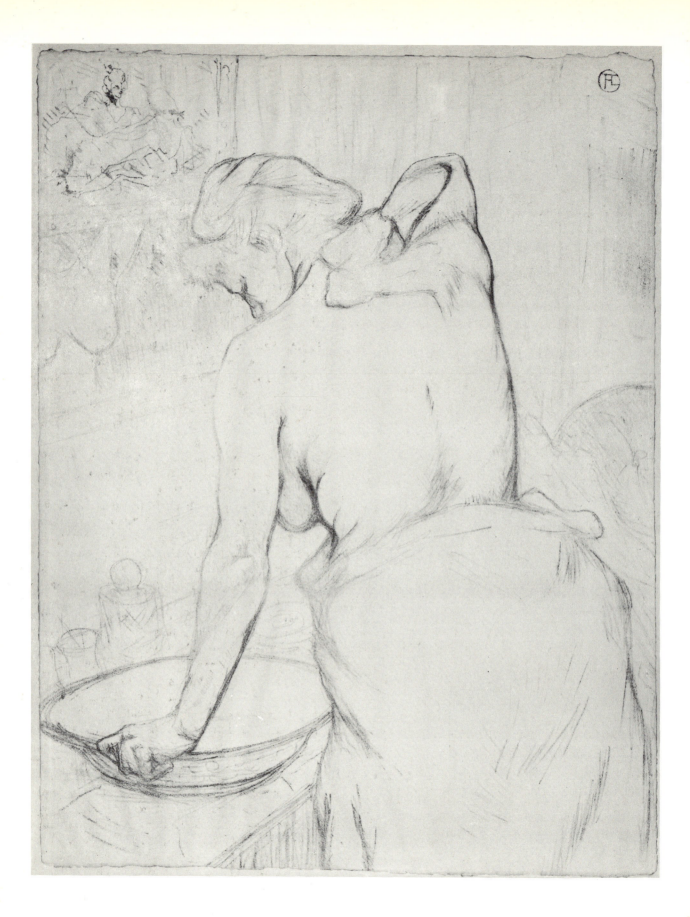

140 **Toulouse-Lautrec** 'La Toilette' from *Elles*, 1896. Colour lithograph, 52·4 × 40·0 (20⅝ × 15¾), British Museum, London

cross-eyed and comical grimaces into which Sharaku froze the physiognomies of his actors are very close to the faces pulled in Lautrec's work by Yvette Guilbert, Jane Avril and others.

Lautrec's lithographic work had an effect on his painting style, which increasingly exploited large areas of solid colour, silhouettes, muscular contours and flattened space. *Jane Avril dancing* (1892), although unfinished, exhibits many of these qualities. The tall vertical format is very Japanese, as is the eccentric placing of the dancer herself, whose puffed sleeves, feathered hat and angled legs create an interesting shape which is emphasized by a more or less continuous purple or white thick contour. Another lithograph of the same subject (Plate 138) reveals Lautrec's fascination for Oriental calligraphy in its freely flowering brush-strokes.

The subject matter of the great series of lithographs entitled *Elles* (1896) is at once entirely Lautrec and entirely Japanese: the everyday activities of the entertainers and prostitutes of Montmartre. It can be seen as a Parisian version of Utamaro's *Twelve Hours of the Green Houses,* although *Elles* makes no attempt to idealize or to show the women doing anything more intimate or elevated than combing their hair, washing and undressing (Plates 139 and 140). The most Japanese aspect of 'The seated clowness', however, is not so much its subject matter as its range of colours, especially the pale reds, the yellow, and the black (Colour Plate 28).

The Japanese character of Lautrec's art may have waned towards the end of his life, but his enthusiasm for Japan remained powerful until he died. Even in 1901, ill and confined to a wheelchair, Lautrec dreamed of sailing to Japan with friends, a project which his mother would have gladly financed and which would certainly have been realized years earlier if only the painter had found someone willing to accompany him. Like van Gogh, he had a fantasy vision of the country, a vision of an ideal and happy land made all the more poignant in Lautrec's case by his belief that 'his brothers', the Japanese, were as short as he was. At least his sustaining dream appears not to have been shattered by his visit to the Exposition Universelle in Paris in 1900, where he could wallow pleasurably in the atmosphere of an imported Japan.

141 **Vuillard** *The seamstress*, 1893. Lithograph, wood and engraving and woodcut, 19·0 × 25·5 (7½ × 10), The Metropolitan Museum of Art, Elisha Whittelsey Fund

The Nabis, Mary Cassatt and the Print Revival

On 25 April 1890 an exhibition of Japanese prints and other Japanese works of art opened at the Ecole des Beaux-Arts on the Quai Malaquais in Paris. There were 725 prints included, all of them from important French collections, and the catalogue for the whole exhibition was edited by Samuel Bing. The items were chosen to illustrate the history of *ukiyo-e* as well as to highlight the work of a selection of masters, especially the early primitives and Utamaro and Hokusai. It was, by all accounts, a beautiful show, and it was certainly the first anywhere to attempt a complete picture of the development of *ukiyo-e*. French, English, German and Belgian artists travelled to Paris especially to see the exhibition. Gustave Geffroy wrote several enthusiastic articles commenting on the large crowds of visitors and urging contemporary artists to learn to apply, in adapted form, avoiding mere slavish imitation, the lessons taught by the Japanese.

The Beaux-Arts exhibition was directly responsible for a renewal of interest in *ukiyo-e* and for a change in the kind of influence they exerted. During the 1890s there was a revival of print making which drew much from the Japanese in both content and technique. Auguste-Louis Lepère (1849–1918) had begun to make woodcuts as early as 1889, and the simplified system of broad areas of black and white he evolved in these owes much to the Japanese aesthetic. Similarly, Henri Rivière (1864–1951) employed the printing-methods and the water-based inks of *nishiki-e* as well as producing lithographs that imitated their subject matter and stylistic devices. Many of these lithographs depict Paris in ways which are suggestive of Hiroshige's views of Edo and Hokusai's views of Mount Fuji. In *Thirty-six Views of the Eiffel Tower* of 1888–1902 (the title is obviously derived from Hokusai), one of the lithographs shows a glimpse through a part of the Eiffel Tower, whose girders dominate the foreground. In another, the uncompleted tower stands out against a grey sky that is dotted with snowflakes in the

manner of Hiroshige's snow scenes (see Colour Plate 7). Rivière not only followed the Japanese penchant for dividing the composition of prints into two planes, one close and one distant, but also, in the woodcuts he produced, he borrowed from Japanese techniques of execution, using pear instead of box-wood and cutting along the grain rather than against it in the traditional European fashion.

The Swiss-born artist Félix Vallotton (1865–1925) also refined and developed the technique of woodblock printing. Unlike Rivière, he restricted himself to black and white; and he showed nothing of Rivière's interest in the subject matter of *ukiyo-e* except in a few early examples, confining his subjects on the whole to contemporary interiors with figures, clothed and nude. Neither did he employ the more extreme Japanese compositional methods in his prints. He did, however, arrange his large black and white shapes in a way that was inspired by the Japanese characteristic of creating a subtle, asymmetrical 'balance' between solid areas of colour and the empty spaces between them.

Vallotton was an intimate of the Nabis, a group of young artists who in 1888 founded a secret society which increasingly became devoted to a quasi-religious, ritualistic sort of art (Nabi is the Hebrew word for 'prophet'). The society, whose pre-eminent members were Maurice Denis, Pierre Bonnard, Edouard Vuillard and Paul Sérusier, played an important role in the development of both painting and print making throughout the 1890s. The most important influences on them at this time were Gauguin and Japanese prints. It was Gauguin's work that provided the initial impetus for the formation of the group. Paul Sérusier, a student at the Académie Julian in Paris, was painting at Pont-Aven in Brittany in the summer of 1888. Intrigued by Gauguin and his work, Sérusier asked his friend Emile Bernard to arrange an introduction to Gauguin, and the outcome of this was a painting lesson. In front of some trees by a river in the Bois d'Amour, Gauguin had urged the young artist to simplify the shapes and brighten the colours of what he saw. 'How do you see these trees?' Gauguin asked him: 'They are yellow. Well then, put down yellow. And that shadow is rather blue. So render it with

pure ultramarine. Those red leaves? Use vermilion.'[63] Sérusier took the result of his tuition – painted on the lid of a cigar box – back to the Académie Julian in triumph, and it so impressed his friends there that they called it *The Talisman,* and resolved to use it as the basis of a new artistic programme.

The founder-members of the newly-formed group (Sérusier, Denis, Bonnard and Paul Ranson) now dedicated themselves not only to a range of religious and mystical subjects related to Christian myths and church rites, but also to developing the exciting and radical style which Gauguin had brought to their attention. The departures from reality which characterize the style (the simplification of form, the exaggeration of colour and line) were made in the belief that paintings could justifiably distort reality in the interests of communicating an emotional impact or even an abstract aesthetic sensation. Gauguin's style, and the Nabi style that derived from it, therefore look forward to non-figurative painting, to an art consisting entirely of colours and forms which make no reference to the 'real' world. Neither Gauguin nor the Nabis achieved anything like total abstraction in their own work, but the theoretical basis for it was there, as is shown by Denis' famous dictum (first published in *Art et critique,* August 1890): 'Remember that a painting, before it is a representation of a battle-horse, a female nude or of some kind of story, is first and foremost a flat surface covered with coloured shapes arranged in a certain order.'[64]

More than a decade elapsed before the full implications of this revolutionary contention were understood and made the cornerstone of a new kind of art (by Kandinsky, Malevich, Mondrian and others). The subsequent rise of abstract painting after 1910 attests to the significance of Denis' theories and of the Nabis' work generally. It also attests, by extension, to the importance of the Japanese influence in France during the 1890s.

The attraction to Japanese prints had undergone a number of changes in emphasis since it had first been felt by French artists thirty years earlier. Manet and Degas had been as fascinated by the 'realistic' subject matter of the *ukiyo-e,* their representation of everyday life, as much as by their formal qualities. With the

Opposite far left
142 **Denis** *Portrait of Mme Paul Ranson, c.* 1892. 89·0 × 45·0 (35 × 17¾),
Collection D. Denis, St Germain en Laye

Opposite left
143 **Bonnard** *The dressing-gown, c.* 1890. Oil on silk, 154·0 × 54·0
(60¼ × 21⅜), Musée d'Art Moderne, Paris

each part of the diptych makes sense as a composition in its own right. The pastel colours of the prints in this album, especially the pinks and greens, may also owe something to *nishiki-e* and to Utamaro in particular. However, it would be wrong to exaggerate Vuillard's debt to Japan. The softness of the colours and the soft, crumbling quality of the line and of many of the edges of the solid areas are the hallmarks of lithography, and are fundamentally different from the sharpness and clarity of a woodcut. Vuillard, moreover, unlike Bonnard and most of the other Nabis, showed no interest in the technique of containing separate areas of colour by a thick dark line.

These prints are related in style and subject to the series of painted decorative ensembles which Vuillard produced at about the same time. Of these the most Japanese in character are the nine landscape panels commissioned in 1894 by Alexandre Natanson for the dining-room of his Paris house. Each contains a high horizon line, which has a flattening effect on the motifs, and the format of each is a pronounced vertical. A feature of them that is even more reminiscent of *nishiki-e* is the fact that the nine panels were conceived as one triptych and three diptychs. As in the interior scene with pink wallpaper, the composition of each fully exploits the join. Another aspect of Vuillard's paintings which has Japanese overtones is his frequent depiction of rich and often clashing fabric designs to create what could almost be described as fabric still-lifes. These are often reminiscent of the varied and bold patterns of the kimono: Vuillard indeed owned a kimono which he often included in his canvases. However, the Japanese qualities of Vuillard's painted work remain inconsiderable in comparison with those of his prints.

As might be expected from his Nabi sobriquet, it was Bonnard who of all the Nabis most radically applied aspects of the Japanese aesthetic to his own work. Like Vuillard, he was more indebted to Japan in his prints than in his paintings; his *The dressing-gown* – which, like Denis' *Portrait of Mme Paul Ranson* (Plate 142), recalls in subject and format the numerous *kakemono-e* depicting women in colourful kimonos – is exceptional among the paintings in having a definite Japanese flavour (Plate 143). In the prints Bonnard's interest in Japanese styles

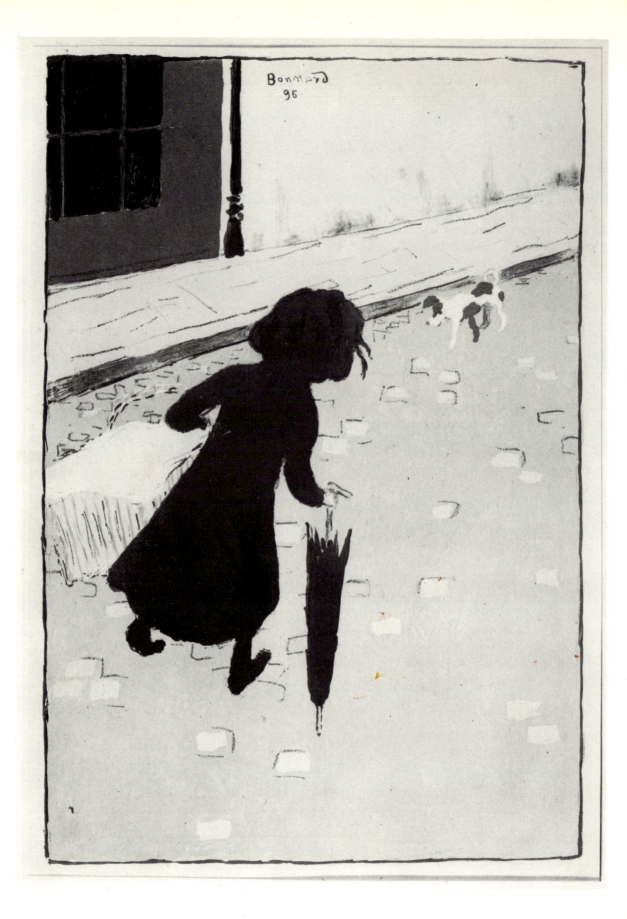

226

victory of Realism, however, the print artists' honest portrayal of the ordinary began to seem less unusual, and painters such as van Gogh and Gauguin found themselves seduced instead by the stylistic traits of *nishiki-e*. They saw in them the basic vocabulary of a new artistic language by which forms and colours, released from their descriptive function, could be freely used to evoke states of mind. The Nabis, drawing on prints both directly and in a form already filtered through Gauguin, took this development away from pure description a stage further in their paintings, while at the same time being stimulated by the prints to make prints of their own, whose subjects were often very Japanese in flavour.

The Nabis met regularly, invented rituals and gave each other special pseudonyms. Denis was called 'the Nabi of the beautiful icons'; Vuillard (who joined later) 'the Zouave Nabi', after the French light-infantry corps (recruited chiefly from Algerians) whom he was fond of representing in his prints in their colourful Oriental costumes; and Bonnard was 'the very Japanese Nabi', because he was the member most interested in Japanese art and the first to be influenced by it in his own work.

Maurice Denis said that the influence of the Japanese 'worked like yeast' on all the Nabis. The precise nature of its working, however, is difficult to isolate because it was exerted twice: indirectly through Gauguin and directly through the *nishiki-e* themselves. Among the obvious examples of direct influence are some of Paul Ranson's lithographs ('Tiger in the jungle' from Marty's album *L'Estampe originale*, for instance) which are slightly modified copies of prints by Utamaro and Hokusai. In the woodcuts produced by Denis to illustrate Verlaine's *Sagesse* between 1889 and 1891, the debt to *nishiki-e* is equally clear: in the Japanese manner, the wood is cut along the grain rather than against it. Denis' lithographic illustrations to Gide's *Voyage d'Urien* (1893) are even more Japanese in flavour: the images, each with a decorative border, are composed of sinuously curving lines and even include figures with Oriental features. Some of Denis' prints use a tall, narrow format that is similar to the shape of *kakemono-e*. Yet these Japanese elements, and others related to them, were restricted to the early part of his career and in any case were not used

extensively. Ranson's interest in Japan was more limited still. Among the Nabis it is to Bonnard and, to a lesser extent, Vuillard that one must turn for examples of a more thorough-going absorption of the techniques of the Japanese print artists.

Bonnard and Vuillard, together with Denis, were frequent and enthusiastic visitors to the 1890 Beaux-Arts exhibition. Almost immediately afterwards they began to borrow Japanese motifs and stylistic devices in their painting and print making. They experimented with bold truncations of major parts of the motif, silhouettes, decorative borders and sharp, sudden shifts from foreground to background. The twenty or so colour lithographs which Vuillard produced around 1895 are especially Japanese, as is *The seamstress* (1893) – a combined lithograph and woodblock print in which several different strong patterns (from the varied chevrons and flower motifs of the background to the bold check of the woman's dress and the sinuous pattern of the material she is sewing) combine to form a harmonious whole (Plate 141). The most important and the most Japanese of Vuillard's prints, however, are to be found in the album *Landscapes and Interiors,* a portfolio of twelve colour lithographs published in 1899 by Ambroise Vollard, himself a collector of Japanese art.

Some of the subjects in this album are seen from a high viewpoint, in a way that is reminiscent of many *nishiki-e*. In one of them, for example, a cook is sitting to the left of an almost vertical line created by the patterned edge of her cooking range, which, unlike the woman herself, is seen from above. The effect of this dual viewpoint is to shift the accent of the picture away from the representational and towards the abstract, so that the cook's plump shape becomes part of an intricate, flat design. This is a device commonly used in Japanese prints. The diptych showing an interior with pink wallpaper is organized on a simpler basis, with an eye-level viewpoint, but the Japanese inspiration is no less apparent (Colour Plate 29). The sense of space created by the ceiling-coping is counteracted by the dense pattern of the wallpaper, the lack of shadows and by the inclusion of the ornate hanging lamp which dominates the foreground and is cut in two by the join in the diptych. In the Japanese style,

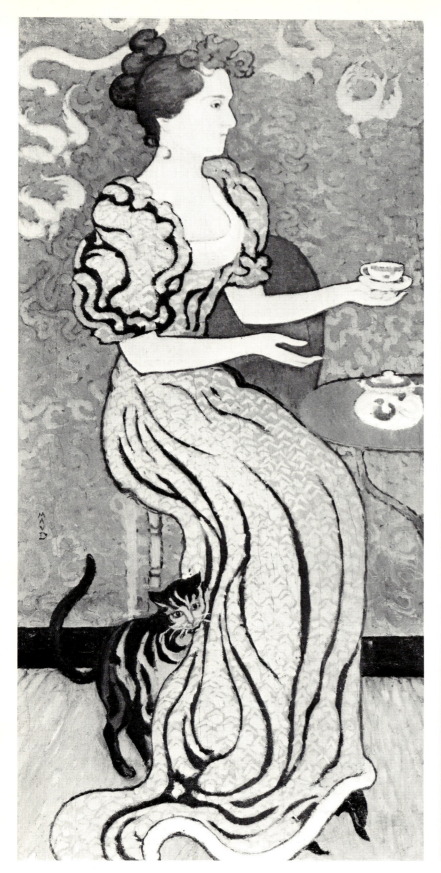

Above
145 Woodcut from *Le Japon Artistique*, March 1891. Private collection

Opposite
144 **Bonnard** 'The little washerwoman' from *Album des peintres-graveurs*, 1896. Colour lithograph, 30·0 × 19·0 (11⅞ × 7¼), The Metropolitan Museum of Art, The Harris Brisbane Dick Fund

was betrayed by his use of silhouettes, emphasized contour lines and areas filled in with a single, unvarying colour.

Elements derived from *nishiki-e* are especially obvious in Bonnard's prints of the 1890s. The lively black silhouette of 'The little washerwoman' from Vollard's *Album des peintres – graveurs* is related to a Japanese woodcut vignette reproduced in *Le Japon Artistique* in 1891 (see Plates 144 and 145); and the 'Woman with umbrella' (Plate 146) seems to be a variation of a pose depicted in the *Manga* (Plate 99). Bonnard's album of colour lithographs, *Some Aspects of Paris Life,* published in 1895, uses Japanese examples in a more subtle way. The idea for the album obviously came from Hiroshige's *One Hundred Views of Edo.* Also derived from the Hiroshige are the essentially geometric construction, which gives each scene an ordered, measured appearance, and the use of a high horizon line (often so high that it does not appear at all). In the latter respect, many of these prints by Bonnard bring to mind Théodore Duret's remarks in an essay on Hokusai published in 1882 in the *Gazette des Beaux-Arts:* 'They are seen,' Duret wrote, 'from a high plane, with a perspective which lifts distant planes up to the top of the picture and makes people and objects stand out not against the background of sky but against the background of the landscape itself.'[65] One of the prints depicts from above the intersection of two roads and the houses that flank them in a way that suggests the inside of a box dotted with silhouetted figures (Plate 147). Similarly, the almost square 'House in the courtyard' is an exercise in rectangles, showing the façade of a house, with its roof and shutters, through an open window. 'Boulevard' has a long horizontal format divided by a series of vertical tree-trunks between which people walk (Plate 148). There is no horizon line and the composition suggests a division into three parts, like a triptych.

Perhaps the most Japanese of all Bonnard's prints are the coloured lithographs he designed for a four-part screen in 1892 (Plate 149). The proportions of the screen are exactly those of a *byōbu* and the various elements of the composition are distributed across the four narrow, vertical rectangles with a delicate sense of space and tonal

146 **Bonnard** 'Woman with umbrella' from *Album de la Revue Blanche*, c. 1895. Lithograph, 22·0 × 14·0 (8¾ × 5½), Private collection

147 **Bonnard** 'At the corner of the street' from *Some Aspects of Paris Life*, 1895. Colour lithograph, 36·8 × 21·0 (14½ × 8¼), British Museum, London

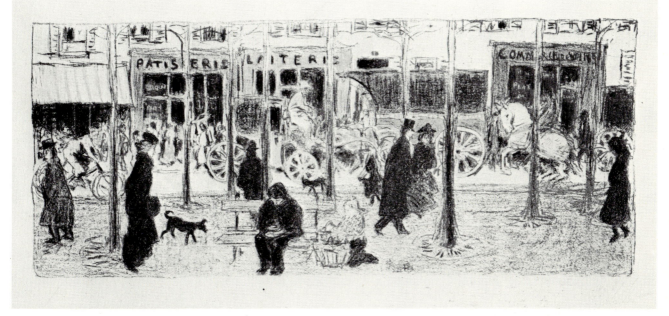

148 **Bonnard** 'Boulevard' from *Some Aspects of Paris Life*, 1895. Colour lithograph, 17·2 × 43·0 (6¾ × 17), British Museum, London

contrast. The composition is anchored by the row of horse-drawn hansom cabs which extends across the top of the screen, and the design is pivoted on the circular hoop, placed slightly off-centre. All the lithographs Bonnard produced at this time exploit the relatively new technique of washing. By using a brushed-on lithographic ink instead of a wax crayon it was possible to imitate the Japanese method of applying water-based paint to the block and printing with the aid of a *baren*.

The Nabis, as well as contributing greatly to the general revival of print making in France during the 1890s, were also important for a rather different, though related reason. Along with Toulouse-Lautrec (with whom they were associated through *La Revue Blanche*), they were the first French painters to allow their prints to be as radically affected by Japanese art as their painting. Some of Manet's etchings and Degas' lithographs reflect their interest in Japan, but the debt is not so clear as it is in the paintings. In the case of the Nabis this emphasis

was reversed, for it is in their prints that the techniques of the *nishiki-e* artists were absorbed most thoroughly and adapted to a Western context.

In addition to the Nabis, another artist working in France who contributed to the revival of print making in the 1890s, as well as being strongly influenced by the Japanese aesthetic, was the American-born Mary Cassatt (1844–1926). She was a close friend of Degas, who not only invited her to exhibit with the Impressionists (which she did in 1879, 1880, 1881 and 1886) but also introduced her to Japanese prints. In 1890 she visited the Beaux-Arts exhibition with Degas, and immediately afterwards she began to collect *nishiki-e* and decorated both her country-house and her studio in Paris with prints of women and children, especially ones by Utamaro.

Although Japanese prints scarcely ever affected her painting in any obvious way, they soon began to make an impact on her graphic art.

Within a year of the exhibition, Cassatt had produced

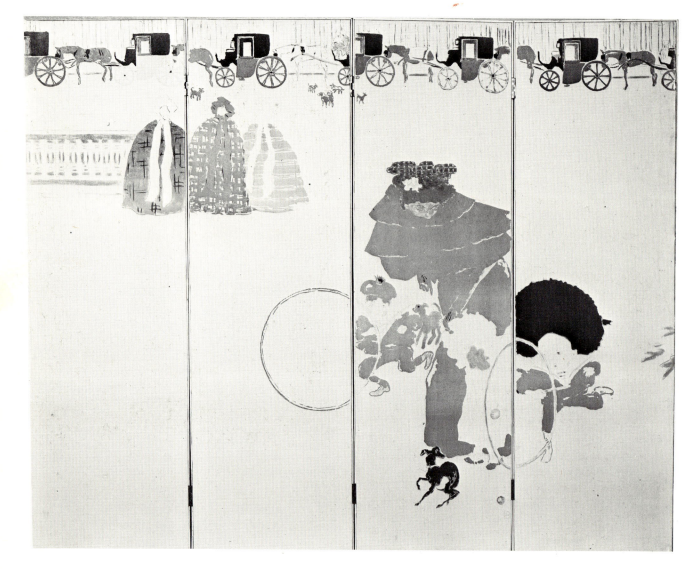

149 **Bonnard** *Street scene, c.* 1899 after a design of 1892. Colour lithograph screen, 147·0 × 186·0 (59 × 73¼), Museum für Kunst und Gewerbe, Hamburg

a series of etchings depicting intimate domestic life (exhibited at Durand-Ruel's gallery in April 1891) which are among the most perfect syntheses of Eastern and Western art ever produced, and mark a definite stylistic departure in her work. The medium she worked in – etching combined with aquatint – was commonly used by her friend Degas but seemed an unlikely choice for an artist inspired by the Japanese aesthetic: lithography, or woodblock printing itself, would have been more obviously appropriate. Cassatt exploited to the full, however, the capacity of etching for producing clean and elegant lines and of aquatint for achieving soft, uniform areas of colour. In a letter of May 1906 to the Curator of Prints at the New York Public Library she described how these etchings were made:

> I drew the outlines in drypoint and laid on a ground where colour was to be applied, then coloured 'à la poupée' [ie., in a flat, uninflected manner]. I was entirely ignorant of the method when I began and as all the plates were coloured by me, I varied sometimes the manner of applying the colour. The set of ten plates was done with the intention of attempting an imitation of Japanese methods.[66]

The Japanese look of these prints was immediately recognized by Pissarro, who wrote to his son Lucien on 3 April 1891 that 'Miss Cassatt has realized just such effects, and admirably: the tone even, subtle, delicate, without stains on the seams: adorable blues, fresh rose, etc. . . . the result is admirable, as beautiful as Japanese work, and it's done with printer's ink!'[67]

In the subject matter of her etchings also, as well as in her technique, Cassatt betrayed a debt to Japanese prints. One of the most important categories of *ukiyo-e* was that concerned with the portrayal of life in the home – women at their toilet, dressing, and suckling or embracing children – and these are the subjects which Cassatt depicted in her etchings. The first of the series, *The bath,* described in the Durand-Ruel catalogue as 'an attempt to imitate the Japanese print', shows a woman testing the temperature of the water with one hand while holding a naked child with the other. There are several analogous prints by Utamaro showing a circular tub truncated by the left-hand edge of the design, as it is in the Cassatt.

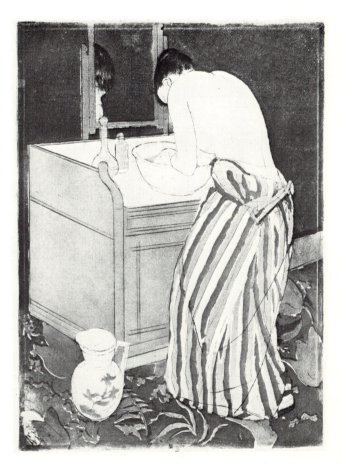

150 **Cassat** *Young woman*, 1891. 36·2 × 26·7 (14¼ × 10½), Bibliothèque Nationale, Paris

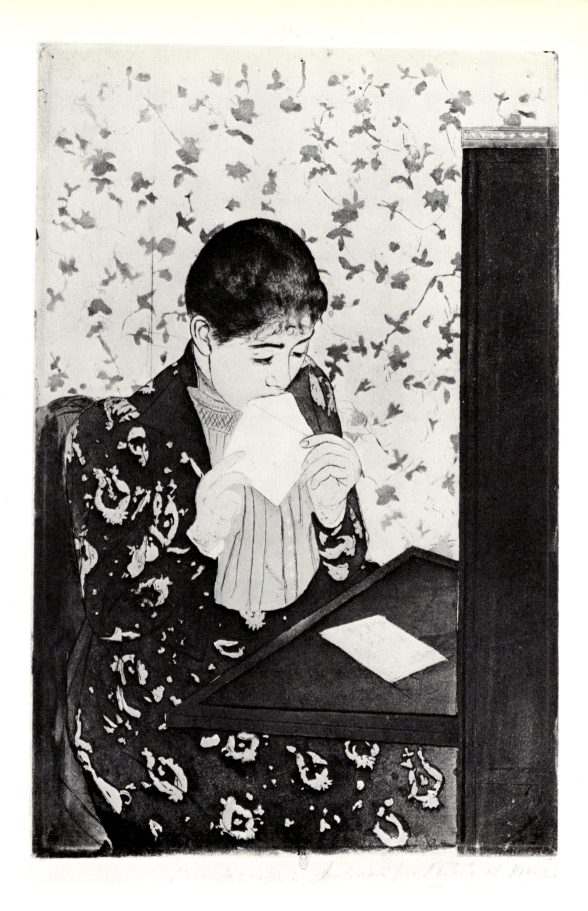

Cassatt's *Maternal caress* and *The fitting* are also strongly reminiscent of prints by Utamaro; and in *The letter* (Plate 151) the pentagon of the envelope being licked recalls the shape of the paper handkerchief which is held in the mouth of many of Utamaro's and Eisen's *oiran* as a sign of great emotion (see Plate 152).

One print in Cassatt's 1891 series which is especially typical in its endebtedness to *nishiki-e* is the delightful *Young woman* (Plate 150). The lady, naked to the waist with her back towards the spectator, is bending over a bowl on a toilet stand. Part of her face is reflected in a small mirror. Not only is the subject clearly Japanese in flavour, but the flat, saturated colours and the subtlety of the colour combinations (the green, pink and white on the robe, for example) also owe much to Japanese models. The clean sharpness of the line, especially around the edges of objects, is also obviously Japanese, and so is the variety of patterns in the lower half of the print. Cassatt has here succeeded triumphantly in translating the qualities of Utamaro's woodcuts into the medium of etching.

These prints of 1891 are among the most important works of art Mary Cassatt produced during her long career. Sadly, for reasons that remain unclear, she never managed to repeat the success. In terms of her own output, her etchings on domestic themes remain an isolated manifestation of the continuing influence of Japan on artists in France during the 1890s.

Above
152 **Eisen** *Woman with an unsettled mind.* 38·1 × 25·4 (15 × 10), Victoria & Albert Museum, London

Opposite
151 **Cassatt** *The letter*, 1891. Colour print with drypoint, soft ground and aquatint, 36·5 × 26·7 (14⅜ × 10½), Bibliothèque Nationale, Paris

Fin de Siècle: England, Germany and Austria

It is inevitable that any study of the influence of Japanese prints during the nineteenth century should concentrate on France, for it was there that their impact on painting and print making was most spectacular and significant. It would be a mistake, however, not to take account, however briefly, of the various manifestations of the Japanese influence in other countries, and especially in Britain. It is likely that Japanese art was 'discovered' in England earlier than in France, and that there was a limited interest in prints in London even before Whistler settled there. According to Elizabeth Aslin, William Burges, the Neo-Gothic architect and designer, was collecting Japanese prints as early as the 1850s. Burges, who believed that the art of Japan, like that of medieval Europe, was more vital than that of nineteenth-century English art, also collected Japanese book-wrappers. On one of these is a pattern which Whistler used in modified form for his butterfly monogram.

The impact of Japan on English art is more obvious in the decorative and applied arts than it is in painting. The only major exception to this generalization is the art of Whistler (see pages 131–47). Rossetti collected prints, pottery and Oriental fabrics, but there is little evidence of this interest in his canvases. In the early 1860s, 'blue-and-white' Oriental pots appeared in several of his paintings (one example of which is *Girl at a lattice,* painted in 1862, now at the Fitzwilliam Museum, Cambridge); and *The beloved* of 1865, intended as an illustration of *The Song of Solomon,* shows the lady of the title dressed in a rich gown embroidered with bamboo leaves and with a gold and red enamel Chinese ornament in her hair. Yet these examples can scarcely be described as clear reflections of Rossetti's interest in the Orient. Only in some of his designs for book-bindings and in some of the patterns he applied to his picture-frames can this interest unambiguously be sensed. In the design for the binding of Swinburne's *Atalanta in Calydon,* four circular Japanese *mon* are placed near the borders, leaving most of

153 **Beardsley** 'The Lacedaemonian Ambassadors' from *The Lysistrata of Aristophanes,* 1896. Ink on paper, 26·0 × 17·8 (10¼ × 7), Private collection, London

the area blank in the Japanese style. Whistler's friend, the painter Albert Moore, was also an admirer of things Japanese, and his enthusiasm is perhaps detectable in his painting in the generalized atmosphere of precious exoticism which pervades several of his works, in his frequent use of flattened perspective and in his close attention to formal balance. Yet such Japanese elements, when they occur, are usually rather inobtrusive and ambiguous, and do not emerge from any whole-hearted absorption of the techniques of Japanese prints.

For a more thoughtful and significant response to Japanese art in England at this time, we must turn not to painting, but to the various minor arts, such as interior design, ceramics, posters and book illustration: for instance, to the functional utensils (the teapots, vases, etc.) of Christopher Dresser, or to the sparsely decorated furniture designs of E. W. Godwin. Walter Crane admitted that his drawings for children's stories were in part inspired by Japanese prints from as early as 1865. And in 1884, when Whistler and Godwin began work on the decoration of Oscar and Constance Wilde's house in Tite Street, Chelsea, and incorporated a dining-room decorated entirely in white, together with folding doors, the inspiration for the scheme was undoubtedly Japanese. While interest in Japan was on the decline in French artistic circles, the Oriental vogue dominated the English design world. It was augmented by a growing number of firms specializing in imported Oriental goods or in English products made in imitation of them. As Elizabeth Aslin writes of this period,

> Every mantelpiece in every enlightened household bore at least one Japanese fan, parasols were used as summer firescreens, popular magazines and ball programmes were printed in asymmetrical semi-Japanese style and asymmetry of form and ornament spread to pottery, porcelain, silver and furniture.[68]

At times ridiculously excessive (and brilliantly satirized by, among others, George du Maurier in his *Punch* cartoons of the 'aesthetic family', the Cimabue Browns), the passion for Japan provided the strongest influence on English design from the middle 1860s to the turn of the century. The qualities of Japanese artefacts that particularly appealed to English designers were their simplicity, their unusual proportions and their high degree of craftsmanship.

The vogue for Japanese design was accompanied by a growth in scholarship and serious collecting. Several books were influential. In 1867 Owen Jones, best-known for his *Grammar of Ornament,* published his *Examples of Chinese Ornaments,* which included items taken from Japan as well as China. In 1872 Charles Eastlake's *Hints on Household Taste* appeared, drawing heavily on Japanese examples. Rutherford Alcock's *Art and Industries in Japan,* which appeared in 1878, had the advantage of its author's lengthy personal acquaintance with Japan and of his extensive knowledge of Japanese arts and crafts. Christopher Dresser's *Japan, Its Architecture, Art and Art Manufactures,* published in 1882, was also based on its author's travels: Dresser, one of the first Englishmen to visit Japan after the Meiji Restoration, had been invited there by the Emperor to advise on the export of arts and crafts from Japan to Europe. In 1871 and 1872 the South Kensington Museum (later to become the Victoria and Albert Museum) substantially increased its holdings of Oriental art and design. And later in the same decade, G. A. Audsley of Liverpool published several books about Japanese art and crafts, including a *catalogue raisonnée* of the important collection of the former consul in Japan, James L. Bowes.

During the 1870s the Japan craze was virtually synonymous with the Aesthetic Movement, which is now linked in the popular imagination with the catch-phrase 'art for art's sake' and with the highly polished writing and studied *persona* of Oscar Wilde and his associates. In the realm of the visual arts the Aesthetic Movement was concerned with elegant expression and the creation of dazzling qualities of decoration and surface. It relied heavily on Japanese examples for its compositional devices and for its various tricks of pattern and design. Wilde often refers to Japanese art in his writings, and on one occasion he explains how the Japanese aesthetic vision can be applicable to the experience of a Westerner:

> If you desire to see a Japanese effect, you will not behave like a tourist and go to Tokyo. On the contrary, you will stay at home and steep yourself in the work of

certain Japanese artists, and then, when you have absorbed the spirit of their style, and caught their imaginative manner of vision, you will go some afternoon and sit in the Park and stroll down Piccadilly, and if you cannot see an absolutely Japanese effect there, you will not see it anywhere.[69]

In the 1890s the Aesthetic Movement gave birth to Art Nouveau, which was a new approach to design of all kinds, including architecture – a highly decorative style characterized above all by flamboyant, curving motifs derived from nature (particularly from plant life), by flat surface patterns, and by a belief that art and design are potentially life-enhancing. It assumed a different form in every country in Europe, and in different countries the theories behind it developed in different ways. The use of the term itself was confined to the English, who had derived it from the name of Samuel Bing's arts and crafts shop (designed inside and out by the brilliant and versatile Belgian, Henry van de Velde) which opened in Paris in 1895. Elsewhere it was called, among other things, Jugendstil and, significantly, Stile Liberty. In each of its various forms it was concerned chiefly with the applied arts and affected painting only indirectly. It is in Art Nouveau that the enthusiasm in Europe for Japanese art of all kinds, including prints, reaches its climax. When the style rapidly began to become obsolescent after the turn of the century, the Japanese obsession was one of the factors which helped to accelerate its decline.

Some of the finest work in England to be executed in the Art Nouveau style, as well as the clearest reflections of the Japanese influence on English art, can be found in the book illustrations of Aubrey Beardsley (1872–98). Throughout his career, Beardsley was an eclectic, and borrowed from medieval art, from rococo, and from Greece and Rome, as well as from Japan. However, the vitality of his line, the precision of his counterpointing of black and white, and the complete lack of light, spatial depth or modelling in his prints, are all characteristics borrowed more obviously from *ukiyo-e* than from any other sources.

Only very infrequently do references to Japanese prints occur in Beardsley's letters, although he does refer on one

occasion to a set of erotic *shunga* which he owned, and on another to one of his own drawings 'worked in a semi-Japanese style'. His interest in *nishiki-e,* however, is made perfectly clear in the works themselves, from 1892 onwards. In that year, in the full-length drawings of Klavsky as Isolde, of Carl Maria von Weber, and of Raphael Sanzio (all now in the University Library, Princeton), he produced the first examples of his own style of *japonisme*. These portraits are devoid of any half-tones, and are characterized also by an almost *kakemono-e* format, and by horizontal bands of black and white.

Any assessment of Beardsley's debt to Japan is complicated by a parallel debt to William Morris and Burne-Jones. Thus, many of the illustrations for *Le Mort Darthur* consciously allude to items produced by Morris' Kelmscott Press, but on the other hand a few of them are very Japanese. 'La Beale Isoud at Joyous Gard' (Chapter LII, Book X, Vol. II), for example, has a very simple design extending across two pages, so that the total effect is like that of a *nishiki-e* diptych.

The frontispiece to *Virgilius the Sorcerer* (1893) (Plate 154) is one of the most Japanese of all Beardsley's drawings. The asymmetrical placing on the page, the expressive contour, the treatment of the pattern on the flowing, kimono-like robe, and the dramatic contrasts of black and white, make the debt to *nishiki-e* plain.

Beardsley was a knowing and cunning manipulator of his sources, incorporating elements from various styles with an air of playfulness. Because his precocious talent emerged all of a piece, apparently mature from the first, there is little sense of development in his style, only of changes in emphasis and direction. The illustrations for Pope's *Rape of the Lock* (1896) mark a move towards a more ornate style derived from rococo; but then, later in the same year, the direction changes again and the dramatic tonal contrasts and linear elegance of the cover for *Ali Baba* and the illustrations for Aristophanes' *Lysistrata* re-introduce the predilection for the Japanese style. The subject matter of the *Lysistrata* is Greek, as is the scatology, yet for all the connections between Beardsley's drawings and pornographic Attic vases, the closest parallel is with Japanese erotic prints, especially in

154 **Beardsley** Frontispiece to *The Wonderful History of Virgilius the Sorcerer of Rome*, 1893. Ink on paper, 22·9 × 14·0 (9 × 5½), The Art Institute of Chicago

the obsession with elephantine male organs and the way in which scenes of enormous grossness are made to seem tasteful by the delicacy of the line and the grace of the positioning (see Plate 153). Beardsley studied Greek vase painting in the British Museum in 1894, but he was also an admirer of *shunga,* and the set of Utamaro's erotic prints given him by William Rothenstein was merely a part of his considerable collection. In the bringing together of Greek and Japanese sources one is reminded of Whistler's concluding remarks in his *Ten o'Clock Lecture,* and of the numerous articles in French art journals that sought to show the connections between the Hellenistic and Oriental artistic traditions.

Beardsley's illustrations (together with his posters advertising books and theatrical productions) must be seen against the background of the upsurge of interest in the graphic arts generally that appeared throughout Europe in the 1890s. One aspect of this which was based directly on the Japanese method was printing from woodblocks with water-soluble inks rather than oil-based inks in the European fashion. In 1894 an anonymous writer published a series of articles in *The Studio* entitled 'Woodcut Printing in Watercolours after the Japanese Manner'. Based on Japanese methods, he wrote,

> but not necessarily imitative in the effects produced, or in many details of the process, it is possible that a new school of artistic prints is growing up in Europe today. Examples by MM. Lepère and Rivière etc., shown lately in Paris and London, and others, less known, produced in England by M. Lucien Pissarro, Mr Edgar Wilson and Mr J. D. Batten, prove that the craft has vitality enough to inspire European artists to develop a convention of printing in watercolours, that may one day take its place with etching, mezzotint, lithography, and those reproductive arts peculiarly under control of the artist himself.[70]

The new interest in graphic arts of all kinds was especially common among the practitioners of Art Nouveau. By this time, the style had become entrenched throughout Europe, and Japanese elements had become so completely synthesized in it and had meshed so inextricably with qualities from other sources, that it is difficult to separate out the various ingredients. In France the style owed much to the flat, decorative approach of Gauguin and Toulouse-Lautrec as well as to the rather similar characteristics of the *nishiki-e,* and this is a further instance of the complexities created by such a profound and long-lasting influence: Gauguin and Toulouse-Lautrec, as we have seen, had themselves been strongly affected by Japanese prints. In every country the style took on slightly different forms, but throughout Europe common ground was provided by two distinctive features which clearly had affinities with *nishiki-e,* however much the connections might be blurred by various cross-currents of influence. One of these features was the prevalence of sensitive, linear, flat yet colourful designs; the other was a love of asymmetry, a tendency to place the focal point of a composition to one side or the other in the interests of greater vitality of form.

The Studio, the magazine which did most to publicize the ideas behind Art Nouveau at a time when they were not yet universally current, acquired a wide readership not only in England but throughout Europe, especially in Germany. Here, its influence was complemented by that of the Munich periodical *Die Jugend,* which soon became so famous that it gave its name to the new style in Germany: Jugendstil. Munich rapidly became an important Art Nouveau centre, and it was here that artists like August Endell, Otto Eckmann and Hans Schmidt-Hals developed a uniquely German version of the style. Endell's famous dramatically curving, almost abstract facade for the photo studio Elvira in Munich was probably based on a Japanese motif, and Eckmann's vigorous, abstract linear designs derive from *nishiki-e* as well as from plant forms. 'We have discovered the path to nature again,' Eckmann wrote, 'by way of Japan,' although he believed that only the English had benefited fully from the Japanese example:

> We must gratefully remember Japan, a land whose wonderful art . . . first pointed out to us the right path. But only England knew how to assimilate and transform the wealth of new ideas and to adapt them to its innate national character, thus deriving real profit from the Japanese style.[71]

Schmidt-Hals owned a large collection of Japanese prints and based his own abstracted studies of water (in both

oil and watercolour) on designs by Hokusai and
Hiroshige.

As in England and France, painting in Germany
remained on the whole untouched by Art Nouveau
traits. It was only in Austria that painting related to the
style was produced, and then only by one artist of
importance: Gustav Klimt (1862–1918). Klimt was a
founder-member and the first president of the avant-
garde art organization, founded in Vienna in 1898, which
called itself the Secession. Its aim was to sweep away the
overblown pompous historicism of nineteenth-century
Austrian art and replace it with something much more
direct and simple, decorative yet at the same time
functional. The Secession championed Art Nouveau with
such commitment in the Austrian capital that they merged
in the popular imagination, and Art Nouveau became
known as Sezessionstil.

In spite of Klimt's presidency, the Secession was more
concerned with architecture and the applied arts than
with painting, and its most typical designs are for
buildings and their furnishings and fittings. In this kind
of work, as in Secession posters and in the typography
and illustration of the Secession journal Ver Sacrum, the
influence of Japan is strong and pervasive.

The sixth exhibition of the Secession at the beginning
of 1900 was devoted to Japanese art of various kinds, all
700 items of which belonged to a single Viennese
collector. However, it was not the Secession which first
introduced Japanese art into Austria but the vogue which
had begun to spread through Europe three decades
earlier. As early as 1869, the Museum für Kunst und
Industrie in Vienna had secured a large collection of
Japanese bronzes, enamel and porcelain. The 1873
World Exhibition in Vienna included a large official
Japanese section, and this met with marked success, as
did exhibitions of Chinese and Japanese art and artefacts
in 1883. In 1901, inspired perhaps by the recent
Secession show, the book publisher and art dealer
E. Hirschler staged the first-ever European exhibition
devoted entirely to the work of Hokusai. By that time,
the Secession artists had incorporated many aspects of
Japanese art into their own work, in various ways, and
Japanese art was regularly illustrated and discussed in

Ver Sacrum. One of the most important articles on this
subject to appear there was Moritz Dreger's 'Zur
Wertschätzung der japanischen Kunst' (On the
Evaluation of Japanese Art) of 1898.

Japan so permeates the work of all the Secession
artists that it is impossible in so short a space to map in
any detail the total extent of its influence. The architec-
ture and furniture of Josef Hoffmann, with its clean
lines, pronounced verticals and horizontals, and
eloquent spaces, is ultimately Japanese in inspiration, and
so are many of the posters designed for the annual
exhibitions around 1900. The book illustrations by Carl
Otto Czeschka, and the graphics of Kolo Moser, Alfred
Roller and Emil Orlik are all obviously indebted to Japan.
Orlik was one of the few German-speaking artists to visit
Japan while its art was still important to European
painting and print making. His first trip, in 1900, lasted
more than a year, and as a result of the visit he produced
not only a number of travel sketchbooks, but also two
remarkable essays about the technique of Japanese wood-
block printing. These pieces, with their close attention to
detail, remain among the best accounts of the subject
ever written, and they directly contributed to the vitality
of the technique in Secessionist Vienna. Orlik went to
Japan again in 1911, and soon after his return wrote the
following remarks in a letter to Julius Kurth, a prominent
collector of nishiki-e:

> The feeling for clear compositional divisions in the
> Japanese colour woodcut impressed me from the first
> moment. The horizontals always stand in an interesting
> relationship to the verticals. The Japanese designer
> constructs a rich interplay of flat planes and the
> representation of depth. . . . He may even develop a
> fence-like structure of posts or trees in the foreground,
> middleground or background, in order to achieve this
> effect.[72]

All the Secessionist artists designed monogram
signatures in frank imitation of Japanese signature seals
(Plate 155) and the posters for Secession exhibitions until
around 1914 show many Japanese qualities, but none of
the Secessionists absorbed Japanese features into their
work as completely as Gustav Klimt did in his painting.
Klimt developed slowly. His early work differs little from

LEOPOLD BAUER ADOLF BÖHM JOSEF HOFFMANN

GUSTAV KLIMT FRIEDRICH KÖNIG RICHARD LUKSCH

KOLOMAN MOSER ALFRED ROLLER ERNST STÖHR

155 Monograms of Klimt and other members of the Vienna Secession

the historicism which the Secession was pledged to destroy, and he did not reach maturity as a painter until after he resigned from the Secession in 1905. His most striking mature paintings are portraits of Viennese society ladies whom he depicted full-length in richly patterned robes standing against equally richly patterned backgrounds. Only the head and hands are realistic in these portraits, the other parts of which seem to sparkle and dazzle with a riot of colours and an explosion of small and widely varied motifs.

Many of these motifs are Japanese, developed from the heraldic *mon,* like the ones which Klimt copied prolifically into several sketchbooks; many, too, are derived from other exotic sources, chiefly from Byzantine art. However, in spite of this eclecticism, the dominant impression remains Japanese, for the format is most often a pronounced vertical, the patterns are confined by strong contour lines, and the poses and costumes often recall *nishiki-e* showing women in kimonos. As a source, moreover, Klimt used Japanese paintings as well as prints. His fondness for precious materials – gold and silver leaf applied to the canvas, for example – recalls the luxurious *byōbu* paintings (such as those of Kōrin) in which large areas are opulently filled with gold and silver paint.

Klimt owned a large collection of prints and other Orientalia of various kinds. Photographs of his studio show walls hung symmetrically with prints, Chinese and Japanese scroll paintings, Nō masks and a magnificent set of samurai armour. The smock which Klimt designed for himself as a working garment has the character of a kimono. Some of these items, and especially the Oriental paintings, appear in the background of many of Klimt's portraits, especially those of the last period.

Klimt's commissioned portraits of women are essentially decorations, representing the social standing of the sitter by the wealth of the pattern, and Klimt was essentially a decorator, a master of the mural. His greatest work is the decorative scheme he created for the dining-room of the Palais Stoclet in Brussels (Plate 157), which was designed by his friend Josef Hoffmann. Stoclet, the patron, was widely known for his extensive collection of *nishiki-e,* and it is appropriate that Hoffmann should have produced

a design which, in its simplicity and its bold contrasts between black and white, seems to have been inspired by Japanese styles. Klimt's design for the dining-room consists of three main panels which fit exactly into shallow niches running from floor to ceiling. The work takes the form of a mosaic of precious and semi-precious materials on a marble base, so that an effective interplay is created between the rich decorative panels and the large expanses of cool, white marble. It is not overfanciful to compare this measured articulation of space with a Japanese room in which the blank areas are made interesting by small points of focus: a hanging painting perhaps, or an arrangement of flowers. The Japanese effect of Klimt's decorative scheme is enhanced by Hoffmann's furniture and by the fitted cupboards which, in their uncompromising geometry, have a distinct Japanese style.

Klimt's role as a decorator and his reliance on styles of ornament derived from Classical and Byzantine models suggest an aesthetic approach that is decidedly nineteenth-century in emphasis. It was left to his two chief disciples, Egon Schiele and Oskar Kokoschka, to abandon the riotous surface decoration and to transform Klimt's elegant line into a tool for the expression of emotion. Schiele took more from Klimt than Kokoschka, who arrived at a new style rather earlier; Kokoschka's so-called 'black portraits' of 1909–10 are quite unlike any kind of art so far produced in Austria, and in spirit if not in style they are close to the Expressionism that had recently made its appearance in Germany.

Kokoschka's earlier work, however, does owe something to Klimt, and some of it is also suggestive of *nishiki-e,* although it is uncertain how far this was a matter of conscious imitation. *Die Träumenden Knaben* (The Dreaming Youths) of 1908, a story-book illustrated with woodcuts, is dedicated to Klimt, but here it is the resemblance to Japanese prints which is the more apparent. Inevitably in a work produced by this technique, the images are simpler and cruder than anything in Klimt's work: the colours are flatter, the contrasts more dramatic and much of the task of description is performed by thick contour lines. The affinities with *nishiki-e,* however, were never very striking, and in any case they soon disappeared as

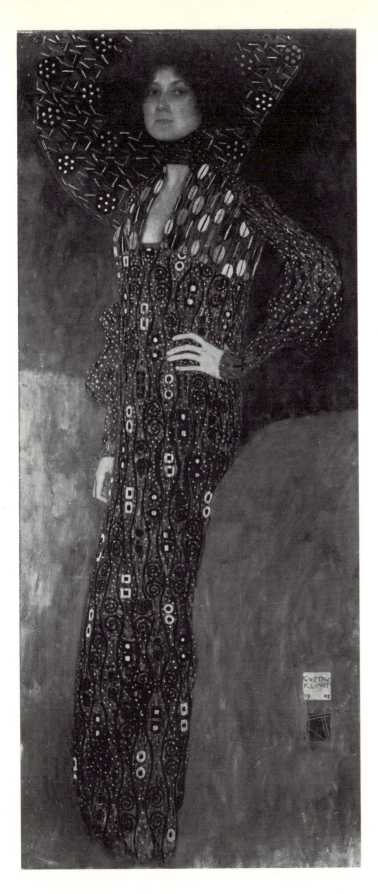

156 **Klimt** *Emilie Flöge*, 1902. 181·0 × 84·0 (71 × 33), Historisches
Museum, Vienna

157 **Klimt** Study for the *Stoclet frieze*, c. 1905–9. Tempera; water-colour; gold, silver and bronze leaf; chalk and pencil on paper, 194·0 × 121·0 (76⅜ × 47⅝), Osterreichisches Museum für angewandte Kunst, Vienna

158 **Kokoschka** *Fan for Alma Mahler*, 1913. Ink and gouache, approx. width 21·5 (8½), Museum für Kunst und Gewerbe, Hamburg

his style matured and lost contact with its beginnings. His interest in the exotic, exemplified early on in some Japanese fans which he painted for his mistress Alma Mahler (Plate 158), was equally short-lived.

Schiele's contacts with Japanese prints are easier to prove, and the impact of *ukiyo-e* styles on his art is somewhat less conjectural. He is reputed to have possessed the best collection of erotic Japanese prints in Vienna, and although his work rarely shows two figures together, his depiction of well-endowed women with their legs spread, or in other sexually suggestive poses (see Plate 159), or of men (usually self-portraits) apparently masturbating, exceed Japanese *shunga* in their frankness. Schiele, however, does not view sex as a pleasurable activity as the Japanese print makers do. His drawings show people as the victims of their own sexuality, driven on by their libido, which can never be satisfied. They are creatures of the Freudian age. It is in fact not so much the subjects of Schiele's art which show resemblances to *nishiki-e*, as their techniques: that is, the expressiveness of their line, their bright local areas of colour, and their

eloquent disposition of motifs on the page. For instance, in the vertical self-portrait illustrated here (Colour Plate 30), which is typical of a whole series of drawings sharing the same subject matter and stylistic approach, the treatment of the face and the pose suggests a psychological tension that is entirely Western, while the flat silhouette of the figure and the use of broad, flat, dark areas is distinctly Japanese.

It is in Schiele's work that the transition from the sophistication of Art Nouveau to the introspective anxieties of Expressionism can be most clearly perceived. In Schiele's drawings, with their tenuous connections with *nishiki-e*, the love affair between Europe and Japan was coming to an end. Except in Austria the liaison survived the turn of the century only with its dying breath. By the time Schiele's style matured around 1910, all major painters outside Austria had ceased to be interested in Japan, and now searched for inspiration in other parts of the world. While the French Cubists were looking towards Africa, the German Expressionists were discovering the attractions of the primitive art of the

159 **Schiele** *Woman from rear, bending over*, 1913. Pencil, 48·3 × 32·4 (19 × 12¾), Fischer Fine Art

Pacific, and of folk art of all kinds. Other varieties of exoticism were now playing the role previously played by Japan.

Meanwhile, for the benefit of foreigners, the official Japanese attitude towards *ukiyo-e* had been made plain. The Imperial contribution to the World Exhibition in Paris in 1900 sought to teach ignorant Europeans that woodblock prints were folk art, if art at all, and that there were varieties of truly great art in Japan which Europeans should be taught to prefer. The Japanese section of the exhibition therefore consisted of masterpieces of court and religious art, of lacquerware and silk painting, and of *kakemono* and *byōbu* decorated by such masters as Sōtatsu and Kōrin. Most of the exhibits had not been seen in the West before. But if the Japanese government were hoping to persuade Europeans to transfer their allegiance from popular to more sophisticated genres of Japanese art, they were disappointed. European artists were no longer interested in Japan at all, a fact which is eloquently expressed by Gertrude Stein's memory of one of her earliest meetings with Picasso around 1905:

> That evening Gertrude Stein's brother took out portfolio after portfolio of Japanese prints to show Picasso. Gertrude Stein's brother was fond of Japanese prints. Picasso solemnly and obediently looked at print after print and listened to the descriptions. He said under his breath to Gertrude Stein, He is very nice your brother but like all Americans, like Haviland, he shows you Japanese prints, moi j'aime pas ça, no I don't care for it. As I say, Gertrude Stein and Pablo Picasso immediately under-stood·one another.[73]

By this time, Rome was no longer in Rome, nor was it in the Orient: it had moved to the Pacific and to the heart of Africa.

Conclusion

Japanese woodblock prints exercised a fluctuating but continuing influence on European artists for about sixty years. From the early 1860s to the first decades of the present century, that influence was in part responsible for the major stylistic changes, and for the rapidly changing attitude towards subject matter, which culminated in the body of feelings and theories we now know as Modernism.

Japan, of course, affected each artist, and each stage of the entire development of painting, in very different ways. The style and subjects of the prints provided a source that was rich enough to satisfy painters whose ambitions and needs were often entirely individual. Yet in spite of this multiplicity, a general trend is detectable. Viewed with hindsight, the mainstream of nineteenth-century European painting seems to have followed the direction of increasing simplification of form, a tendency which reached its climax with the appearance of abstraction between 1910 and 1920. Abstraction was above all an attempt to release painting from its reliance on the external, 'real' world, from the tyranny of the object, and to enable it, like music, to speak directly of subjective experience in the language of pure forms and pure colours. The attainment of this aim was the culmination of many factors. It would have been unthinkable without the achievements of Cézanne and the Cubists, and it would not have been likely either without the influence of Japanese prints, which, although far from being abstract themselves, do rely for their effects on pronounced abstract characteristics: on their decorative colours and calculated compositional devices. One of the first painters to perceive these qualities in the prints was Manet, whose art is a compromise not only between Classical and contemporary subjects, but also between traditional and modern approaches to style.

While Japanese art was having a profound effect on European painting, Western styles were being imitated by the Japanese. Although traditional subjects and styles continued to be used by Japanese artists after the Meiji Restoration, there was nevertheless a sudden enthusiasm for European art, from about 1870 onwards. Japanese painters went to study in France, England and America, and over the years they quickly assimilated a succession of foreign styles: from Realism, through Impressionism, to Cubism, Fauvism and finally to abstract art. The manner in which this absorption took place, and the extent to which the Japanese were successful in acquiring entirely foreign attitudes to painting, is beyond the scope of this study. It is perhaps enough to mention that there is a crucial difference between the Japanese attitude to European painting and the European painters' attitude to Japanese art. The Japanese voraciously swallowed and digested Western painting in all its manifold forms. The Europeans, on the other hand, took from the Japanese only what they needed to create an original style, or to crystallize the styles towards which they were already tending.

In Europe the influence of Japanese prints waned and disappeared during the rise of Cubism. Western artists of all kinds now drew inspiration from other sources: from the carving and painting of primitive African and Oceanic tribes, from the folk art of some parts of Europe, from the work of children and of naïve artists such as the Douanier Rousseau, and from the art of the mentally disturbed. Japanese prints now became the province mainly of collectors and museum curators and the subject of academic research.

However, the fascination of Oriental art was not eclipsed altogether for European artists, but merely underwent a change of emphasis. Now, it was not the *nishiki-e* which provided artists with an exciting stimulus, but more esoteric forms of Oriental culture, in particular the painting and calligraphy of the monasteries and shrines. These sources were especially important to European and American artists after 1945, although the influence had been present in embryo in the 1930s. Some

idea of how it manifested itself can be obtained from the example of the American artist Mark Tobey (1890–1976). In 1923 Tobey met a Chinese painter who gave him his first lessons in calligraphy. Ten years later he went to Shanghai and then to Japan, where he lived in a Zen monastery and attempted to master Zen calligraphy, a kind of spontaneous brush-writing that springs directly from deep meditation and from the urge to simplify forms. Drawing upon these experiences, Tobey eventually evolved a style of painting derived entirely from calligraphic marks freely and randomly applied to the canvas, which gradually took on the appearance of a dense weave. The pictures executed in this manner are not representational: they are records of their own making and, simultaneously, active surfaces inducing meditation. Although not obviously Oriental in their appearance, they owe a definite debt to the East in their intention.

Oriental calligraphy and Oriental notions about the meditative function of art continued to have relevance for Western painters into the 1960s. They made an impression not only on the highly gestural kind of Abstract Expressionism practised by Jackson Pollock (1912–56) and Franz Kline (1910–62), but also on the more controlled and simple colour-field painting of Barnett Newman (1905–70) and Mark Rothko (1903–70). But however considerable the impact made on such artists by various aspects of Oriental styles, it never matched the importance for earlier painters, especially in France in the second half of the nineteenth century, of Japanese prints. As an instance of a completely foreign style reacting fruitfully upon artists whose own received aesthetic had come to seem inadequate for their needs, the absorption of the techniques and subjects of *nishiki-e* is without parallel in the history of European art.

Brief Chronology

1853 Arrival in Japan of American fleet under Commodore Perry.

1854 Some Japanese ports opened up to American shipping.

1856 In Paris, Bracquemond discovers a volume of Hokusai's *Manga*.

1858 Japan signs commercial treaties with Russia, U.S.A., Great Britain and France.

1860 First Japanese diplomatic delegation to a foreign country (U.S.A.).

1862 Rutherford Alcock shows his collection of Japanese art at the London Great Exhibition.

In Paris, the Boutique Desoye opens in the rue de Rivoli.

1864 Whistler's *Golden screen*.

1866 Zacharie Astruc publishes a series of articles in *L'Etendard* entitled 'L'Empire du Soleil Levant'.

1867 Japanese woodcuts shown at the Exposition Universelle in Paris.

Société Japon du Jinglar founded in Sèvres.

1868 Meiji Restoration.

Manet's portrait of Emile Zola.

1875 Establishment of Liberty's in Regent Street, London.

1876 Monet's *La Japonaise*.

1885 Whistler's *Ten o'Clock Lecture*.

First performance of Gilbert and Sullivan's *Mikado*.

1887 Van Gogh begins three oil copies of Japanese prints.

Publication of Pierre Loti's *Madame Chrysanthème*.

1888 Gauguin's *Vision after the sermon*.

Exhibition of woodcuts at Samuel Bing's gallery in Paris.

1889 First publication of Bing's periodical *Le Japon Artistique*.

1890 Large exhibition of Japanese prints at the Ecole des Beaux-Arts, Paris.

1891 Mary Cassatt produces a series of prints inspired by Utamaro.

Publication of Goncourt's *Outamaro, le peintre des maisons vertes*.

1894–5 Sino-Japanese War.

1896 Publication of Goncourt's *Hokusai*.

1900 Vienna Secession stages large exhibition of Japanese art.

Large official Japanese representation at the Exposition Universelle in Paris.

1904–5 Russo-Japanese War.

Select Glossary of Japanese Words

aiban *Ai* means 'in between', *han* means 'print'; hence, the print format between *chūban* and *hoso-e*. Approximate size: 33·0 × 23·0(13 × 9). (Some Japanese words change the first consonant when joined to an adjective.)

baren Smooth wooden or bone tool used to transfer ink to paper in woodblock printing. The paper is applied face-down to the inked block and the *baren* is then rubbed over it in a circular movement.

beni-e Literally, 'red picture'; but the term is used to describe any print in which the colour is applied by hand rather than printed.

benizuri-e Literally, 'red-printed picture'; but the term is in fact used to describe a print in which the colour has been applied from more than one block, with no hand-painted areas. The technique originated in China in the Ming Dynasty in the mid-17th century and soon became known in Japan, but it was not used there commercially until the 18th century. It was one of the vital stages in the evolution of polychromatic prints.

bijin Literally, 'beautiful person'; the word is always used, however, to mean 'beautiful woman'.

bijin-e Pictures of beautiful women.

byōbu Movable screens, used for decorating and partitioning rooms. An essential item of Japanese furniture. Usually about 180cm.(6 ft) tall, with accordion-like folds approximately 90cm.(3 ft) wide.

chūban *Chū* means 'medium', *han* means 'print'; hence, medium-sized print, between 22·0 × 16·0($8\frac{3}{4}$ × $6\frac{1}{4}$) and 28·0 × 21·0(11 × $8\frac{1}{4}$).

daimyō Literally, 'big name'; a samurai with a large estate. In the Tokugawa period the absolute ruler of a feudal clan.

Edo Present-day Tōkyō. Capital of the Tokugawa Shōgunate.

fusuma Sliding door of a Japanese house, used as a divider in open-plan rooms. *Fusuma* are usually constructed as wooden frames with a covering of stretched paper, but they are sometimes made entirely of wood. In either case they give ample scope for decoration.

geta Wooden sandal-clogs, usually with two ridges to raise the feet off the ground and with thongs for the toes.

gidayū Narrative chorus used extensively in the Kabuki theatre. See also **jōruri.**

hashira-e *Hashira* means 'pillar', *e* means 'picture'; hence, pictures which are specifically shaped to be hung on pillars and are therefore tall and narrow. Approximate siz: 61·0 × 11·0(24 × $4\frac{1}{4}$).

hinin The lowest rank in the Japanese caste system. Some were born into this caste, while others, such as actors, courtesans and criminals, belonged to it by virtue of their occupation.

hoso-e *Hoso* means 'narrow, thin', *e* means 'picture'; hence, a long, thin print or painting. Approximate size: 32·0 × 15·0 ($12\frac{5}{8}$ × $5\frac{7}{8}$).

ikebana The art of flower arrangement.

inkan Signature stamps. Personal hand-written signatures were used by artists and calligraphers, but signature stamps were necessary for everyday transactions in banks, etc., as well as being used on many prints.

ippai tori Literally, 'full-take' or 'full production'. *Beni-e* prints could be printed at the rate of 200 a day, and this came to be called 'full production'. Now used by Japanese printers to denote a 200-sheet quantity of paper.

jidaimono *Jidai* means 'period'; hence, historical plays for the Kabuki theatre.

jikyokuga 'Contemporary pictures'; the *nishiki-e* depicting contemporary events after the Meiji Restoration. The last flowering of the prints in this form was the time of the Sino-Japanese war of 1894–5.

jōruri Form of musically accompanied narrative; for instance, as used in the Kabuki and Nō theatres.

Kabuki The popular theatre of the Tokugawa period. Though it had its origins in the dance and mime aspects of the aristocratic Nō and Sarugaku theatres, it developed into a lavish dramatic expression of the lives and dreams of the common people.

Kabuki-za The theatre building in which Kabuki is performed. The suffix 'za' – 'the seat of' – is also added to the names of particular theatres.

kakemono Literally, 'hanging thing'; the word is used specifically to describe the long painting or piece of calligraphy, weighted at the bottom, which adorns the wall above the *tokonoma,* or raised dais, in a Japanese room.

kakemono-e A print often hung on a wall as a *kakemono.* Approximate size: 76·0 × 26·0(30 × $10\frac{1}{4}$).

Kamigata Literally, 'the upper direction'; Kyōto and its environs, including Osaka. There has always been a cultural rivalry between the Kamigata, with its Imperial court, and Edo, the Shōgunal capital.

kamuro A trainee courtesan, at an early stage of her apprenticeship. A girl would become a *kamuro* at the age of about 8, and for a year or so would act as a general help in the brothel. Then, until she was about 13 or 14, she would be a servant-apprentice to a particular *oiran*. After that she left the *oiran* and received instruction from the brothel madam for another year.

Kanji Literally, 'writing of the Han dynasty of China'; Chinese characters, the first kind of writing introduced into Japan (at the same time as Buddhism). By the 10th century the Japanese had developed a phonetic alphabet used in conjunction with Kanji. Official documents were written mainly in Kanji well into the 20th century.

kaomise In the Kabuki theatre, either the presentation of the actors at the beginning of the autumn season, or the first play put on in that season.

koban *Ko* means 'small', *han* means 'print'; hence, a small-sized print. Approximate size: $14.0 \times 11.0 (5\frac{1}{2} \times 4\frac{1}{2})$.

koto A large zither-like musical instrument.

kozō Originally a Buddhist acolyte, the word later came to mean small boy.

kuge The aristocrats of the Imperial court. They were enormously rich and powerful between the 9th and 13th centuries, but their influence declined with the rise of the samurai. They lost their wealth during the civil wars of the 14th, 15th and 16th centuries but returned to the political arena with the Meiji Restoration.

Meiji The title given to the Emperor Mutsuhito and his reign (1868–1911). (Reign-names, which are used in the Japanese dating system, were once changed at intervals by the Imperial court, but since 1868 there has been one reign-name for each reign.)

Meiwa A reign-name (1764–71), describing part of the reign of the Emperor Go-Sakuramachi.

minō A variety of fine-quality Japanese paper named because the best sheets originally came from Minō, a town near Kyōto in the Gifu prefecture.

mitate Fanciful humorous picture, either printed or painted.

mon A Japanese heraldic device. All Japanese families are entitled to use the *mon* appropriate to their particular clan. The Imperial Family has its own exclusive *mon*: a chrysanthemum with sixteen petals.

naga-e *Nagai* means 'long', *'e'* means 'picture'; hence, long or tall picture. Approximate size: $61.0 \times 11.0 (24 \times 4\frac{1}{2})$.

Nagasaki-e Prints depicting the city of Nagasaki and the foreigners to be found there: the Dutch, the Chinese, their clothes, equipment and customs.

nara ehon Hand-illustrated popular books of the 15th and 16th centuries. They varied greatly in artistic merit. When demand exceeded the capacity for production, the publishers turned to printing.

netsuke Little carved figures used as stoppers for tobacco- and seal-pouches or for purses. They gained enormous popularity in the West for their intricacy of design and the humour of their subject matter.

nishiki-e *Nishiki* means 'brocade', a metaphor for sumptuousness; hence, *nishiki-e*, or 'brocade picture', means a sumptuous polychromatic print.

ōban *O* means 'large', *han* means 'print'; hence, large print. Approximate size: $39.0 \times 26.0 (15\frac{1}{4} \times 10\frac{1}{4})$.

obi The largest and outermost of the many belts of the kimono. Usually worn with a bow at the back, except by courtesans, who wore a bow at the front.

oiran Originally the most prestigious courtesan of a brothel, but later any prostitute attached to a house.

okabasho Unlicensed brothel area, such as the famous one at Fukagawa.

oyatoi gaikokujin During the Meiji period, those foreigners officially employed by the government in various advisory or technical capacities.

sarugaku A comic intermission, in the form of music and dance, in recitals of serious music in Imperial palaces. It later became popularized as a branch of Nō drama.

samisen Three-stringed banjo-like instrument played with a fan-shaped pick. It is an instrument favoured by geishas to accompany their singing.

samurai The warrior caste. The samurai emerged into prominence around the 11th century at the expense of the decadent aristocratic courtiers.

sewamono *Sewa* means 'helping out', usually by women; hence, *sewamono* means stories of domestic life, as acted in the Kabuki theatre.

Shintō The indigenous, pantheistic religion of Japan. It was the main religion of the country until it began to be eclipsed by Buddhism at the end of the 8th century. It regained ascendancy in the 18th century, and from 1868 to 1945 it was the state religion, proclaiming the Emperor as the descendant of the Sun Goddess (the leading deity).

shinzō An understudy to an *oiran* or courtesan. This was the final stage of a courtesan's apprenticeship. Usually aged between 14 and 16 at recruitment.

shita-e Literally, 'bottom picture'. In the terminology of printmaking, this was the final draft of the design which was pasted onto the block, prior to the cutting.

Shōgun The military ruler of the country, by virtue of his headship of the leading clan. Between 1603 and the Meiji Restoration the controlling clan was the Tokugawa family.

shōji Sliding door in a Japanese house, made of opaque white paper stretched over a wooden frame. It is generally positioned on the sunniest side of the room.

shumpon Literally, 'spring books'; erotic books, a very important area of print illustration.

shunga Literally, 'spring pictures'; individual erotic prints, or single pages of erotic books.

sumi Ink used for writing and drawing. The Japanese borrowed the Chinese method of writing with brushes, a flat palette and a hard ink-stick. The ink-stick, when moistened with water and rubbed on to the palette, produced an ink whose density was infinitely variable, according to the amount of water used.

sumō A kind of highly ceremonial wrestling unique to Japan.

sumō-e Prints depicting the stars of the *sumō*.

surimono Luxury edition of a *nishiki-e* with over-printings, *gaufrage*, etc. Usually small-format and made in very small editions for private New Year greeting cards.

tabi Japanese socks. These are split-toed and usually fastened around the ankle by hooks.

tan A yellowish-red; one of the first colours to be used in *ukiyo-e* prints.

tanzaku A narrow piece of paper on which poems or short messages were written. By extension it came to mean a short poem. Also a standard print format.

tatami The thick, rice-straw floor-covering in a Japanese home, made up of separate mats. Approximate size of each mat: 180·0 × 90·0(70 × 35).

uki-e Perspective pictures. The technique of depicting perspective was imported from the West, probably by the Dutch, and used in prints from the 18th century onwards. It was always regarded rather as a curiosity. It reached its greatest popularity as a genre in the early 19th century.

ukiyo A Buddhist term meaning 'the sad world' or 'the floating world', with connotations of the transience of earthly existence. By extension the word came also to denote 'the floating world' of urban pleasure-seeking in the peaceful regime of the Tokugawa Shōgunate.

ukiyo-e 'Pictures of the floating world'; a blanket term covering all pictures, whether hand-painted or printed, depicting scenes from Japanese life. These include not only prints showing the pleasures of the merchant classes but also 16th-century screen and scroll paintings and prints of subjects such as the Sino-Japanese War and the opening of Parliament by the Emperor Meiji, and landscapes.

urushi-e Literally, 'lacquer pictures'; prints with certain areas made to look 'lacquered' or shiny by mixing the colours with glue. The technique was first used around the middle of the 18th century.

Yamato-e Yamato was one of the earliest names for Japan; hence, the term means a painting in a purely Japanese style (as opposed to the Chinese manner).

Yamato eshi *Eshi* means 'master painter', and *Yamato eshi* was a term used by ancient court painters. Print artists like Harunobu signed themselves in this way for prestige purposes.

Yoshiwara A district of Tōkyō. An elaborate red-light district was opened here in about 1615 and continued to function until prostitution was outlawed in 1957.

Notes to the Text

Translations are by the author except where indicated

1 Nikolaus Pevsner, *Pioneers of the Modern Movement* (London 1936), pp. 143–4.

2 Francis L. Hawks, *Narrative of an American Squadron's Expedition to the China Seas and Japan,* ed. Sidney Wallach (London 1954), p. 76.

3 See Fukuzawa Yukichi, *Autobiography,* trans. E. Kiyooka (New York 1966). Another outcome of Fukuzawa's experiences abroad was the belief that his future lay in education. He founded Keiō University in Tōkyō and introduced the Western concept of higher education into Japan.

4 Richard Storry, *A History of Modern Japan* (Harmondsworth 1960) p. 104.

5 R. Alcock, *The Capital of the Tycoon* (London 1863), vol. 2, p. 281.

6 Ibid, vol. 2, p. 275.

7 Quoted by H. Honour, *Chinoiserie: The Vision of Cathay* (London 1961), p. 207.

8 Alcock, *The Capital of the Tycoon,* vol. 2, p. 283.

9 Quoted in H. Lüdecke, 'Eugène Delacroix in Marokko und Algerien' in *Bildende Kunst,* 1963, pp. 28–9.

10 Wilhelm Worringer, *Abstraktion und Einfühlung,* 10th edn (Munich 1921), p. 71.

11 Quoted in Herbert Scurla (ed.), *Reisen in Nippon: Berichte deutscher Forscher des 17. und 19. Jahrhunderts aus Japan,* 3rd edn (E. Berlin 1974), pp. 541–2.

12 Asai Ryoi, *Ukiyo Monogatari* ('Tokugawa bungei ruiji 2') (Tōkyō 1970), pp. 334–5. Translated by Richard Lane in 'The beginnings of the modern Japanese novel: *Kana-zōshi,* 1600–1682', *Harvard Journal of Asiatic Studies,* vol. 20, pp. 671–2.

13 The Western calendar was not introduced into Japan until after 1868, when it was used as an alternative to the traditional manner of dating according to the reign-names of the various Emperors. 1765 was the 2nd year of the Meiwa reign. The old system is still in use: 1977 is Showa 52.

14 Alcock, *The Capital of the Tycoon,* vol. 2, pp. 281–2.

15 J. Penell, *The Life of James McNeill Whistler* (Philadelphia 1908), p. 117.

16 Quoted in Elizabeth Aslin, 'E. W. Godwin and the Japanese taste', *Apollo,* December 1962, p. 781.

17 *The Architect,* 23 December 1876. Quoted in A. Adburgham, *Liberty's: A Biography of a Shop* (London 1975), pp. 21–2.

18 *Blackwood's Magazine,* February 1887, pp. 281–91.

19 J. de Caso, 'Hokusai rue Jacob', *Burlington Magazine,* September 1969, pp. 562–3

20 E. G. Underwood, *A Short History of French Painting* (London 1931), p. 249.

21 Quoted in Ernst Scheyer, 'Far Eastern art and French Impressionism', *Art Quarterly,* 6 (1943), p. 140, n. 9.

22 W. M. Rossetti, *Rossetti Papers 1862–1870* (London 1903), 15 June 1863.

23 See especially Mark Roskill, *Van Gogh, Gauguin and the Impressionist Circle* (London 1970), pp. 57–85.

24 E. Goncourt, *Hokusai* (Paris n.d.), p. 15, n.

25 W. M. Rossetti, *Some Reminiscences,* (London 1906), vol. 2, p. 276.

26 George Moore, 'A visit to Médan', appendix to 1926 edn of *Confessions of a Young Man* (London 1886), p. 248.

27 Nils Gösta Sandblad, *Manet: Three Studies in Artistic Conception* (Lund 1954), esp. pp. 81–7.

28 J. Meier-Graefe, *Edouard Manet* (Munich 1912), p. 92.

29 Quoted in Denys Sutton, *Nocturne: The Art of James MacNeill Whistler* (London 1963), p. 48.

30 James Laver, *Whistler* (London 1930), p. 115.

31 Quoted in Sutton, *Nocturne,* p. 49.

32 J. Meier-Graefe, *Modern Art* (London 1908), vol. 2, p. 200.

33 J. Meier-Graefe, *Degas* (Munich 1920), p. 50.

34 E. Degas, *Lettres* (Paris 1931), p. 148.

35 Quoted in Pierre Cabanne, *Edgar Degas* (Munich n.d.), p. 55.

36 J. Meier-Graefe, *Vincent van Gogh* (London 1922), p. 77.

37 John Rewald (ed.), *C. Pissarro: Letters to His Son Lucien,* (London 1943), p. 206.

38 Ibid, p. 207.

39 E. Zola, *Salons,* ed. F. W. J. Hemmings and Robert J. Neiss (Paris 1952), p. 242.

40 Quoted in R. Marx, *Maîtres d'hier et d'aujourd'hui* (Paris 1914), p. 292.

41 See A. Vollard, *La Vie et l'œuvre de Pierre August Renoir* (Paris 1919), p. 63.

42 P. Gauguin, *Lettres à Emile Bernard* (Brussels 1943), p. 122.

43 E. Pottier, 'Grèce et Japon', *Gazette des Beaux-Arts,* August 1890, pp. 105–33.

44 Vincent van Gogh, *Verzamelde brieven* (Amsterdam 1952–4), June 1888, letter 500.

45 Ibid, letter T16.

46 Gauguin, *Lettres à Emile Bernard,* p. 99.

47 Van Gogh, *Verzamelde brieven,* letter T19.

48 Ibid, letter B18 (15).

49 Ibid, letter 437. There is a letter to Alice Furnée from Nuenen as early as January 1884 (351a) which refers to China and Japan and remarks: 'I have seen excellent things

from these countries.' The earliest reference specifically to the prints, however, occurs in the December 1885 letter from Antwerp.

50 Ibid, letter 542.

51 Ibid, letter B2(2).

52 Ibid, letter 487 (May? 1888).

53 Ibid, letter 516 (August 1888).

54 Ibid, letter 554 (September? 1888).

55 Ibid, letter W7 (September 1888).

56 Ibid, letter 545 (October 1888).

57 Ibid, letter B10(18).

58 Quoted in H. Dorra and S. C. Askin, 'Seurat's Japonisme', *Gazette des Beaux-Arts,* February 1969, p. 87.

59 H. Dorra, 'Seurat's dot and the Japanese stippling technique', *Art Quarterly,* Summer 1970, p. 110.

60 *Japonisme,* catalogue of Cleveland Museum of Art exhibition (Cleveland 1975), p. 127.

61 See Roskill, *Van Gogh, Gauguin and the Impressionist Circle,* p. 44.

62 Colta Feller Ives, *The Great Wave,* catalogue of New York Metropolitan Museum exhibition (New York 1974), p. 87.

63 See P. Sérusier, *ABC de la peinture* (Paris 1942), pp. 42–4.

64 M. Denis, *Théories,* 4th edn (Paris 1920), p. 3.

65 T. Duret, 'Hokusai', *Gazette des Beaux-Arts,* 1882, p. 114.

66 Quoted in Adelyn Breeskin, *The Graphic Work of Mary Cassatt* (New York 1948), p. 15.

67 J. Rewald (ed.), *C. Pissarro: Letters,* p. 44.

68 Elizabeth Aslin, *The Aesthetic Movement* (London 1969), p. 79.

69 'The Decay of Lying' in Oscar Wilde, *Intentions* (London 1891), pp. 46–7.

70 *The Studio,* vol. 3 (1894), p. 113.

71 Otto Eckmann, *Neue Formen. Dekorative Entwürfe für die Praxis* (Berlin 1897). Quoted in Robert Schmutzler, *Art Nouveau-Jugend* (London 1964), p. 73.

72 Letter of 1912, quoted in *Weltkulturen und Moderne Kunst,* catalogue of Haus der Kunst, Munich, exhibition (Munich 1972), p. 227.

73 Gertrude Stein, *The Autobiography of Alice B. Toklas* (New York 1933), p. 50.

Appendix: Important Collections of Japanese Prints outside Japan

U.S.A.

California: Achenbach Foundation for Graphic Art, California Palace of the Legion of Honor, San Francisco.
Art Center, La Jolla.
Grunwald Graphic Arts Foundation, University of California.
Los Angeles County Museum.
Pasadena Museum.
Santa Barbara Museum of Art.
Columbia, Dist. of: Library of Congress, Washington D.C.
Freer Gallery of Art, Smithsonian Institution, Washington D.C.
Florida: Norton Gallery and School of Art, Palm Beach.
Hawaii: Honolulu Academy of Arts.
Illinois: Art Institute of Chicago.
Indiana: Notre Dame University.
Iowa: Davenport Public Museum.
Kentucky: Nerea College Art Department.
Maryland: Baltimore Museum of Art.
Massachusetts: Fogg Art Museum, Harvard University.
Museum of Fine Arts, Boston.
Smith College Museum of Art, Northampton.
Worcester Art Museum.
Michigan: Albion College.
Detroit Institute of Arts.
Flint Institute of Arts.
Minnesota: University of Minnesota, Minneapolis.
Missouri: City Art Museum of St Louis.
William Rockhill Nelson Gallery of Fine Art, Kansas City.
Nebraska: Joslyn Art Museum.
New Hampshire: Dartmouth College.
New Jersey: Princeton University Art Museum.
Public Library of Newark.
Rutgers State University.
New York City: Andrew White Museum of Art, Cornell University.
Brooklyn Museum.
Cooper Union Museum.
Metropolitan Museum of Art.
New York Public Library.

North Carolina: Ackland Art Center, University of N. Carolina, Raleigh.
North Carolina Museum of Art, Raleigh.
Ohio: Akron Art Institute.
Cincinnati Art Museum.
Cleveland Museum of Art.
Toledo Museum of Art.
Oregon: Portland Art Museum.
Pennsylvania: Carnegie Institute, Dept. of Fine Art, Pittsburg.
Free Library of Philadelphia.
Philadelphia Museum of Art.
South Carolina: Gibbes Art Gallery.
Vermont: University of Vermont, Burlington.
Virginia: Norfolk Museum.
Wisconsin: Milwaukee Public Library.

UNITED KINGDOM

Blackburn: City Art Gallery.
Cambridge: Fitzwilliam Museum.
London: British Museum.
Victoria and Albert Museum.
Maidstone: City Museum.
Oxford: Ashmolean Museum.

BELGIUM

Brussels: Musées Royaux d'Art et d'Histoire.

FRANCE

Paris: Musée Guimet.
Musée des Arts Décoratifs.
Cabinet des Estampes.

GERMANY

Berlin, W.: Museum für Ostasiatische Kunst.
Cologne: Museum für Ostasiatische Kunst.
Hamburg: Museum für Kunst und Gerwerbe.
Munich: Ethnographisches Museum.

HOLLAND

Amsterdam: Rijksmuseum.
Leyden: Rijksmuseum voor Volkenkunde.

Select Bibliography

Japanese History and Culture

Barr, Pat *The Coming of the Barbarians,* London 1967.

Dresser, Christopher *Japan: Its Architecture, Art and Art Manufacturers,* London 1882.

Earle, Ernest *The Kabuki Theatre,* London 1956.

Fukuzawa Yukichi *Autobiography,* trans. E. Kiyooka, New York 1966.

Hawks, Francis L. *Narrative of an American Squadron's Expedition to the China Seas and Japan,* 3 vols., Washington 1856. New edn abr. and ed. by Sidney Wallach, London 1954.

Sansom, George *The Western World and Japan,* London 1950
Japan, a Short Cultural History, London 1946.

Smith, Bradley *Japan, a History in Art,* London 1964.

Storry, Richard *A History of Modern Japan,* Harmondsworth 1960.

Japanese Prints and Painting

BOOK AND ARTICLES

Anderson, William *The Pictorial Art of Japan,* London 1886.
Japanese Wood Engravings: Their History, Technique and Characteristics, London 1895.

Binyon, R. L. *Japanese Colour Prints,* London 1923.

Duret, T. *Livres et albums illustrés du Japon,* Paris 1900.

Fenollosa, Ernest F. *An Outline History of Ukiyo-e,* Tōkyō 1901.

Ficke, Arthur Davidson *Chats on Japanese Prints,* New York 1917.

Goepper, Roger *Meisterwerke des japanischen Farbenholzschnittes,* Cologne 1973.

Hillier, Jack *Japanese Masters of the Colour Print,* London 1954.
Hokusai, London 1956.
The Japanese Print: A New Approach, London 1960.
The Harari Collection of Japanese Paintings and Drawings, London 1970.

Kurth, Julius *Von Moronobu bis Hiroshige,* Berlin 1924.

Lane, Richard *Masters of the Japanese Print: Their World and their Work,* London 1962.

Ledoux, Louis V. *Japanese Prints in the Occident,* Tōkyō 1941.

Michener, James A. *The Hokusai Sketchbooks: Selections from the 'Manga',* Rutland (Vermont) 1958.
Japanese Prints: From the Early Masters to the Modern, Rutland (Vermont) 1959.

Narazaki Muneshige *The Japanese Print: Its Evolution and Essence,* Tōkyō 1966.

Robinson, B. W. *Japanese Landscape Prints of the Nineteenth Century,* London 1957.

Kuniyoshi, London 1961.
Hiroshige, London 1964.

Seidlitz, W. von *Geschichte des japanischen Farbenholzschnitts,* Dresden 1897.

Stewart, Basil *Japanese Colour Prints and the Subjects They Illustrate,* London 1920.
Subjects Portrayed in Japanese prints: a collector's guide to all the subjects illustrated, including an exhaustive account of the 'Chushingura' and other famous plays, together with a causerie on the Japanese theatre, London 1922.

Strange, Edward F. *The Colour-prints of Japan, an Appreciation,* London 1895.
Hokusai: The Old Man Mad with Painting, London 1906
The Colour-prints of Hiroshige, London 1925

Takahashi Seiichiro *The Evolution of Ukiyo-e: The Artistic, Economic and Social Significance of Japanese Woodblock Prints,* Yokohama 1955.
Traditional Woodblock Prints of Japan, New York 1972.

Volker, T. 'Ukiyo-e quartet: publisher, designer, engraver and printer', *Mededelingen* No. 5, Rijksmuseum voor Volkenkunde, Leyden 1949.

Waterhouse, D. B. *Harunobu and his Age: The Development of Colour Printing in Japan,* London 1964.

CATALOGUES OF GALLERIES, EXHIBITIONS AND SALES

Blackburn, U.K., Arts Council: *Japanese Prints from the Permanent Collection of the Blackburn Art Gallery,* London 1965.

Boston, U.S.A., Museum of Fine Arts: *The Making of Japanese Prints and the History of Ukiyo-e* (C. Hirano), Cambridge (Mass.) 1939.

Brussels, Libre Esthétique: *L'Evolution du paysage. Exposition rétrospective d'estampes des maîtres paysagistes japonais de la fin du XVIIIᵉ siècle à la première moitié du XIXᵉ siècle: collection Adolphe Stoclet,* 1910.

Chicago, Art Institute: *Masterpieces of Japanese Prints from the Clarence Buckingham Collection,* 1955.

Cologne, Museum für ostasiatische Kunst: *Kunisada,* 1966.

Düsseldorf, Kunstmuseum: *Farbholzschnitte von Kuniyoshi und Kunisada,* 1962.

Hague, Gemeentemuseum: *Van Moronobu tot Harunobu: Japanse primitieve Kunst,* 1952.

Hanover, Kestner-Gesellschaft: *Sammlung Preetorius: chinesische und japanische Holzschnitte,* 1952–3.

Leyden, Rijksmuseum voor Volkenkunde: *De Japanse Kleurenhoutsnede* (C. Ouwehand), 1964.

London, British Museum: *A Catalogue of Japanese and Chinese*

Woodcuts Preserved in the Sub-department of Oriental Prints and Drawings (R. L. Binyon), 1917.

London, Burlington Fine Art Club: *Catalogue of Prints and Books Illustrating the History of Engraving in Japan,* 1888.

London, International Exhibition: *Catalogue of Works of Industry and Art sent from Japan* (Rutherford Alcock), 1862.

London, Sotherby and Co.: *Henri Vever Collection,* Part 1, 26 March 1974; Part 2, 26 March 1975.

London, Victoria and Albert Museum: *Japanese Books and Albums of Prints in the National Art Library, South Kensington* (Edward F. Strange), 1893.

Tools and Materials Illustrating the Japanese Method of Colour Printing, 1913.

The Floating World: Japanese Popular Prints 1700–1900 (R. A. Crighton), 1973.

New York, American Art Galleries: *Catalogue of Japanese Engravings: An Important Collection of Old Prints in Colour Belonging to Mr S. Bing in Paris,* 1894.

New York, Anderson Galleries Sale Catalogue: *The Frank Lloyd Wright Collection of Japanese Antique Prints,* New York 1927

New York, Metropolitan Museum: *Japanese Prints in the Metropolitan Museum of Art,* 1952.

Paris, Ecole Nationale des Beaux-Arts: *Exposition de la gravure japonaise à l'Ecole Nationale* (S. Bing), 1890.

Paris, Ernest Leroux Sale Catalogue: *Catalogue des peintures et estampes. Collection Philippe Burty,* 1891.

Paris, Hôtel Drouot Sale Catalogues:

Objects d'art japonais et chinois, peintures, estampes, composant la collection des Goncourt, 1897.

Dessins, estampes, livres illustrés du Japon réunis par T. Hayashi, 1902.

· *Estampes japonaises: peintures des écoles classiques et de quelques maîtres de l'Ukiyoye. Collection Charles Haviland,* 1922, 1924, 1925, 1927.

Collection Louis Gonse, œuvres d'art du Japon, 1924 and 1926.

Paris, Louvre: *Les Estampes japonaises au Musée du Louvre,* 1894.

Paris, Musée des Arts Décoratifs: *Images du temps qui passe: peintures et estampes d'Ukiyo-é,* 1966.

Paris, Musée Cernuschi: *Japon, estampes du XVIIIᵉ siècle,* 1950.

Philadelphia, Museum of Art: *The Theatrical World of Osaka Prints* (Roger S. Keyes and Keiko Mizushima), 1973.

Tōkyō, National Museum: *Illustrated Catalogue of the Tōkyō National Museum: Ukiyo-e Prints* (3 vols), 1960–73.

Vienna, Osterreichisches Museum für Angewandte Kunst: *Japanische Holzschnitte,* 1954.

The Influence of Japan in Europe

BOOKS AND ARTICLES

Aslin, Elizabeth 'E. W. Godwin and the Japanese taste', *Apollo,* December 1962, pp. 779–84.

Astruc, Zacharie 'Beaux-Arts, l'Empire du Soleil Levant', *L'Etendard,* 27 Feb and 23 March 1867.

Bing, S. (ed.) *Le Japon Artistique,* Paris 1888–91.

Bousquet, Georges 'L'Art japonais', *Revue des Deux Mondes,* May 1877, pp. 288–329.

Brüning, Adolf 'Der Einfluss Chinas und Japans auf die europäische Kunst', *Velhagen und Klasings Monatshefte,* 15 (1900–01), pp. 281–96.

Burty, Philippe 'Japonisme', 6-part series in *La Renaissance littéraire et artistique:* Part 1, May 1872; Part 2, June 1872; Parts 3 and 4, July 1872; Part 5, August 1872; Part 6, February 1873.

Caso, Jacques de 'Hokusai rue Jacob', *Burlington Magazine,* September 1969, pp. 562–3.

Chesneau, Ernest *L'Art japonais,* Paris 1869.

'Le Japon à Paris', *Gazette des Beaux-Arts,* 18 (1878), pp. 385–97.

Cooper, Douglas 'Van Gogh', *Burlington Magazine,* June 1957, p. 204.

Danielsson, Bengt 'The exotic sources of Gauguin's art', *Gauguin and Exotic Art,* Santa Cruz n.d.

Dorra, Henri 'Seurat's dot and the Japanese stippling technique', *Art Quarterly,* Summer 1970, pp. 108–13.

Dorra, H. and Askin, S. C. 'Seurat's japonisme', *Gazette des Beaux-Arts,* February 1969, pp. 81–91.

Duranty, Edmond 'L'Extrême Orient à l'Exposition Universelle', *Gazette des Beaux-Arts,* December 1878, pp. 1011–48.

'Japonisme', *La Vie Moderne,* 26 June 1879, pp. 178–80.

Duret, Théodore 'L'Art japonais', *Gazette des Beaux-Arts,* August 1882, pp. 113–33.

Focillon, Henri *L'Estampe japonaise et la peinture en Occident dans la seconde moitié du XIXᵉ siècle,* Paris 1921.

Goncourt, Edmond de *La maison d'un artiste,* Paris 1881.

Outamaro, le peintre des maisons vertes, Paris 1891.

Hokusai, Paris 1896.

L'Art du dix-huitième siècle, et autres textes sur l'art, ed. J. P. Bouillon, Paris 1967.

Gonse, Louis *L'Art japonais,* 2 vols, Paris 1883.

'L'Art japonais et son influence sur le goût européen', *Revue des Arts Décoratifs,* April 1898, pp. 97–116.

Honour, Hugh *Chinoiserie, the Vision of Cathay,* London 1961.

Ikegami, C. 'Le Japonisme de Félix Bracquemond en 1866',

The Kenkyu (Kōbe University, Japan), March 1969.

Kobayashi, T. 'Hokusai et Degas: sur la peinture franco-japonaise en France at au Japon', *Japanese National Commission for U.N.E.S.C.O., Collection of Papers Presented: International Symposium on History of Western and Eastern Cultural Contacts*, Tōkyō-Kyōto 1957.

Lancaster, Clay 'Oriental contributions to Art Nouveau', *The Art Bulletin*, 34 (1952), pp. 297–310.

Meier-Graefe, J. *Der moderne Impressionismus,* Berlin n.d.

Muther, Richard *The History of Modern Painting,* vol. 3, London 1907, pp. 81–104.

Orton, F. 'Vincent's interest in Japanese prints', *Mededelingen van de Rijksmuseum Vincent Van Gogh*, 3 (1971), pp. 2–12.

Rappard-Boon, Charlotte van 'Japonisme, the first years, 1856–1876', *Liber Amicorum, Karel G. Boon*, Amsterdam 1974, pp. 110–17.

Renan, Ernest 'Hokusai's *Mangwa*', *Le Japon Artistique,* 1889, pp. 99ff.

Rich, Daniel Catton 'Notes on Sharaku's influence on modern painting', *Chicago Art Institute Bulletin*, January 1935, pp. 5–6.

Rhys, H. 'Afterword on Japanese art and influence' in G. Becker and E. Philips (trans. and ed.), *Paris and the Arts from the Goncourt Journals*, Ithaca (Michigan) 1971.

Sandberg, John 'Japonisme and Whistler', *Burlington Magazine,* November 1964, pp. 500–07.

'The discovery of Japanese prints in the nineteenth century before 1897', *Gazette des Beaux-Arts*, June 1968, pp. 295–302.

Scheyer, Ernst 'Far Eastern art and French Impressionism', *Art Quarterly*, 6 (1943), pp. 116–43.

Schwartz, William Leonard 'The priority of the Goncourts' discovery of Japanese art', *Publications of the Modern Language Association of America*, 42 (September 1927), pp. 798–806.

Sullivan, Michael *The meeting of Eastern and Western art,* London 1973.

Thirion, Yvonne 'La Japonisme en France dans la seconde moitié du XIXᵉ siècle, à la faveur de la diffusion de l'estampe japonaise', *Cahiers de l'Association Internationale des Etudes Françaises,* 13 (1961), pp. 117–30.

'L'Influence de l'estampe japonaise dans l'œuvre de Gauguin', *Gazette des Beaux-Arts*, January–April 1956, pp. 95–114.

Tralbaut, M. E. 'Van Gogh's Japonisme', *Mededelingen van de dienst voor schone Kunsten der Gemeente's Gravenhage,* symposium issue, vol. 9, nos. 1–2 (1954), pp. 6–40.

Vever, Henri 'L'Influence de l'art japonais sur l'art décoratif moderne', *Bulletin de la Société Franco-japonaise de Paris,* June 1911, pp. 109–19.

Weisberg, Gabriel P. 'Félix Bracquemond and Japonisme', *Art Quarterly*, Spring 1969, pp. 56–68.

CATALOGUES OF EXHIBITIONS

Berlin (W.), Haus am Waldsee: *Der Japonismus in der Malerei und Grafik des 19. Jahrhunderts* (L. Reidemeister), 1965.

Cleveland, Museum of Art, *Japonisme, Japanese Influence on French Art, 1854–1910* (Gabriel P. Weisberg *et al.*), 1975

Munich, Haus der Kunst: *Weltkulturen und Moderne Kunst* (S. Wichmann), 1972. Abridged English version *World Cultures and Modern Art,* Munich 1972.

New York, Metropolitan Museum: *The Great Wave: The Influence of Japanese Woodcuts on French Prints* (Colta Feller Ives), 1974.

Paris: *Rencontres Franco-Japonaises (Catalogue de la collection historique réunie sur les rapports de la France et du Japon du XIXᵉ siècle)*, Paris-Osaka 1970.

European Art

GENERAL STUDIES

Brookner, A. *The Genius of the Future: Studies in French Art Criticism,* London 1971.

Lövgren, Sven *The Genesis of Modernism,* Uppsala 1946.

Meier-Graefe, J. *Modern Art,* 2 vols, London 1908.

Pevsner, N. (*et al.*) *The Sources of Modern Art,* London 1962.

Rewald, J. *Post-Impressionism from van Gogh to Gauguin,* 2nd edn New York 1963.

Roskill, Mark *Van Gogh, Gauguin and the Impressionist Circle,* New York 1970.

Zola, E. *Salons,* ed. F. W. J. Hemmings and Robert J. Niess, Paris 1952.

MANET

Courthion, P. and Cailler, P. (eds.) *Manet raconté par lui-même et par ses amis,* Geneva 1953.

Reff, Theodore 'Manet's *Portrait of Zola*', *Burlington Magazine,* January 1975, pp. 35–44.

Sandblad, Nils Gošta *Manet, Three Studies in Artistic Conception,* Lund 1954.

WHISTLER

Bénèdite, Léonce 'Whistler', *Gazette des Beaux-Arts,* August 1907, pp. 142–58.

Cary, E. L. *The Works of James McNeill Whistler,* New York 1907.

Laver, J. *Whistler,* London 1930.

Penell, J. *Life of James McNeill Whistler,* Philadelphia 1908.

Sutton, Denys *Nocturne: The Art of James McNeill Whistler,* London 1963.

Way, T. R. and Dennis, G. R. *The Art of James McNeill Whistler,* London 1903.

DEGAS

Boggs, J. S. *Portraits by Degas,* Berkeley 1962.

Browse, L. *Degas: Dancers,* London 1949.

Cabanne, Pierre *Edgar Degas,* New York 1958.

Degas, E. *Lettres,* Paris 1931.

Lemoisne, P. A. *Degas et son œuvre,* Paris 1946.

Meier-Graefe, J. *Degas,* Munich 1920. English edn London 1923.

Rich, Daniel Catton *Degas,* New York 1951.

MONET AND THE IMPRESSIONISTS

Rewald, J. (ed.) *Camille Pissarro: Letters to his Son Lucien,* London 1943.

The History of Impressionism, New York 1973.

Seitz, William C. *Monet,* London 1960.

Venturi, Lionello *Les Archives de l'Impressionisme,* 2 vols, Paris 1939.

GAUGUIN

Jaworska, W. *Gauguin and the Pont-Aven School,* London 1972.

Kane, William M. 'Gauguin's *Le Cheval Blanc:* Sources and Syncretic Meanings', *Burlington Magazine,* July 1966, pp. 352–62.

Malingue, Maurice (ed.) *Paul Gauguin: Letters to his wife and friends,* London 1946.

Rookmaaker, H. R. *Gauguin and 19th-century Art Theory,* revised edn Amsterdam 1972.

Wildenstein, Georges (ed.) *Gauguin, sa vie, son œuvre,* Paris 1958.

VAN GOGH

La Faille, J. B. de *The Works of Vincent van Gogh,* London 1970.

Tralbaut, M. E. *Van Gogh,* London 1969.

Van Gogh-Bonger, J. (ed.) *Vincent van Gogh: Complete Letters,* 3 vols, London 1958. First Dutch edn Amsterdam 1952–4.

SEURAT AND NEO-IMPRESSIONISM

Dorra, H. and Rewald, J. *Seurat: l'œuvre peint, biographie et catalogue critique,* Paris 1960.

Rewald, J. *Georges Seurat,* New York 1943.

Signac, P. *D'Eugène Delacroix au Néo-Impressionisme,* Paris 1889.

TOULOUSE-LAUTREC

Adhémar, Jean *Toulouse-Lautrec: His Complete Lithographs and Drypoints,* New York 1965.

Dortu, M. G. *Toulouse-Lautrec,* 4 vols, New York 1971.

Joyant, Maurice *Henri de Toulouse-Lautrec, 1864–1901: dessins, estampes, affiches,* ed. H. Floury, Paris 1927.

Henri de Toulouse-Lautrec, 1864–1901, peintre, ed. H. Floury, Paris 1926.

THE NABIS, MARY CASSATT AND THE PRINT REVIVAL

Breeskin, Adelyn *The Graphic Work of Mary Cassatt,* New York 1948.

Brillant, M. *Portrait de Maurice Denis,* Paris 1945.

Denis, Maurice *Journal, 1884–1943,* 3 vols, Paris 1957–9.

Théories, 1890–1910, 4th edn, Paris 1920.

Die Maler der Revue Blanche, catalogue of exhibition, Kunsthalle, Bern 1951.

Die Nabis und Ihre Freunde, catalogue of exhibition, Kunsthalle, Mannheim 1963–4.

Dugdale, James 'Vuillard the decorator', *Apollo:* Part 1, February 1965, pp. 94–101; Part 2, October 1967, pp. 272–7.

Roger-Marx, Claude *Bonnard, lithographe,* Monte-Carlo 1952.

'L'Œuvre gravé de Vuillard', Monte-Carlo 1948.

Russell, J. (ed.) *Vuillard,* London 1970.

FIN DE SIECLE: ENGLAND, GERMANY AND AUSTRIA

Adburgham, Alison *Liberty's: A Biography of a Shop,* London 1975.

Aslin, Elizabeth *The Aesthetic Movement, Prelude to Art Nouveau,* London 1969.

Fischer, Wolfgang 'Kokoshka's early work', *Studio International,* vol. CLXXXI, no. 929 (January 1971), pp. 4–5.

Harbron, D. *The Conscious Stone: The Life of Edward William Godwin,* London 1949.

Hofstätter, Hans H. *Geschichte der europäischen Jugendstilmalerei,* Cologne 1963.

Kallier, Otto *Egon Schiele Œuvre-katalog der Gemälde,* Vienna 1966.

Leopold, Rudolf, *Egon Schiele, Paintings, Watercolours, Drawings,* London 1973.

Liberty's 1875–1975, catalogue of exhibition, Victoria and Albert Museum, London 1975.

Madsen, S. Tschudi *Art Nouveau,* London 1967.

Nebehay, C. M. *Gustav Klimt-Dokumentation.* Vienna 1969.

Novotny, F. and Dobai, J. *Gustav Klimt Œuvre-Katalog,* Salzburg 1969.

Reade, Brian *Beardsley,* London 1967.

Rossetti, W. M. *Rossetti Papers, 1862–1870,* London 1903.

Some Reminiscences, 2 vols, London 1906.

Schmutzler, Robert *Art Nouveau,* London 1964.

Spencer, Robin *The Aesthetic Movement: Theory and Practice,* London 1972.

Vergo, Peter *Art in Vienna 1898–1918,* London 1975.

Weisberg, Gabriel P. 'Samuel Bing: patron of Art Nouveau', a 3-part series in *The Connoisseur:* Part 1, October 1969, pp. 119–25; Part 2, December 1969, pp. 294–9; Part 3, January 1970, pp. 61–8.

Wien 1900, catalogue of exhibition organized by the Cultural Office of the City of Vienna, 1964.

Index

Page numbers in italics refer to illustrations